3D Movie Making

Stereoscopic Digital Cinema
from Script to Screen

Bernard Mendiburu

ELSEVIER

AMSTERDAM • BOSTON • HEIDELBERG • LONDON
NEW YORK • OXFORD • PARIS • SAN DIEGO
SAN FRANCISCO • SINGAPORE • SYDNEY • TOKYO
Focal Press is an imprint of Elsevier

Focal
Press

Focal Press is an imprint of Elsevier
30 Corporate Drive, Suite 400, Burlington, MA 01803, USA
Linacre House, Jordan Hill, Oxford OX2 8DP, UK

 Recognizing the importance of preserving what has been written, Elsevier prints
its books on acid-free paper whenever possible.

Library of Congress Cataloging-in-Publication Data
Application submitted

British Library Cataloguing-in-Publication Data
A catalogue record for this book is available from the British Library.

ISBN: 978-0-240-81137-6

For information on all Focal Press publications
visit our website at www.books.elsevier.com

09 10 11 12 13 5 4 3 2

Printed in the United States of America

Contents

Ray Zone

In 2007 I was struggling with an assortment of 3D postproduction formats working with various digital geniuses to finish my independent short stereoscopic movie "Slow Glass." The principle stereo cinematography had been completed in 2005 within a single week by Tom Koester and myself using a pair of JVC HD-10 digital cameras side-by-side on a bar. Now, almost two years later, the complex stereo blue screen compositing was slowly being finished. Terrific work had been completed by Brian Gardner, SFX supervisor Sean Isroelit, Tom Koester, co-producer and editor of the movie, and Bernard Mendiburu.

I had met Bernard in 2006 at the Stereoscopic Displays and Applications Conference held annually in San Jose, California. It was the centennial of the 1906 earthquake in San Francisco and Bernard had recently completed a wonderful short anaglyphic 3D documentary about the event combining historic stereoview card images and digital motion graphics. Subsequently I enlisted Bernard's expertise to create an opening title sequence for "Slow Glass" and he did not disappoint. Within a week, and working in his spare time, Bernard created an amazing sequence, laying animated mirror-like 3D titles into the live action stereoscopic background plates.

"Slow Glass" would not have been finished without Bernard. The final shot, with complex blue screen composites, had been proving baffling to my geniuses. We called it the "shot from hell." In this shot the actors walked across frame in front of a series of blue screen plates in the background and the 3D cameras panned with them as they moved. After the fact, I realized that all of the other blue screen shots in "Slow Glass" used a locked-down camera, except this final shot which came at the climax of the story. By shooting blue screen panels with panning cameras the complexity of the stereo comps had been logarithmically increased. It meant that every frame (or field) of the shot effectively became an individual special effect.

"I see why everybody called in sick on this shot," Bernard told me when he saw the problem he had to solve. But all Bernard needed was a deadline, which I promptly gave him. Two weeks later the shot was finished. It worked perfectly, seamlessly, as a special effects shot should, by not calling attention to itself. "Slow Glass" went on to win two awards at 3D film festivals and is very well received today.

Bernard continued with his work to make stereoscopic contributions to the Disney/Pixar movie "Meet the Robinsons," do 3D consultation with various

software companies and to write this book. Up to the present day, stereo cinema has been such an intermittent format in theatrical exhibition, reappearing every few years, that no technological standards, or even consistent terminology, has evolved. This book marks a watershed in stereo cinema. As digital imaging fuels stereography at every level of image capture, generation, manipulation and display, the need for a fundamental pedagogy and toolset is daily evident. Bernard Mendiburu has opened up the stereoscopic toolbox and explained for us what is inside it. He has created a very useful overview of some of the tools and applications that exist today for the creation of digital stereoscopic motion pictures along with a clear explication of basic principles. And he has done this just in time for the desktop digital 3D revolution.

The digital 3D tools will continue to evolve along with the rapidly changing skillsets for motion pictures in general. Stereoscopic technologists, building or writing digital images on the z-axis, have always had to refashion existing tools for a perennially "new" application. No readymade tools for stereography have ever existed. But that is about to change, along with a fundamental understanding of how motion pictures can tell stories in a visual space that is elaborated both behind and in front of the screen.

For the creation of a technical "primer" on stereoscopic production, postproduction and exhibition, the ideal candidate was enlisted. He is a technological problem solver with a specific stereographic vision. This book will enable other workers, stereographers of the future, to share in that deep vision and participate in its enlargement in the coming years.

Ray Zone is an award-winning stereographer, 3D film-producer and writer who has published or produced over 130 3D comic books. Zone is the author of "3D Filmmakers: Conversations with Creators of Stereoscopic Motion Pictures" (Scarecrow Press: 2005) and "Stereoscopic Cinema and the Origins of 3-D Film; 1838–1952" (University Press of Kentucky: 2007).

Acknowledgments

Before I wrote this book, I never had a chance to understand why so many acknowledgments start by mentioning the author's family. Now I know. Thanks to Fabienne, Alienor and Lupin for supporting me and dealing with such a bad husband and daddy for the last two months. Chain writing is a painful experience, for the relatives too.

We are all Dwarfs on giants' shoulders, and the giants that gave me a ride along my journey to the center of the 3D knowledge were, by order of appearance;

Bernard Tichit, franck verpillat*, Guy Rondy, Pierre Alio, Alain Derobe, Henry Clement, who collectively taught me all about video and 3D in Paris before I moved to new worlds.

All the 3D experts I met then and who shared their precious knowledge in interviews, conferences, or meetings; Rob Engle, Steve Schklair, Kommer Kleijn, Tim Sassoon, Michael Karagosian, David Seigle, Chris Yewdall, Brian Gardner, Yves Pupulin, Jeff Olm, Andrew Woods, Bruce Block, and, above all of them, the pioneer of modern stereography, Lenny Lipton.

Along with them, I'm deeply indebted to Ray 3D Zone and Philip "Captain 3D" McNally for their help at learning the Hollywood 3D navigation rules.

I want to mention the members and employees of the movie professional associations that make sharing knowledge a reality. Here comes the acronyms soup; SMPTE, ASC, VES, CST, BKSTS, ISU, NAB, IEEE, SPIE . . . There would not be any magic without them.

I would like to express my appreciation to all the 3D professionals that provided me with illustrations and digital content for this book and its enclosed DVD.

And, eventually, just like every 3D maniac, I owe a huge debt to the members of the Stereoscopic Clubs that kept the 3D craft alive during all these years since the 1950s. As a final note, I want to address special thanks to Phil Streather who suggested tons of corrections to improve this revised print.

CHAPTER 1

Introduction to 3D Cinema

WHICH ONE OF THESE PICTURES IS IN 3D?

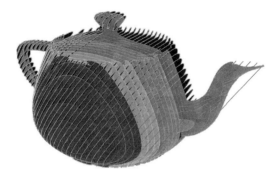

FIGURE 1.1
The Utah teapot is the emblematic 3D model, used over and over in CG research and development.

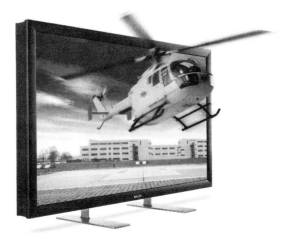

FIGURE 1.2
The action reaching out to the viewer is the signature representation of 3D displays. In reality such an effect is impossible, and the 3D action remains inside the frustum between the viewer and the screen.

The term "3D" in cinema refers to two concepts: computer-generated images (CGI or CG), which relies on 3D virtual models of objects like the famous Utah teapot; and stereoscopic (s3D) movies, in which the images, if seen through appropriate glasses, seem to reach out of the screen. These two 3Ds should be clearly distinguished, even if the current renaissance of 3D cinema was sparked by a dozen "3D animation" movies released "in 3D." CG-3D has been intensively used in 2D medias like movies and video games for the last 15 years, and many "nonanimation" 3D movies are slated for release in next few years.

WHAT IS 3D CINEMA?

Chances are that you have recently seen a 3D movie in a theater near you. As you may know, 3D cinema is cinema where landscapes extend far beyond the screen and objects fly inside the room, thanks to 3D projectors and glasses. In the late 20th century, 3D has been falsely associated with cheap red-and-blue glasses. However, even in the 1950s, 3D used sunglass-like, neutral-gray filters that provided a full-color, highly comfortable viewing experience.

We enjoy that visual art, because 3D is the natural form of vision for predators. Stereoscopic 3D vision provides acute trajectory interception and impact point computation. Animals lower on the food chain tend to have wide-angle vision, to look for danger. This is why watching a 3D movie gives us a feeling of visual completeness that was lacking in 2D films, despite the tremendous efforts and skills of the cinematographers.

Eventually, 3D will make its way into mainstream cinema the way color and sound did: it will be considered useless until it's available with a reasonable price tag. And then, all of a sudden, it will be unavoidable and ubiquitous, to the point that the very mention of "3D" will disappear from posters. At some point in the near future, you will go to see a "flattie" for nostalgia's sake, just as you sometimes watch black-and-white movies on TV today.

Before we see this happening, 3D cinema faces challenges. First, how can it provide this feeling of additional depth to the audience via an industry that has gotten by without it for a century? Furthermore, experience in 3D movie making is so scarce that one can count world-class 3D directors on a single hand. The situation is the same regarding 3D directors of photography (DPs) and postproduction houses. On the other hand, 2D equipment and experience is widely available, and thousands of gifted cinematographers have beautifully mastered the tricks that let you forget that your current cinema experience is actually flat. Going into 3D production means leaving the well-known area of 2D movie making for the dangerous, mostly uncharted land of 3D.

We are in a transitional time. The creativity and freedom of directors, DPs, and editors will suffer some restraints until better 3-D production tools are crafted and the audience gets educated to this new cinematographic language. For

example long lenses flatten their subjects, camera rigs are bulky and complex, and caution needs to be used in 3D cuts. All this will settle down within a few years. In the meantime, we should remember that we are reentering a mostly unexplored world, crossing a frontier to an unmapped wild land where mistakes hurt, sometimes badly. This will be a challenge to an artistic industry in which the digital revolution and CG images have brought forgiveness to any possible mistake of shooting or creative megalomania. To some extent the whole profession is going back to school. However, we must remember that 3D has existed for as long as the cinema itself, and it has already seen a golden age and an extinction. The purpose of this book is to put together what we already know about 3D cinema and help you avoid known pitfalls while finding a path to your own 3D cinematographic style.

There will be no 3D cinema without these two elements: stories really benefiting from 3D and fully developed 3D cinematography. On one hand, this may not happen soon, just like not all movies have to be in color and people have enjoyed black-and-white movies for decades. Cinema has been flat for a century and economic realities could kill 3D once again. On the other hand, would you choose to watch a recent blockbuster on a smaller screen, or in plain stereo sound, if it would bring you a $2 reduction on the ticket price?

WHAT DOES 3D ADD TO MOVIES?

This is not an easy question if we want to get an answer that goes beyond "depth, of course!" Cinematography is all about feeling, experience, and identification with characters—and 3D is mostly a technical trick. Can we put feelings into numbers? The entertainment industry does, and calls it box office. We will see their figures in the next chapter. For now, let's focus on artistic and emotional dimensions.

Because 3D is our natural way of seeing, it brings a feeling of realism to the audience. With 3D, we no longer have to rebuild the volume of objects in the scene we are looking at, because we get them directly from our visual system. **By reducing the effort involved in the suspension of disbelief, we significantly increase the immersion experience.**

When it comes to close-ups, the effect is even stronger. The actor's head fills the room, and this dramatically increases the emotional charge of the shot. If a person were as flat as a cardboard puppet, we would notice it immediately when we met him face-to-face. We naturally prefer the fine details of flesh structures, the volume and movement of underlying bones and muscles. The increased realism of human figures in 3D movies positively affects the identification and projection processes.

When it comes to landscape shots, the effect is a mixed bag. Because of optical laws, there's a maximum size of what can be shown in a theater, and it's not that much bigger than the screen itself. Until we have the movie projected directly

onto our eyeballs, we won't see a picture bigger than the screen we're looking at. As a result, a majestic landscape placed beyond the screen will either look big and flat, or—in order to look nicely sculpted, with roundness and volume—will have to be scaled down to fit the theater's metrics. This effect is usually not detected by the audience, and at worst will make you feel like a giant looking at a scale model.

Overall, 3D cinematography can't perfectly fit all the depth of the real world inside a 3D theater. We have seen the limitations affecting far-away subjects and landscapes. "In-your-face 3D" has constraints, too. Just as a viewer can't look into his popcorn bucket and at the screen at the same time, there's a limit to the intensity of the up-close effects we can achieve. Consider that half the theater's room volume is the area where you'll be able to display floating objects without hurting anyone's feelings.

Not only does scene and picture composition have to be fine-tuned for 3D, but the pacing of the editing and the visual effects need special finessing, too. Because of increased visual complexity and extended reading time, 3D pictures require a smoother, gentler editing style than 2D.

Throughout this book, we will rely on comparisons with the addition of color and sound to movies. If neither of them did actually turn the cinema industry on its head, they both had a significant impact on the storytelling and movie-making process.

THE EFFECT OF 3D ON THE BOX OFFICE

The 3D effect on the box office is simple: on the opening weekend, it generates three-times the revenue per screen of flat cinema. Speaking to this point, Variety had a headline on its web site reading: "3D stands for dollars, dollars, dollars." Furthermore, 3D movies tend to hold an audience after their first weeks on screen much better than 2D movies do.

"3D stands for dollars, dollars, dollars"

It is widely recognized that the 3D renaissance was ignited by the release of *The Polar Express* in 3D in IMAX theaters in December 2003. We can't really compare 2D and 3D raw box offices figures because the 2D movie was released on 3,650 regular screens, while the 3D movie was released in 70 IMAX 3D theaters. However, if we look at the revenue per copy, then the figures get quite impressive, with a 14-fold increase. And if we consider how well the movie did over time, this is really amazing, with long-lasting high revenue in the 3D theaters. Equally impressive is the fact that *The Polar Express* was re-released for Christmas 2004, competing against its DVD release, and still made more money than the 2D version's opening weekend in 2003. Further still, in Christmas 2005, some IMAX theaters released it again, even after the 2D movie had been on television, and it once again made more money per seat than the 2D prints had made two years earlier. Eventually, over the years, each 3D print made 14 times more money than the 2D prints did.

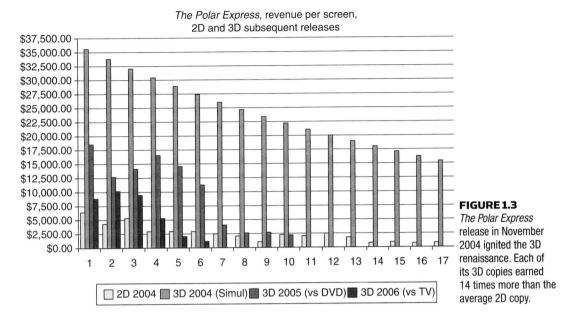

The Polar Express, revenue per screen,
2D and 3D subsequent releases

Legend: 2D 2004 · 3D 2004 (Simul) · 3D 2005 (vs DVD) · 3D 2006 (vs TV)

FIGURE 1.3
The Polar Express release in November 2004 ignited the 3D renaissance. Each of its 3D copies earned 14 times more than the average 2D copy.

This was no isolated event. When *Chicken Little,* the first 3D Disney Animation Studios feature, was released on November 4, 2005, the average seat occupancy was 96 percent over the weekend. In November 2007, *Beowulf 3D* was sold out for the first three days in the United Kingdom.

The 3-D screens count

Despite the promising box-office numbers, 3D movies still suffer from the scarcity of 3D screens. Until 2005, only 70 IMAX theaters were able to show 3D movies. Since then, digital projection in regular theaters, coupled with relatively inexpensive add-ons, has allowed 3D projection in regular theaters at a marginal additional cost. As a result, venue owners have converted their screens by the hundreds, allowing 3D releases on 600 to 800 screens in 2007.

Despite these expanding numbers, the issue remains that Hollywood releases big budget movies on 3,000 screens. On 800 screens, you cannot pay back the advertising expenses involved in a nationwide release. Current 3D movies could not be released without the 2D version paying the marketing bill. Experts consider the break-even number of 3D screens to be in the 1,500 to 2,000 range. It was expected that this number would be reached by mid-2008.

This screen count was central in the decision to delay the release of 3D movies like *Journey to the Center of the Earth,* and *The Dark Country,* or 3D conversions of 2D movies, like the long-awaited 3D version of the 1977 George Lucas original *Star Wars.* Eventually, Eric Brewig's movie was renamed *Journey to the Center of the Earth,* with no "3D," and had a coupled 2D/3D release.

Early in 2008, analysts announced that 3,000 3D screens would be available to show two 3D milestones over Memorial Day weekend 2009: James Cameron's

Avatar and PDI's animated feature *Monsters vs Aliens*. As of this writing, both are planned to have 3D-only releases and are expected to signal the definitive entry of 3D cinema into the mainstream.

As of late 2008, *Avatar* was rumored to be postponed until December 2009 and *Monsters vs Aliens* was advanced to March 2009. As of July 2008, there were 1,084 3D screens in the United States using real-D systems. Even with the Dolby 3D and NuVision systems, along with the IMAX 3D theaters, we are a bit shy of the expected 1,500 3D screens. It should be noted that 3D screen deployment forecasts have been regularly overestimated by 30 to 60 percent since 2005. This has been the cause of big disappointments and some angry phone calls in Hollywood but has not seriously affected 3D's commercial reputation.

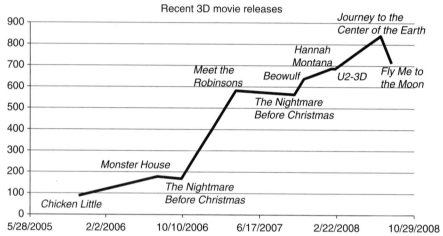

FIGURE 1.4
Since 2005 the number of digital 3D screens available for movie releases has steadily increased, allowing 3D-only releases (*Hannah Montana*, *U2-3D*) or combined 2D and 3D releases, where 3D screens grossed 30 percent of the box office (*Beowulf*, *Journey to the Center of the Earth*). We have already seen the effect of the shortage of available 3D screens (*Fly Me to the Moon*) due to previous 3D movies' on-screen longevity (*Journey*).

WHAT IS THE FUTURE OF DIGITAL 3D?

This is definitely one of the few questions that the whole movie business is trying to answer. Shall we prepare for a complete switchover to 3D, like we did with color and sound? Or shall we consider 3D cinema as passing hype that will fall into oblivion once again? Let's compare the current renaissance with the passing 3D hype of the 1950s.

The 1950s' golden age of 3D and the current renaissance

Both occurred when regular cinema was fighting against a powerful challenger. It was the TV set popping up in living rooms, and it's now home entertainment electronics, including home cinema, video games, legal video on demand, and illegal Internet file sharing.

Both were ignited by the release of a 3D movie—*Bwana Devil* in 1952 and *The Polar Express* in 2003. The unexpected box office numbers rang many a bell in the corporate offices in Hollywood, and subsequent 3D movie projects were green lighted.

What is different about the golden age and the current renaissance?

If both involved repurposing existing cinema technologies, the impact on the overall production processes has been deeply different, to the point that the eventual outcome of the current renaissance will be affected.

The 1950s 3D technology was reusing the multicamera technologies developed for early color and panoramic formats. Within years, new film stock and anamorphic lenses had provided studios with single-camera solutions for widescreen color movies, leaving 3D alone with the burden of multi-camera productions. Furthermore, 3D required extreme caution in the projection booth to prevent the 3D effect from turning into a simply painful visual experience. Projectors needed to be perfectly matched and synchronized, which was sometimes beyond the average projectionist's technical skills.

For today's 3D, riding on all-digital production pipelines, the benefits extend far beyond principal photography into postproduction and distribution. Considering that 1950s 3D is said to have been crippled by image quality issues that couldn't be tackled in the analog age, this distinction is crucial. Basically, a digital 3D movie should not give you a headache (unless the director made an awful film)—and not hurting the audience tends to be a key issue when you're selling entertainment.

It should be noted that the development of single-camera 3D in the 1970s and 1980s sparked a revival of 3D movies (*Jaws 3D, The Stewardess*) but was unable to generate a full-scale renaissance. To the same extent, the digitization of post-processing and visual effects gave us another surge in the 1990s (*Spy Kids, The Adventures of Sharkboy and Lavagirl*). But only full digitization, from glass to glass—from the camera's to the projector's lenses—gives 3D the technological biotope it needs to thrive.

The second distinction is the absence of competitive technology in large-venue entertainment industry. Where is today's CinemaScope? All the emerging technologies are actually supporting a 3D switchover. Digital effects, virtual studios, and virtual actors—all these modern marvels are key to high-quality 3D production.

To summarize, for the first time there's a technology—digitization—that addresses the whole set of issues in 3D production. This makes 3D possible. The question now is, "Will 3D be valuable enough to make its way to ubiquity rather than oblivion?"

What are today's 3D challenges?

The real challenge is to improve definitively the cost-to-advantage ratio of 3D. On the cost side, producing a 3D movie will never come as cheap as 2D. Nothing comes for free. Black-and-white stock is still cheaper than color, recording sound requires a sound recorder, and A-list talent comes with hard-bargaining agents. On the other hand, the audience has responded, and the box office is playing a central role in the current 3D renaissance. But will this last for long? Nobody goes to the theater to see technology. Audiences want to be told stories, and they will pay for enjoying them in the best visual experience possible. 3D can be part of that experience.

Cost-effective 3D production will come with computerized 3D cameras and stereo-compatible postproduction pipelines. This is just a time and money issue, and hundreds of engineers are ready to take on the challenge.

Cost-justified 3D production will come with actual storytelling gain, or people will stay at home and see it in 2D. This is a more complex issue. We need the whole movie industry to learn and master this new media, just like it has been able to convert to color, sound, or live TV production. We not only need a new generation of cinematographers and film editors, we also need screenwriters and producers who understand 3D and create their stories with depth.

The objective of this book is to give you an all-encompassing overview of the technical and editorial switchover our industry is facing. You'll see that 3D is not a mere technological plug-in or an additional pass at the back end of production. It's much more like a new spice to be wisely used in film industry recipes, and it affects each and every step of movie making.

One last comment on the future of 3D: It should be stressed that the large-venue projectors and file servers that bring 3D to the theater are actually using the very same technologies as your home theater projector or rear-projection HDTV, hooked to a DVR, cable, or satellite TV receiver. This means that millions of current home theater installations could be turned into 3D entertainment systems almost overnight. As of late 2008, some 2 million rear-projection HDTVs sold in the United States are 3D-ready, but sometimes neither the buyer nor the seller even know it. This means that if 3D cinema catches up, it will pave the way to rapid deployment of 3D-TV, increasing the need for 3D production, creating a need for live 3D.

What does this mean for venues' business?

Cinema survived television and video, and it should survive file sharing for the same reasons: movie-watching is a social event that brings kids out of their homes. And 3D comes with a secret weapon for venues: in 3D, screen size matters, as we'll see in the next chapters.

Key Points

- 3D cinema creates the illusion of volume by projecting two pictures, one for each eye.
- Special glasses filter the light and isolate one picture per eye.
- 3D has been on and off ever since cinema has existed, with a notable peak in the 1950s.
- Technical difficulties in production and exploitation led to poor 3D quality, and prevented it from definitively taking off.
- The digital revolution has created the possibility of perfectly matched left and right pictures, that is, a comfortable and enjoyable 3D experience.
- Recent 3D releases generated three times more revenue per screen than 2D prints.
- As a result, in a "renaissance of 3D," we may see as many 3D movies in 2005–2010 as in 1950–1955.

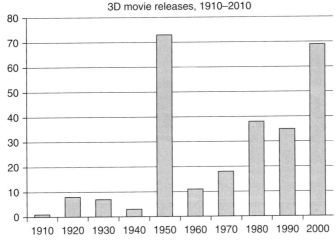

FIGURE 1.5
3D movie releases from 1910 to 2010.

This "renaissance of 3D cinema" faces a wide set of challenges:

1. Economically: 3D is being shown with high-end modern cinema projectors, its commercial deployment is conditioned to the current digital retrofit of thousands of theaters, and the revenue increase has to pay for the incremental cost of the stereoscopy.
2. Technologically: 3D requires production of twice as many images per movie, images that have to be matched to a level of perfection not required in 2D movie production. This amounts to an additional 10 to 25 percent in production costs.

3. Artistically: For the last hundred years, the movie industry finessed the art of showing a 3D world using a 2D medium. Filmmakers now have to show how 3D actually brings more emotion to the screen or it will remain a fad.

Stereoscopic Vision and 3D Cinematography

The purpose of this chapter is to introduce you to the human 3D perception. Our ability to combine the two images our brain receives from our eyes, to perceive depth, is called stereopsis. It's just one of many ways we understand the 3D world we're living in. We will see how stereopsis works and relates to other 3D perception tools, how it may sometimes not work properly, and, eventually, how it affects 3D moviemaking. The final experiment will give you a chance to voluntarily control your stereoscopic reflexes.

STEREOSCOPIC DEPTH PERCEPTION

Understanding the layout of our surrounding world is key to keeping us comfortably on top of the food chain. How far away is that lion, looking at me? Is this rock really flying toward my head? Can I jump from here to there? Neurologists tell us we answer these questions using an internal representation of the world that our visual cortex builds by using visual depth cues. We will see that monoscopic depth cues can be extracted from a single view, sometimes using some sort of time shift, although stereoscopic cues are built on the comparison between the two eyes' points of view.

Monoscopic depth cues

It is likely that you know people with one blind eye, but they've overcome their handicap to the point you'd never notice it. They do not bump into chairs, they do not drop glasses over the table edge. How is that?

It's because we can extract a lot of 3D information from a single 2D view. Just consider that distant objects are smaller and partially hidden by closer objects, and you'll get the gist of it. Let's have a closer look at these cues. Let's start with monoscopic cues, for they are part of cinema for a century, and we give them preeminence when we watch a movie.

PERSPECTIVE AND RELATIVE SIZE

If you see a picture of a man and a skyscraper, and they both look the same size in the frame, you can safely assume that the building is farther away.

FIGURE 2.1
Relative size depth cue.

TEXTURE GRADIENT

If a texture has a repetitive pattern, it will appear to get smaller as it recedes toward the horizon.

FIGURE 2.2
Texture gradient depth cue.

OCCLUSION

If the building hides half the man, it means that the building is in front of him. Therefore, you're looking at a giant or a scale model.

FIGURE 2.3
Occlusion depth cue.

ATMOSPHERE BLUR, SATURATION, AND COLOR SHIFT

If you live in Los Angeles, you are probably familiar with atmosphere blur. Particles suspended in the air blur and desaturate the image of distant objects. This natural effect, generated by water particles, can have an artificial cause, like industrial pollution and traffic fumes. Water diffusion will generate a bluish color shift. Pollution-based diffusion will generate gray to brown color shifts.

FIGURE 2.4
Atmosphere blur depth cue.

FIGURE 2.5
Up and down 3D buttons and cast shadows.

CAST SHADOWS AND SPECULAR HIGHLIGHTS

In most situations, there's one main identified source of light. For natural light, it will be the sun or the moon. The shadows cast by this light source are depth cues for recessed surfaces. The specular reflections on glossy objects are depth cues for surfaces facing the light source.

This is the reason we push the key light off-axis to generate volume on the characters and we add a butterfly overhead to get shiny hair. There's even a visual convention that light is cast from the upper left. You can see it used on topographic maps and on graphic interfaces.

When the shadow direction changes, you see the shape as recessed, as on these user interface buttons.

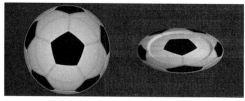

FIGURE 2.6
The first object is read as a soccer ball, until it skews and is identified as a ball-textured plate.

PREVIOUS KNOWLEDGE OF SHAPES

We have a memory of the shape of every object we've already encountered. And we fetch that shape information every time we see that object again. This is more a shape perception than a depth perception, but, as we will later see, it is an important part of our experience of 3D movies.

POSITION RELATIVE TO THE HORIZON

Where our line of sight hits the ground, defines one end of our visual range, the horizon is the other end. As objects move away from us, they get closer to the horizon. Cars, boats, trees, houses, and everything else is ordered in depth by its position relative to the horizon, with the notable exception of airplanes, which cheat us by flying high or low.

FIGURE 2.7
Objects and horizon.

Motion-based Depth Cues

Motion pictures allow us to express movement, based on our brain's ability to process visual stimuli against time. This analysis reveals objects' speeds and directions, as well as their placement in 3D space. It even helps us to generate 3D models of the objects shown on screen. Through this process, we recreate the third dimension and enjoy movies without ever complaining that they look flat. Truth is, they do not. Moviemakers master the art of providing us with motion-based depth cues, and depth cueing is the motivation for most lateral camera movement.

DEFINITION OF PARALLAX

At this point we need to introduce the key word of 3D: parallax.

Parallax is the relative position of an object's image in a set of pictures.

Let's decipher this definition step-by-step, by looking through a train window like in Figure 2.8. You see the character in the center of the window. You've got a position (center) of an object image (the character) on a picture (the window view). A fraction of a second later, that character is on the left edge of the window frame. The distance between the left and right edge of the window is the parallax affecting the character's image. That distance is a key point in your depth-perception system.

A parallax can be expressed as a motion vector. The size and direction of its vector usually describe the distance of an object.

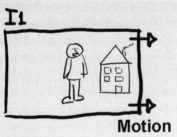 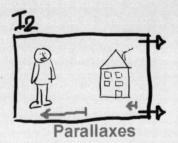

Motion **Parallaxes**

FIGURE 2.8
The distance in the frame between two positions of the same object is called parallax.

PARALLAX INDUCED BY POINT-OF-VIEW MOVEMENT

The train window is a perfect example of point-of-view (PoV) motion parallax. But you do not need to be in a moving vehicle to enjoy motion parallax. Every time you move your head, you're generating motion parallax and your brain makes sure it gathers information.

You will notice that all other monoscopic depth cues rely on some sort of previous knowledge of the viewed object. Motion parallax is the only purely optical depth cue. Even occlusions could be faked if objects do not have the shape you expect them to have. Faking motion parallax would require tracking, in real time, the viewer's position and motion-control the objects the viewer is looking at. This makes motion parallax very powerful and you will relate to it when you need to call on conflicting depth cues.

You will instinctively move your head sideways to definitively assess the 3D layout of a scene.

PARALLAXES INDUCED BY OBJECTS' MOVEMENT

Moving objects can show how far away they are from the viewer by how fast they seem to move. A plane flying high up in the sky seems stopped in the air, and a plane landing is among the faster objects you'll look at, despite the fact that it's actually flying at one-third of its cruising speed at 35,000 feet.

Imagine looking at a plane taking off, from the center point of the runaway. The plane accelerates toward you and seems to slow down after it passes by. By the time it takes off at the far end of the runaway, it seems to have stopped accelerating. Why is that? The farther away they are, the slower objects seem to move.

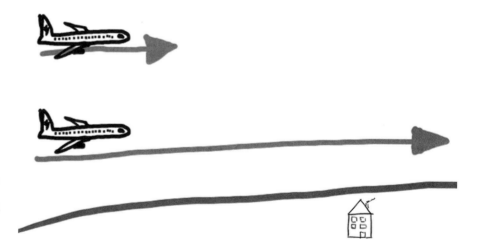

FIGURE 2.9
These two planes are visually the same size. The slow-moving one is a jet 10,000 feet away; the fast-moving one is a scale model, 1,000 feet away.

This effect was intensively used in 2D games like "Defender" in the 1980s and 1990s. Fast-moving sprites suggested close-up and slow-moving sprites were far

away. The background plate was the reference world, and was usually static or moving slowly to express the viewer's own motion.

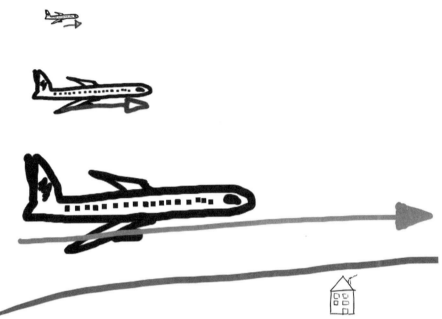

FIGURE 2.10
The relative velocity of objects is a monoscopic depth cue when the reference speed is known.

Stereoscopic depth cues

Stereoscopic depth cues are just a specific kind of motion parallax cues. We are using our two eyes as two points of view, and we make comparisons between these two views. Discrepancies between the two images are called "retinal disparities." Because we actually process the two pictures together, with specialized neurons in the visual cortex looking for these disparities, we can extract more information, more accurately, than we can from motion parallaxes.

What are we looking for? Mostly horizontal parallaxes, occlusions revelations, some shape changes, and convergence cues. One could rightfully argue that there is no stereoscopic depth cue that is not a motion cue. Because this book is addressing the generation and control of stereoscopic depth cues, we need to study them specifically in the stereopsis process.

HORIZONTAL PARALLAX

When you are looking at a stereoscopic picture, your brain extracts and computes the size of the disparities to assess the distance of the objects.

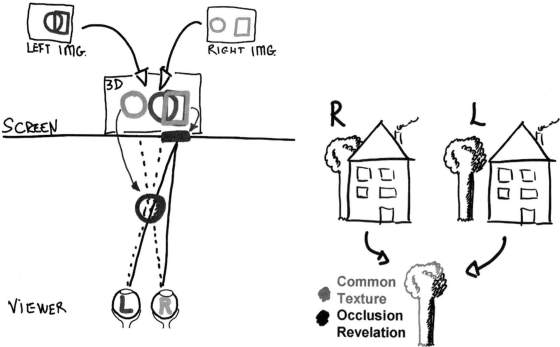

FIGURE 2.11
The left and right images of the square overlap, it would be seen on the page plane. The left image of the circle is rightmost than the right image, it would be seen floating over this book.

FIGURE 2.12
On the right view, the tree is totally out of the house, and reveals details the left eye cannot see.

OCCLUSION REVELATIONS

Occlusion occurs when objects overlap each other. Occlusions are the most powerful depth cues. In monoscopy, we notice that some parts of the background object are hidden. In stereoscopy, there is a thin stripe of the background object that is seen by only one eye. This additional texture is a major cue for the brain to reconstruct a scene, to the point that occlusion will supersede any other cue, and your brain will twist reality in every direction to make it work.

Exercise

When 3D goes wrong: Inverted stereoscopy

If you want to experience inverted stereoscopy firsthand, look at an anaglyph 3D picture included in the DVD, with the red-and-cyan glasses put on backwards, that is, with the red over your right eye. Your visual system will struggle for a few seconds, but eventually it will let you see 3D. Uncomfortable and strange, for sure, but still, it's 3D. This effect is well known among experienced stereographers and is called "pseudo stereo" or "inverted stereo." It happens every time left and right assets are messed up. And that's far from a rare event, believe me. Even with years and years of experience, we may be fooled and it would take us a few seconds to even realize something is wrong, assess it, and identify what's wrong.

SHAPE CHANGE

Look at this die in Figure 2.13. Your left eye can't see the 4 and your right eye can't see the 3. The shape of the die didn't change, but what each eye sees is different. Your brain will combine both images into one coherent 3D object.

In stereoscopy, there's an additional factor. The distance between our eyes is fixed at an average of 2.5 inches; therefore, the amount of "side view" we enjoy per eye is the function of an object's size and distance. A die you hold in your hand will reveal more of its sides than one on the other end of a craps table. And a building may not let you see its sides because it's more that 2.5 inches wide. If you see more or less of an object, and you can locate it in the distance or have a reference shape to compare it to, then you'll have enough information to infer the missing information and assess its actual size. Most of the time, this will tell you the size and distance. When we actually shoot 3D, we may (actually will) play with the camera's interocular distance. This will create size effects on objects, landscapes, and actors, and make them feel giant or small.

Standard Stereo

HypoStereo and Gigantism

HyperStereo and Dwarfism

FIGURE 2.13
Hyper stereo views of a die.

Exercise

If you want to see a side effect of conflicting depth cues and the 3D reconstruction process, put your glasses on, look at a 3D picture from the DVD, and move your head from left to right. What happens? You feel like the whole scene is skewing sideways, following your head. Why is that?

Because when you look at an object and move your head to the right, your brain expects to see more of the right side of the objects in the scene. The still picture doesn't change as you'd expected, so your brain faces this dilemma: The image should change, but does not. The only plausible cause is that the scene is changing, and objects move and change shape in order to keep

you seeing the same thing. Repeat the test with one eye closed; the effect does not show up.

In virtual reality applications, this effect is taken care of by tracking the viewer's head and having the PoV follow his or her movements in the synthetic 3D world. If you want to see an amazing depth-feeling effect using regular 2D displays and a cheap Wii Remote to generate the PoV, have a look at Johnny Lee's amazing work as he presents it at the TED 2007 conference.

http://www.ted.com/index.php/talks/johnny_lee_demos_wii_remote_hacks.html

Proprioception and depth perception

Proprioception is the sense of movement and spatial orientation arising from stimuli within the body. It is the sense that indicates whether the body is moving

by its own effort, as well as where the various parts of the body are located in relation to each other. It's distinct from

- The external senses, sight, taste, smell, touch, hearing, and balance, which describe the outside world to us
- The other internal senses, which inform us about pain in or stretching of internal organs.

VERGENCE, DIVERGENCE, AND CONVERGENCE

We have established that occlusion cues are very accurate for relative depth. You can tell without error which object is in front of the other, and make a good guess about the distance between the objects. But that won't tell you the absolute distance from you to the objects you're looking at.

To get that information, you need to gather it from your visual motor system, the muscles that control your eyes' movements. As you know, when you're looking at an object, both your eyes are aiming precisely at that object, generating a picture on the very same area of both retinas. You can squint on a close-up, or gaze on a direct parallel at a faraway landscape. The latter is comfortable and relaxing. The former, involving a muscular effort, can even be painful. We call this action "converging" on an object or at a distance. Understanding this, with the concept of parallax, is the cornerstone of making good 3D stereoscopic movies.

And this information from your squinting effort, being part of our self-perception, or proprioception, is only accurate at very short range. Even if you can tell you're squinting, you can't precisely say how much. In the fury of a stunt scene, you'll follow the action and place objects in respective layers, but you will not assess the actual distance from your seat to the subject. We will explore the use of this limitation in a subsequent chapter on 3D cinematography dedicated to the stereoscopic window and depth real estate.

FIGURE 2.14
Human eyes include a lens that focuses in coordination with vergence.

ACCOMMODATION

Actually there's another muscular structure involved in vision: the lens that focuses on objects, just like your camera lens. This lens would provide us with monoscopic depth cue if we were able to measure it. To the best of my knowledge and experience, humans cannot feel the focus plane they're accommodating to. And that's good news for us, because in a 3D movie, objects are seen floating around the space, but are actually shown and looked at on the screen. You are converging somewhere in the room, and

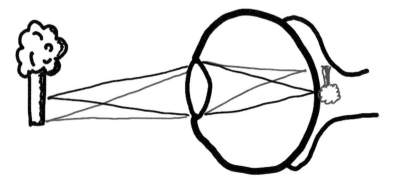

focusing on the screen. This focus/convergence de-synchronization is something most of us do without trouble, or 3D cinema would just not exist.

The ability to control convergence and focus separately can be learned and then become a very useful skill for the 3D moviemaker. This is called free viewing and allows you to look at 3D images without any 3D display or equipment. You will learn how it works and how to do it later in this chapter.

Range and limits of stereoscopic depth perception

Whereas the monoscopic depth cues have virtually no range limitations, stereoscopic perception hits a limit when objects are too far away to be seen differently by our eyes. This limit occurs in the 100- to 200-yard range, as our discernment asymptotically tends to zero. In a theater, we will hit the same limitation, and this will define the "depth resolution" and the "depth range" of the screen.

FIGURE 2.15
The stereopsis comfort zone.

2D RESOLUTION AND 3D DEPTH RESOLUTION

When the optical or digital 2D resolution limits of the imaging systems are reached, the audience loses the ability to extract any more 3D information. In other words, the better the pairs of 2D images, the better the depth resolution of the fused 3D image. In 3D cinema, compression artifacts, defocused projectors, lost details in highlights or shadows, and any kind of low-resolution image will affect the quality of the depth reconstruction.

MAXIMUM AND MINIMUM DISTANCE

In our natural environment, we are not used to looking at objects farther away than infinity. Even when we are looking at the stars, our two eyes' optical axes are parallels, and it's a very relaxing configuration. On a theater screen, this is the case when the left and right

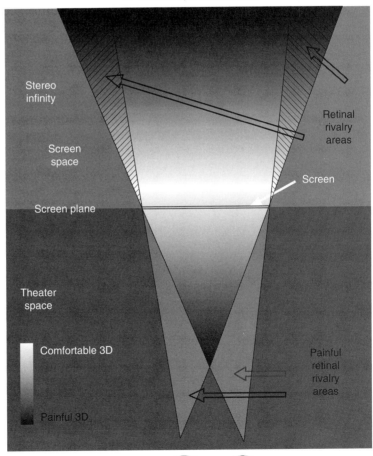

The stereoscopic comfort zone

Stereo infinity

Screen space

Screen plane

Theater space

Comfortable 3D

Painful 3D

Retinal rivalry areas

Screen

Painful retinal rivalry areas

pictures of an object are displayed 2.5 inches apart. We call this "infinity." What happens when the image is zoomed in on, or if the screen is bigger? That 2.5 inches increases to 3, 4, or 5 inches. To some extent, you'll bear it, but after a while you'll feel eyestrain. The same limitations occur when you gradually squint your eyes. At some point it begins to be uncomfortable. Good 3D cinematography has to take care of these two limits and stay inside the "comfort zone" as defined in Chapter 4.

LIMITS IN CONVERGENCE AND ACCOMMODATION DECORRELATION

When you look at an object in the real world, your eyes are converging and accommodating, or focusing, on a single point. When you look at a 3D image of an object flying in the room, you are accommodating on the screen, but you are converging somewhere between yourself and the screen. This decorrelation is not a natural function of our visual system, and our brain is actually forcing our eyes to do it. This oculo-motor exercising can be painful and can increase in difficulty with age. Kids would just not care, when elderly persons may be unable to practice it.

FIGURE 2.16
Convergence and Accommodation.

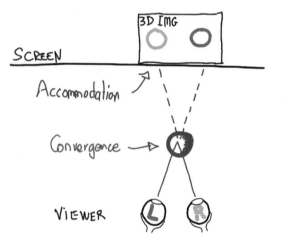

As with any muscular activity, decorrelation increases in efficiency and comfort with exercise. Training reduces the eyestrain and processing time involved in assembling the pairs of 2D images into one 3D scene. Objects displayed far away from the screen plane, fast 3D jump cuts, and rapid depth motion can then be viewed comfortably. This means that, after a few weeks' working on stereoscopic projects, you will have the ability to "catch 3D" much faster.

As a result, experienced stereographers tend to underestimate the strain they put on the audience. The renaissance of 3D cinema is expected to put a new movie on the market every month, starting in the winter of 2009. This will give the audience a chance to become as efficient at decorrelation as experienced 3D artists.

FUSION RANGE LIMITATION

Fusion is the process by which your brain merges two 2D pictures into one single 3D view. You can actually feel this when you first look at too strong a 3D picture and struggle to see it. The experience begins with "double vision," where each object seems to appear twice in the scene. At some point, the two instances of the objects merge into one single 3D shape, the virtual image.

That fusion process occurs in the brain. We can fuse images of objects close to and far from us. But we cannot fuse, at the same time, on the same picture, objects that are too far away from each other. We would either fuse the foreground or the

background. Our willingness to visually control our surrounding environment led us to unconsciously scan what's happening the background. This is one of the reasons why shallow focus is used to isolate characters. We want to force the audience not to look anywhere but in the eyes of the hero.

In stereoscopic cinema, this range limitation must be taken care of. Typically, you will not use the whole available depth in a single shot, and the action will be condensed in a fraction of it. No big close-up will be shown in front of a deep landscape set beyond infinity. Unless, of course, you have an artistic intent and it blends well into your editorial.

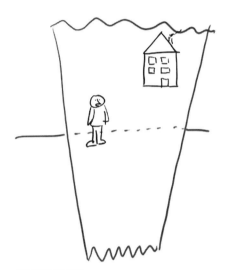

FIGURE 2.17
Background and foreground are both in the comfort zone, and close enough to each other to be fused using the same eye convergence. This is adequate for a character reading a billboard.

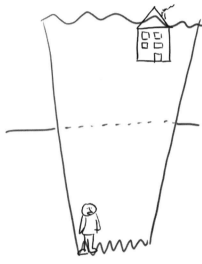

FIGURE 2.18
Background and foreground are both in the comfort zone, but too far away from each other to be fused using the same eye convergence. This is adequate for a character standing in front of a building.

Key Points

- The 3D reconstruction of the surrounding world occurs in the visual cortex at the back of the brain
- This reconstruction is based on visual stimuli and previous knowledge of the world
- Monoscopic depth cues are among the most powerful visual cues used in 3D reconstruction
- Still picture monoscopic depth cues include
 - Occlusions
 - Atmospheric effects
 - Shadows
 - Illumination

- Motion picture monoscopic depth cues include
 - Parallax induced by subject motion
 - Parallax induced by point-of-view motion
 - Objects apparent and relative speed
- Binocular vision consists of combining the images of our two eyes
 - Some species use it only to widen their visual field
 - Some species use it to generate depth perception, in a process called stereopsis
 - Stereopsis is only one of the many ways we reconstruct 3D
 - Stereoscopic imaging simulates 3D by combining a pair of 2D images
 - Achieving this is called fusing the images
- Stereoscopic depth cues includes
 - Parallaxes
 - Shape change
- Some inaccurate depth cues come from our proprioception
 - Convergence distance is a binocular proprioception
 - Accommodation, or focus distance, is a monocular proprioception

STEREOSCOPIC VISION GONE WRONG

There are some circumstances where stereoscopic vision is impossible. That's the case every day for part of the population suffering specific vision impairments, and for everyone watching "bad 3D" in poorly produced movies.

Stereo blindness

Not everybody sees 3D, and stereo blindness is estimated to affect 3 to 15 percent of the population, mostly due to poor binocular vision. It means that one in 30 persons will not see 3D at all, and one in six has some sort of stereoscopic vision impairment. Most people who do not perfectly see 3D have converging issues like strabismus, and some have greatly asymmetric visual acuity and therefore can only roughly rebuild a 3D scene. Because the brain is wired to share visual information between eyes and between hemispheres, this only affects persons with really important visual deficiency, where one eye is strongly dominating. People who do not see 3D at all may have lost vision in one eye, or lost the muscular ability to converge and focus both eyes on any point of their visual field. Their brain has given up on using stereopsis to rebuild a visual perception of depth, and relies on monoscopic depth cues.

There is at least one documented case of a person who achieved teaching herself how to see 3D, after years of stereo blindness. Her name is Sue Barry and she was featured in an article in the *New Yorker* and on "Morning Edition" on NPR. Born with amblyopia, or lazy eye, she underwent three eye surgeries and regained normal binocular vision, with the exception of stereopsis. In college, she was told that she would never regain depth perception, because her brain cells in charge of that process didn't develop during her infancy. It was many years later, at the age of 50, that she tried vision therapy and after a few months she was eventually able to see the world in 3D.

Bad 3D: causes and effects

The most common source of stereo blindness in a theater is bad stereoscopy, and it affects the remaining 85 to 97 percent of the population that would otherwise see depth perfectly. Almost everything that can go wrong in a 2D picture will eventually destroy the 3D effect. Image geometry, colorimetric, and photographic treatments are likely to damage depth perception. Mistakes in postproduction, in the projection booth, or even in the use of 3D glasses can prevent stereopsis.

Even with technically perfect images, retinal rivalry can occur if the lighting or layout is not optimal. Objects shown out of the stereoscopic comfort zone will affect 3D perception and eventually generate discomfort. Even inside the safe area, specular lights, flares, or reflections on water, glasses, or glossy surfaces can be troublesome.

Depending on the intensity of the image defects, the audience will experience an insensible overload of the visual system, slight discomfort from less-than-impressive 3D effects, and eventually major eyestrain with total loss of the depth perception. The ultimate outcome would be a screaming audience looking at a pair of 2D images that makes no 3D sense.

The level of discomfort increases with the duration of the exposition to the faulty stimuli. The longer the mistake, the worse the headache.

STEREOSCOPIC VISION AND CINEMATOGRAPHIC GRAMMAR

When you make your movie 3D, you are deeply changing the visual experience, and you will be telling your story in a radically changed visual medium. Based on our overview of the human stereoscopic depth perception, we can infer some rules and guidelines to be applied in 3D moviemaking.

"Stereopsis is more like a feeling than a perception"

Credit for this catch phrase goes to Josh Greer, Real D CEO. As he would explain, when we see a color or a shape, its information is cast onto our retina and replicated on neurons in a one-to-one relationship somewhere in our visual cortex. We hear a sound because our inner ear vibrates: it's a physical event. But 3D does not exist as stimuli. What we see is a pair of 2D pictures. What we look at is a 3D world. Our brain extracts information from the flat views provided by our eyes and generates a 3D model of our world that matches what we see and what we already know.

This has two implications. First, the stereoscopic depth reconstruction relies as much on cognitive processes and learned associations as on the visual stimuli. We can fool it to a great extent, but we can't expect the audience to be passive in its experience. Second, we are reaching the moviegoers on a deeper level. Even if visual gimmicks like flying objects trigger survival reflexes, most of the additional mileage provided by 3D images will be in the emotional sphere.

3D increases the visual system workload

Going from black and white to color movies increased the amount of information, but it did not generate any sensible additional load on the visual system. It was more like a reduction, for there was no longer a need to guess information (color). The contrast and readability being increased, the segmentation process and shape recognition is actually simpler. Going from flat movies to 3D triggers more muscular and brain activity, plus it requires us to act against the reflex coordination of convergence and accommodation. To that extent, it's more like the extension of the range of stimuli that sound provided to the cinema.

All throughout your project, you will want to care about the visual workload. Remember that 3D pictures are more complex to read, so they would benefit from being blended together at a slower pace. The last years have seen an increased complexity in the image composition and an acceleration of the edit rhythm, as the so-called MTV generation brought its visual proficiency and artistic taste to the moviemaking craft. This trend may not do very well with the 3D renaissance, at least for the first few years while the audience is still getting trained to 3D imagery, but they will be able, eventually, to cope with more "depth per second."

The hierarchy of 2D and 3D depth cues

Cinema has been relying exclusively on monoscopic depth cues for over a century. Even if we rewrote the grammar and educated the artists overnight, the audience culture and expectations would remain. There is a saying that a 3D movie is a pair of 2D movies; that's not very accurate. It's much more accurate to say, "A 2D movie is a 3D movie shot with only one camera". All of the 3D perception you enjoy daily on television comes exclusively from 2D cues, and nobody ever complained that television looks flat. 2D depth cues are part of the visual grammar we grew up with, and they are now hardwired into our image reading processes.

This is a very important point in understanding 3D cinema: you'll first have to consider that 2D cinema is not flat, it's monoscopic. Then you will want to make some room for actual 3D in your depth discourse. And sometimes these two efforts will collide, like on the issue of focus. Shallow depth of field will help you isolate the subject and force audience attention toward your point of interest. On the other hand, stereoscopic image reading asks for infinite depth of field, allowing for unconscious scanning of the 3D space before concentrating on the subject. Overall, cinematographic monoscopic depth cues will be stronger than stereoscopic ones.

This evolution from 2D to 3D depth reveals another paradigm shift. We have seen that stereoscopic depth perception asymptotically decreases until a maximum distance somewhere around 100 to 200 feet. Beyond this, monoscopic cues kicks in. Therefore, 2D cinematography is actually applying long-range 3D cues indistinctly to the whole image. Not only does the 3D cinematography reclaim the ability to display depth at short distances, but it actually extends its scope to the whole frustum by squeezing the whole world's deepness into the screen's 3D space.

As we have just seen, perception of volume in our surrounding world depends on many visual cues, most of them monoscopic, some of them stereoscopic. And the stereoscopic accuracy decreases with distance, to a point where it's useless, somewhere around the 150-yard mark.

When making your 3D movies, you'll have to take into consideration all these new factors. What you will make of it is not yet known, and that's where your artistic creativity will have to express itself—that's where the audience is waiting to be surprised and entertained.

The 3D comfort zone and palette limitation

We have established that the 3D space you'll be able to use in the theater is limited and you may consider that it comes with a rather obscure user manual. Recent cinematography evolution leaned toward media range freedom, with ever more sound channels and pressure levels, high dynamic range imagery, and virtually unlimited camera movements. Opposite these liberties, the stereoscopic 3D space is more like a pyramidal box, less than 200 feet deep, and touching its walls can hurt like hell. Not only do we have to squeeze the world inside this box, we can't even use its full range at once due to fusion limitation.

New 3D cinematographic tools

In order to overcome the classic limitations of 3D imagery, new tools are being created, or old tricks are being brought to fruition, thanks to the complete digitization of the production pipeline. You will be introduced later to the concepts of depth budget, depth bracket, floating stereoscopic window, multiple rigs, depth warping and depth grading. They all relate to technical ways to artistically fit a story universe inside a screen volume.

STEREOSCOPIC VISION EXPERIMENTS

Exercising your stereoscopic vision

If you want to experience the limit of your stereoscopic vision you can try this simple set of three visual experiments.

Exercise

Maximum distance for stereoscopic discernment

First, go outside and look at objects in the landscape, in the mid-distance range, like a tree and the house next door. You should be able to see stereoscopically which one is in front of the other. Search for the ability to see the depth gap between the objects, at the edge of the overlapping one. Now, select pairs of objects farther away. At some point, you'll be unable to see that depth gap. This is your maximum stereoscopic discernment distance. Depending on your vision accuracy, you'll find this limit ranging from 100 to 200 feet.

Exercise

Binocular parallax and occlusion revelations

For the second test, select two close objects and look at the edge of the overlapping one. Try not to select a flat-colored background like a white wall, but search for a textured one, like a picture hanging on the wall. Alternate closing your left and right eyes and see how the foreground object seems to move laterally in front of the background one. What you are looking at is the occlusion revelation generated by your binocular parallax. Repeat this with more distant pairs of objects and you'll lose the ability to see any occlusion revelations much closer to you than your maximum stereoscopic discernment. This is because the stereopsis is hardwired in your brain and uses the slightest visual cue, whereas the active and conscious left-and-right view comparison is almost never practiced in everyday life.

Exercise

Motion parallax and hyperstereoscopy

The third experiment completes the two previous ones. When you have identified your binocular parallax, close one eye and move your head sideways, back and forth, to recreate the same amount of occlusion revelation. Now you have generated a motion parallax of the same intensity as your binocular parallax. And your brain is much better at motion parallax than at conscious left-and-right view comparisons. Keep moving your head and look at the edge of objects in the distance. You'll be surprised how small an occlusion your brain can catch to generate 3D perception.

In order to perceive any parallax, you may be tempted to move your head more than 2.5 inches. This process, called hyperstereoscopy, is used in 3D cinematography, by increasing the distance between the cameras more than the average human eye width. This will increase the "3Dness" of a scene.

Stereoscopic free viewing

Seeing stereoscopic images in 3D without a specialized display or glasses is a very useful skill for the stereographer. The general public was introduced in the 1990s to this process with the publication of the ever-popular Magic Eye books of autostereograms, where the 3D picture is hidden in repetitive patterns. In stereoscopic free viewing, left and right pictures are shown side-by-side, in a cross-view or a parallel-view layout. When you squint at the former the images appear in 3D and seem to float in front of you; by relaxing your eyes' convergence with the latter you can see the 3D images far away. With some training,

these can eventually become reflex gestures that you can perform without really paying attention to the effort.

AUTOSTEREOGRAMS, A POPULAR FORM OF FREE VIEWING

An autostereogram is a single-image stereogram designed to create the illusion of depth. The simplest type of autostereogram consists of horizontally repeating patterns and is known as a wallpaper autostereogram. When viewed with proper vergence, the repeating patterns appear to float above or below the background. 3D maniacs perpetually search for such effects, which can even be found in some classic artwork.

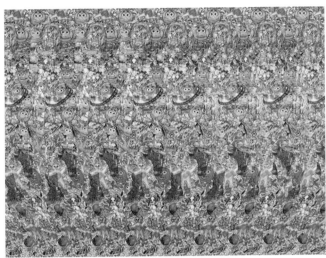

FIGURE 2.19
This random-dot autostereogram reveals a 3D image of a skating girl.

FIGURE 2.20
The depth map of the skating girl encoded in the autostereogram.

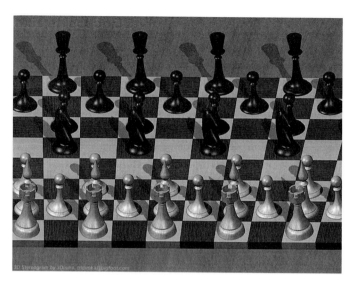

FIGURE 2.21
This is an object array stereogram of a chessboard. If viewed with the parallel-view method, a stereoscopic relief will appear.

Figures 19,20,21 are from Dmytro Bersmertnyy, alias 3Dimka, www.hidden-3D.com

HOW TO FREE-VIEW 3D, CROSS-VIEW METHOD

FIGURE 2.22
Cross-view 3D picture.

In cross viewing, the left image is on the right and the right image is on the left. You will see the 3D picture by squinting. The process to learn it is:

1. Hold the picture in one hand, at an appropriate distance, usually by extending your arm.

2. Make sure the picture is not warped and stays perpendicular to your sight axis.
3. Raise a finger in your line of sight, approximately halfway to the picture.
4. Keep looking at the finger, but observe the pictures in the background.
5. You should see four blurry pictures, due to the double-vision effect.
6. Move the finger back and forth, and see the four pictures sliding sideways.
7. Search for the point where the white circles overlap on a center image.
8. Make sure you can keep this convergence value for a few seconds.

At this point, what you see is most likely three images. A right image on the left, a 3D pair in the middle, and a left image on the right. The next step is to focus on the pictures, keeping the convergence that makes them overlap.

1. Slowly remove your finger from your line of sight, along a vertical trajectory.
2. Keeping the images overlapping, try to focus on them.
3. When the picture is sharp, you should be able to fuse it and see the 3D image.

HOW TO FREE-VIEW 3D, PARALLEL-VIEW METHOD

FIGURE 2.23
Parallel-view 3D picture.

The process is basically the same as the cross-view, with the exception that you move the picture instead of your finger.

1. Look at a distant point.
2. Pay attention to keeping the same eyesight convergence.
3. Raise the picture into your field of vision.

4. Adjust the convergence in order to overlap the central pictures into a 3D pair.

5. Focus on the pictures, and 3D fusion should follow.

Key Points

2D and 3D

- Scientifically, 3D actually describes anything, data or object, that;
 - is not flat, or in other words does not fit on a single sheet of paper,
 - needs three axes (X,Y,Z) to be properly represented.

- In the movie business, 3D is commonly used for;
 - computer-generated images (CG or CGI) using 3D models,
 - stereoscopic images, creating the illusion of depth.

- In the movie business, 2D is commonly used for
 - classic cell animation, where flat layers of pictures are hand drawn or computer generated.
 - visual effects generated with flat images composited together.
 - monoscopic movies.

Stereoscopic vision

- Stereoscopic vision describes the use of two points of view with overlapping visual fields to perceive 3D volumes.
- It needs coordinated use of both eyes and is hardwired in our brain.
- Stereoscopic cinema simulates it by showing two flat images, one per eye.
- Stereoscopy is only one of the many ways we can see 3D objects in depth.
- 2D still pictures can represent a 3D world using monoscopic depth cues.
- Animated 2D images, like movies, extend this representation using motion-based depth cues.
- Despite the film medium being 2D, classic movies are not experienced as a "flat medium."
- Depth perception is a feeling extracted from flat stimuli.
- Color and basic shape information are actual perceptions occurring in our eyeballs' retina.
- Movement and depth cues are generated in the brain visual cortex.

When stereoscopic vision goes wrong

- A small percentage of the population can't get full 3D perception from stereoscopy.
 - Between 3 and 5 percent don't see any 3D stereoscopy.
 - Up to 15 percent have imperfect stereoscopic vision.

- Stereo blindness comes from asymmetric or uncorrelated binocular vision.

- Stereoscopic vision is uncomfortable or impossible when
 - The two eyes see images that do not match.
 - The brain has to make a decision as to which eye to believe.

In 3D cinema

- retinal rivalry potentially creates strong discomfort.

Stereoscopic vision and 3D cinematography

- Left and right images should be identical in all characteristics, except for a slight horizontal shift in object positions, shapes, and textures.
- Any other discrepancies in lighting, timing, focus, and so on would lead to visual discomfort and eventually eyestrain and headache.
- This makes 3D moviemaking a complex process with very high quality requirements.

When 3D cinematography goes wrong

- Perception of 3D is generated by left-and-right image disparity
- Good disparity for 3D is moderate horizontal disparity
- Any other form of disparity will lead to, by increasing effect
 - Reduction of perceived 3D
 - Discomfort, up to eye strain and headache
 - Total loss of 3D perception, with double-vision effects
- Perception and impact of such faults increase with time.

- The most common camera-generated disparities are
 - Excessive horizontal parallaxes due to inadequate i.o. or convergence.
 - Vertical parallaxes generated by zoom discrepancies, keystone effect, rotation, tilting, or
 - photographic mismatches in focus, lightness, contrast, motion blur, or shutter angle

- Most common set-generated disparities occur when
 - An object is seen by only one eye, due to occlusion
 - Optical reflections or flares are point-of-view based

- Disparities can occur at the display level due to
 - Desynchronization and geometry mismatching
 - Screen-size effects generating excessive depth amplification
 - Cross-eye leaking generating "ghosting," resulting in double vision

CHAPTER 3

Learning 3D Cinematography

There's a popular belief that a 3D movie is just a movie shot with two cameras. This would be true if making a 2D movie were just shooting it with a single camera. And what distinguishes a feature movie from a birthday party video is precisely not the camera, but all the work done before, during, and after the production on location. People who talk about two cameras are either ignorant of the moviemaking craft, or are insulting both 2D and 3D cinematography by reducing them to technical gestures when they are long and collaborative creative processes. Refusing to acknowledge the high complexity of 3D cinematography never made it simpler—it just made bad movies.

In this chapter we will see that 3D cinematography knowledge is an elusive and treacherous concept, the real thing being experience. We'll focus on the interference of existing 2D experience, and the best way to fast-track your own acquisition of stereoscopic-imaging experience. We will then examine why the deployment of sound and color technologies offers very good analogies, helping us to cope with the current 3D evolution.

KNOWLEDGE IN 3D CINEMATOGRAPHY

Phil McNally, alias "Captain 3D" and a global stereoscopic supervisor at PDI, teaches stereoscopic 3D to hundreds of artists who have already mastered animation 3D. After many years of producing 3D movies, he is often quoted as saying: "One can teach the whole theory of stereoscopy in two hours. You can learn all about 3D moviemaking in two months. That will never give you the 10 years of experience needed to master it. Good movies are made with experience, not with knowledge."

Another very experienced stereographer, Kommer Kleijn, says: "A good cinematographer can study 3D, and in two weeks, he'll know how to avoid mistakes that hurt the audience, and make 3D work nicely. Nonetheless, he would use the 3D just as a technique, not as a full-fledged and compelling storytelling tool. He would produce a 3D-converted movie, not a 3D-intended movie. That would take him years to master."

Let's see how this impacts the crews starting a 3D project.

The treacherous 3D learning curve

One of the dangers you'll face in learning 3D is that at first glance, it seems dead easy. Taking a pair of pictures, assembling them, and showing them in 3D is a no-brainer. You will master this in a few hours, if not in minutes. After a while, you will spend more time looking at your 3D art than it took to create it. This is the "free ride" part of learning 3D. The ratio of reward to complexity is huge, and this, by itself, explains most of the "3D curse" that made some of us 3D maniacs the moment we tried it. At first, making 3D is easy, enjoyable and highly rated as a water-cooler topic. Making basic 3D look good, or even great, is not complex at all, and within arms' reach of anyone who has some graphic background. After a while, you may want, or be asked, to venture into deeper waters. You will then discover that making complex 3D look good is no simple task. Failing with a single detail makes it look awful and painful, and most often instantly breaks the suspension of disbelief. Complex 3D can be incredibly hard to achieve. That's the end of the free ride, and you are in for a couple days of cursing at the camera rig, and spending even more nights fixing shots. Eventually you'll learn to avoid 3D's minefields, and rebuild your productivity in this new creative universe you are exploring. You will have reached a comfortable plateau, and some colleagues will introduce you as "the 3D guy."

As a result, 3D movie productions are sometimes initiated by crews who ran a couple of camera tests and feel confident they understand the basics and will figure out the details in needed time. They usually face two challenges: details are not just details but they totally break the 3D experience, and by the time you identify and understand your mistakes, it's most likely too late to fix them. That's not to mention the artistic creativity that just can't surface while keeping the whole project afloat. And remember, 3D can be among the hardest things to fix in post. As we'll see, 3D quality is the result of end-to-end quality assessment all along the production process. If 3D was not properly handled at any given point, there's no way it can be fixed later for a reasonable price. "We'll fix it in post" is likely the single most expensive phrase ever pronounced in Hollywood (besides "They won't sue us"). In 3D, this is a dead end, and some movies would have needed to be fixed in post from end to end. 3D cinema history books are filled with stories of movies that were never released, or that performed poorly for this very reason.

The stereographers' paradoxes

The stereographers' paradoxes are an unfortunate confluence of events that prevents most existing 3D knowledge and experience from reaching the places where they are the most needed in the Hollywood system. They may be the side effect of hiring rules, 3D experts' behavior, the industry's self-teaching habits, or a combination of the three.

The first stereographers' paradox starts with the unwritten law in Hollywood that stipulates that you need to be working on medium-size movies for 10 years in order to work on a big movie. To some extent, it's close to a paradoxical, "You need to be in the movie business to get into the movie business." It continues

with the fact that almost no 3D movies were produced until recently, and most of the recent 3D wave was produced by a handful of teams. If you don't count the 3D movies where Peter Anderson, Shawn Phillips, Hugh Murray, Robert Engle and Phil McNally were directing, shooting or supervising stereo, you are close to none. Beside these happy few big names, there are tens, if not hundreds, of talented and experienced stereographers who could bring their knowledge to the crews. They sure don't have 10 years of experience in 3D feature movie making, and that's for a good reason; there was no such production.

The second component of this paradoxical situation is, because of the novelty of digital 3D cinematography, most of the serious questions one may ask to a talented stereographer do not have a definite answer yet. Basically, he would know what you should not do, what has a good chance of working fine, and how to make sure that's the case. And it's not an easy sell to Hollywood executives to answer, "I don't know the response to your question, but I'll bill you to search for it." Unless you have a proven track record of problem solving in the movie industry, which refers to the first paradox, you're not likely to get a callback soon.

Actually, this is very good advice to use to find your 3D expert. Discard anyone that has an immediate response to your questions. Most likely he does not know that much about the complexity of stereoscopic cinematography. In some rare cases, he may actually know a lot about it, and makes the mistake of considering he has figured it all out. He will likely provide you with concrete-solid 3D expertise and prevent most big mistakes from happening, at the cost of killing all potential creativity from the rest of the crew. He will be remembered as the "3D-can't-do-this" guy. In 3D, one should beware of the know-it-all experts.

The usual consequence of these two paradoxes is that studios prefer to invest money in their research and professional development departments, rather than in hiring external knowledge. This trend is deeply rooted in the movie-making community, where self-education on new techniques is a must. World-class professionals are used to learn a new skill or tool on every project they join. When these persons meet a 3D expert who does not have feature movie credentials, and then read the "It's just a pair of cameras" tale, they decide try to figure it out by themselves.

When they survive the project, they usually write papers for trade magazines, and they insist on 3D being much more than a pair of flat pictures.

EXPERIENCE AND 3D CINEMATOGRAPHY

Experience is a two-sided blade. Most of the time, it will help you. Sometimes, it will trap you in the confidence that you are doing the right thing when you are actually not. An experienced 2D professional will do his best at achieving two objectives: making the audience forget they are looking at a flat presentation of a 3D world, and cutting all possible corners to get the shots in the box, fast and cheap, without being caught by the deadline. These are the two major sources of problems that your 2D experience will smuggle into your 3D career.

You will want to build your 3D experience by working on it as if on a treadmill. You want it to get stronger, to the point where it will counterbalance your 2D experience and you'll be able to intuitively infer parallaxes values, or instinctively detect mismatching pairs.

> In the meantime, enforce the first rule of the digital stereographer: Always visually check in 3D. Remember not to trust your experience; always test the 3D assumptions you make, especially if they are based on your experience in 2D moviemaking.

Watching 3D

3D experience starts with experiencing 3D. Go to see each and every 3D movie that is released. Get 3D demo reels on the internet, watch them, and critique them. You need to educate yourself and your crew about 3D for two reasons.

First, you want to build a 3D culture. There is hardly any 3D trick or effect that has not yet been used in a movie. Sometimes it was limited to one shot, sometimes it was not efficiently put together, but you'll be surprised how much 3D cinematography has been reinventing itself, thanks to the long time span separating its reappearances on screen. And when you will watch recent 3D movies you'll be able to catch on the fly all the references made to the old timers.

Second, you want to educate yourself and your visual system to 3D. Watching 3D is not a sport, but it involves muscular activity and reflexes. Practicing it is getting better at it. You'll soon find yourself much quicker at fusing 3D images. This has a drawback and an advantage. The drawback is you will be tempted to go into a strong and dynamic 3D that you enjoy, but your audience may have trouble following you. The advantage is you can teach yourself to be much more efficient at catching 3D disparities and errors.

As a rule, give the artists free access to 3D displays, to 3D dailies in the theater. Just like you check a rough edit with the soundtrack, or check camera shots in color, you will want to work in 3D all throughout the production, not just at so-called "3D stations." Not doing so is taking a chance to not catch a problem and have your project severely damaged when it needs quick fixes down the road. A sign of a team really caring about 3D is to see 3D glasses all over the place—on desks, on shelves, on monitors, in shirt pockets. Flood your facility with 3D glasses.

Forgetting 2D

We have already established that a 3D movie is much more than a pair of 2D animated pictures. It may be useful to repeat that mantra once again. It's not the existence of these two shots that makes the 3D. It's not their content. It's the relationship between the two. The way they are matched makes the 3D effect. You need to master how each pixel is affected by any action in the moviemaking process and make sure it adequately affects the matched pixel on the other view. The audience's brains will do a quality assurance pass on both pictures and consider each

difference as a 3D cue. If it does not generate comfortable and enjoyable 3D, this very image disparity will be identified as a fault, and lead to visual glitches, hurt the suspension of disbelief, or even worse, give a visually induced headache.

> This introduces a recurring law of stereoscopy you'll want to remember:
> What you used to get away with in 2D will potentially hit you harder in 3D.

Let's examine the two most-often-used tools of 2D effects, known as "roto and paint": rotoscoping is the cutout of elements, like foreground actors, and paint is the recreation of textures, say, to recreate a clean background plate. A regular process is to clone-stamp parts of the picture to remove unwanted objects like wires or markers. As seen in Chapter 8 both need a specific stereo pass otherwise they'll break the 3D effect apart. Effects may have to be up to 10 times more accurate, as in *Journey to the Center of the Earth*, where the compositing artists sometimes had to shift images by a quarter of a pixel to have the actors "stick on the ground."

Even in high-level artistic decisions like a shot composition, you have to think in 3D. Diagonals are a very good example. They are used to build a 2D picture, where they generate very dynamic strength lines. As soon as you see them in 3D they are just perspectives that fly away from the audience. They lose all their dynamic visual impact.

Remembering 2D

Some of your experience in 2D will be especially useful in 3D. Mostly the safeguards, protocols, and organizational tools will help you survive the production of 3D content with equipment and procedures that are not yet adapted and extended to 3D.

ASSET MANAGEMENT

The story of asset management in 3D starts with a well-known line: Your asset numbers will double. And your quality requirements will triple, for an unpaired left or right asset is a dead asset, with another dead asset somewhere in your data tree or tape vault, and its share of lost time and resources. Furthermore, this matching is not taken care of by default by most asset management tools that are not 3D-aware. To prevent this from happening, some teams stack the pictures together, as a side-by-side or over-under format in the digital realm. In our physical world this is done by color-coding the physical supports, say red for left and blue or green for right, as on a pair of anaglyph glasses. Usually, all the equipment, especially the cables, are likewise color coded. Regarding the cables, in order to avoid mismatching with analog RGB cabling, it may be wise to use other colors for left and right equipment, like orange and purple, with yellow being sometimes reserved for digital links.

RESOURCES MANAGEMENT

Making a 3D movie is much more effort than making a 2D movie, and the workload increase on your pipeline is pretty close to a factor of two. Basically, you will handle twice the amount of data, and this applies to storage, manipulation, and archiving. At this point you should be aware of your network bandwidth if you run a big facility. You can double the number of CPUs, hard drives and workstation screens. It's costly, but, at least, it's a known cost. You can't double the network bandwidth, for it's a fixed figure based on your network topography, most likely using gigabit Ethernet. File copying and moving will inherently tend to be twice as long. Then you will be handling twice as much rendering, and you will want renderings to match. The quality checks need to be in 3D, and will likely generate more re-renders for technical reasons. While a missing effect or inadequate render parameter on a preview pass would be acceptable in 2D, it will not go forth in 3D, because it makes this asset uneven with its matching asset and prevents adequate stereoscopic checking of the pair.

TRANSITIONING TO 3D CINEMA

In order to explain or assess the impact of the 3D renaissance on the entertainment industry, experts frequently use the deployment of sound or color technologies as a comparison. Lenny Lipton, the leading expert on 3D cinema, published a paper entitled "The Last Great Innovation: The Stereoscopic Cinema" in the November 2007 issue of *Motion Imaging Journal,* published by the Society of Motion Picture and Television Engineers (SMPTE). His article explains how the cinema extended his medium's palette from black-and-white silent movies, to widescreen color movies with soundtracks, and, now, depth. This comparison is so useful, we will study it in this chapter, and we will bring it back throughout this book. It may even help you spontaneously find answers to questions regarding your 3D project. When you are facing a dilemma, or trying to evaluate the impact of 3D on your work or organization, ask yourself, "What would be the response if this was a black-and-white versus color, or a silence versus sound question?"

An interesting contribution from Phil McNally, alias "Captain 3D," global stereoscopic supervisor at PDI, is to consider that all technical progress in the cinema industry brought us closer to the ultimate entertainment experience: the dream. We dream in color, with sound, in an incoherent world with no time reference. The cinema offers us a chance to dream awake for an hour. And because we dream in 3D, we ultimately want the cinema to be a 3D experience, not a flat one.

Comparison with color, a technical evolution

Conversion to color and conversion to 3D present many technical similarities. Earlier color systems relied on hand-painting the film, frame by frame, in a way that preceded the current labor-intensive 2D/3D conversion system based on

roto and paint. Duplicating the camera, or more exactly, the film, was the first color cinema process, as the first generations of color camera used a beam splitter to illuminate two or three films in the red, green, and blue domains. Some dual projection systems were tried, but eventually, dye transfers were used to generate single-strip color films for exhibition.

TECHNICAL NOTE

The technical challenge of color cinematography was to put a five-dimensional physical phenomenon (X, Y, R, G, B) onto a three-dimensional support (X, Y, lightness) by using three supports. Don't be confused by the notion of color space where a color value is associated with a point in a 3D cube whose sides can be red, green and blue, or hue, saturation, and luminosity. This is a different 3D space than the physical world where we live. When you record a stereoscopic video stream, you are recording two sets (left and right) of three values (red, green, and blue), along three dimensions (width, height, and time). This can be described as a seven-dimensional dataset. To add to the confusion, there's a CIE (international commission on illumination) XYZ color space.

The same evolution happened to the widescreen systems. Cinerama was the most famous, with its three cameras and three projectors set in high-end venues using a special screen. The early widescreen theaters were cashing in on the very same business model that the current large format 3D theaters like the IMAX 3D have been using since the 1980s and 1990s. They used multiple camera and multiple projectors, an improved sound system, and presented movies loaded with scenes shot from an airplane.

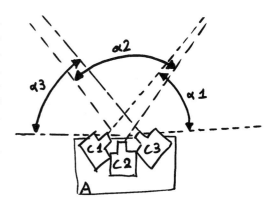

FIGURE 3.1
Three cameras (C1, C2, and C3) were assembled in a rig (A) in the Cinerama process. The camera and projection system had the same geometry and synchronism issues as 3D ones.

FIGURE 3.2
The 70 mm conversion of a Cinerama triptych, showing vertical lines and vignetting artifacts where the three strips of film are sewn together.

Soon, the various multicamera systems were killed by the improvements of film stocks. Increased finesse and sensitivity opened the path to light-efficient color layering and the compression of a wide picture inside an academic aperture. The invention by Eastman Kodak of the three-layer Kodachrome film eventually made the multicamera color rigs useless and turned any camera into a color camera. The anamorphic lenses brought wide aspect ratios to any camera and projector. Eventually, even multiple soundtracks found their way to the film strip too, using various forms of visual encoding.

There have been many attempts to apply the film-gain leverage to stereoscopic production. The 1970s and 1980s 3D revival was mostly based on the single-strip format, using over-and-under, side-by-side, or even in-camera anaglyph processes. The camera bulkiness, postproduction complexity, and exhibition requirements were taken care of once and for all at the camera lens. Why could it not bring 3D to full fruition? Three reasons: one design flaw and two missing links.

First, you need the camera to be bulky to artistically accommodate any scene inside a 3D movie. Whether it be a super-wide interocular distance for hyper stereo, or a beam-splitter configuration with a giant mirror and short wide angle lens, good 3D does not come from a small camera. And then, you need some sort of real-time control, for directors and cinematographers are graphic artists. They do not want to create visual mediums by blindly relying on trigonometric formulas. And eventually, because producing perfect 3D is artistically a challenge and mechanically a chimera, you need to be able to fix images at very low cost. These functions were not provided by the analog postproduction processes. To some extent, the digitization of the production pipeline allows for virtually putting the two eyes inside a single support, a single digital file, something the physical film stock could not do to the extent needed for perfect 3D quality. And there's no 3D quality but perfection, digital perfection.

That transition, where the 3D movie is no longer a pair of 2D movies, has yet to reach the camera. Some companies are working on such an approach, with mechanical, optoelectronic, digital, and software integration into a single digital 3D camera, not a 3D rig. This was, as of 2009, the most challenging and promising area of development for 3D cinematography.

Despite all technical progress, 3D production will never come as cheap as 2D. After almost a century, producing a black-and-white or silent movie would still be cheaper. Three-D is initiated by additional visual stimuli and generates more emotions. There's no such a thing as a free lunch, and 3D can't and won't come for free.

In the case of color, the release of Kodachrome single-strip color stock made all the existing equipment color-capable. Cameras, Moviolas, projectors—everything was manipulating color in an overnight makeover. The same is not likely to happen in 3D, even if some links in the production chain were to enjoy such an unexpected retrofit, most notably the digital projectors made 3D-capable by the simple addition of filters and glasses. Some companies have developed

3D encoding systems that are 2D compatible, and allows the processing of 3D footage through, say, a 2D OB van and a 2D satellite link. We can foresee the conversion of oversized 1080 60p equipment retrofitted into HD-3D television at 30p.

As we have seen, the underlying technical reasons of the success of color or widescreen cinema deployment gives us some clue as to whether the 3D may be passing hype, or stay for good. It mostly underlines how much the pipeline digitization is the key element that will free the 3D from its drawbacks.

Comparison with sound, a storytelling revolution

It is close to impossible to tell a story without sound or speech. When the movies were silent, directors found a way to put some of the soundtrack into the picture with billboards stating the actors lines. In the very same way, we are loading our 2D movies with monoscopic depth cues. We feel the urge to present the set depth even on a 2D medium. There is not such a compelling need to put the color in a movie, and we have watched color movies on black-and-white TV sets for many years. This is a strong common point between sound and depth.

In the first years of the sound era, two technologies fought for dominance: sound on a disk and sound on the film. Sound on disk was simpler to put together, but relied on mechanical synchronization of the record player with the film projector. And this came with the same issues as the dual projector 3D systems. If there is some chance for failure, time, statistics, and luck will make sure it happens. Because it was much more foolproof, the sound-on-film system eventually caught up for large deployment in small town theaters. It took eight years, from 1919 to 1927, from Lee De Forest's first patents to the agreement between the big five studios on a common sound-on-film system. The impact on how the distribution and exhibition businesses were conducted was minimal, but it had a huge effect on the production world.

The addition of sound changed the movie industry from end to end. Writing, acting, directing, editing—each and every step in the creation process of the movies was impacted. People and equipment had to remain silent on stage, directors used close-up to emphasis on the lip-syncing effect, and music was integrated into the creativity process. Cinematography was actually affected to the point that many consider cinema as having a silent age before it entered talking's reign. You don't make such a distinction with the introduction of color.

It is not yet known if 3D cinema will be referred to as a new era for movies. Nonetheless, 3D will deeply impact the movie production processes in two ways. Inside each department, adjustment will be needed to accommodate new constraints and exploit new opportunities. Across departments, new coherency tools and synchronization procedures will have to be implemented to coordinate the work on 3D, to maintain the pristine quality it requires.

MOVIE PROJECTS AND 3D CINEMATOGRAPHY

If you are reading this book, you are most likely doing so with a movie project on your desk or on your bedside table. That project can be 3D, and you are evaluating it, or 2D and you are considering adapting it to 3D. Your decision to go 3D will depend on many factors, and one of the purposes of this book is to help you understand if, why, and how you should, or should not, do this movie in 3D. Not knowing the project you are working on, we will likely have hard time answering the "if" part. You'll nonetheless find clues to answer by yourself the "why and how" dilemma. If you are not actually working on a project, pick one from your classic movies collection and start planning to remake it in 3D.

Movies, projects, and productions come in every size, from home hobby to super-productions costing hundreds of millions of dollars. Yet all 3D movie projects are the same, and throughout this book you will find examples based on three typical projects: amateur, low budget, and big budget. Why would we bother look at low-budget productions when it comes to high-end entertainment industry techniques? Because it's important to understand that, just like 2D movies, if 3D movies benefit from high-end tools and big crews, the real quality comes from actual medium mastering from the director. This book will provide you with the tools and blueprints that allow you to make a nice 3D shot for free. If you can't do that, no millions of dollars will bring it to you, unless you are clever enough to spend a chunk of a million hiring experienced stereographers and have them help you expedite the cumbersome, and sometime painful, 3D trial-and-error phase.

These are the three typical main roads to enter into the world of stereoscopic cinema: As a lone voyager freely wandering around, as a small group with limited resources and higher expectations, or as an army of professionals with the highest quality objectives. Before this book addresses the nuts and bolts used by each of them, let's define our typical journeyer.

Level one: Amateur movie and self-teaching 3D

If you want to have a personal journey into 3D, traveling does not have to be expensive. We'll see how to reuse existing equipment and how to reach the last mile for free.

You want to make 3D pictures, show them to friends, or publish them on the internet. You want to make short 3D animation, and maybe a couple 3D video shoots using a low-end 3D rig. The workshops in this book will show you how to make great 3D pictures, and some 3D cinematography for free, or almost free. All you'll need is a personal computer, a digital still camera and the 3D glasses and the DVD provided in this book. You will be using free software, and get references for cheap equipment you may consider buying, like pairs of webcams or shareware, for a few dollars.

You may be interested in going one step further and try real 3D shooting, editing, and posting. You'll then enter Level Two.

Level two: Student movies and low-budget movies

You can be leading a small exploration team mapping its corner of the 3D jungle. This 3D project can be a student movie, or a hands-on professional training, a warm-up skill acquisition for your production crew, or even a small-budget commercial. Say that you want to produce a short that would look nice on your 60-inch 3D television as well as on the 30-foot screen at the digital cinema down the street. You own or rent some 2D movie gear, have access to workstations loaded with serious production software, and plan to spend a few hundred dollars in 3D shopping or rental.

The advanced workshops will show you how to use generic 2D equipment to produce a 3D movie. The Level-One proficiency will be needed to really benefit from them. They will cover the hardware side, like pairing an HD video camera into a 3D rig, and the software side, like using Adobe Premiere and After Effects, or Sony Vegas to post some 3D content. You will be presented a few items recommended for acquisition or rental, like 3D displays and accessories, camera synchronization electronics, and 3D plug-ins for 2D software.

It would be advisable, for a Level-Two project, to look for a "3D maniac" in your neighborhood. They are plenty and you are most likely to have one in you family or circle of friends. In a company related in any way to the cinema industry, the likelihood of finding hidden 3D experience among the employees' is extremely high.

Level three: Feature 3D movies

Level Three projects are feature movies, or any short that aims at a feature-like quality level. We are talking about large crews, highly skilled and specialized. We are talking millions of dollars and weeks of production. If you are in operations management, you will need to build, buy, or rent one or more 3D rigs, check all your equipment against 3D compatibility, upgrade your screening room to 3D, and prepare your pipeline to gulp and spit at least twice as much data as it used to. This book will provide you with a road map for running a 3D studio and a good overview of the pitfalls. If you are a producer or a director, you will have to ask your teams for additional work, with a whole new technical and artistic vocabulary. You'll need to improve your quality assurance tools, and tighten the bonds between remote teams.

No project of that scope can succeed without hiring a 3D expert from the very beginning. Producing a Level Two project to get the technical team together and up to speed with stereo is a must.

Key Points

- The need for 3D professionals in the movie industry is ramping up.
 1. 3D is making a strong comeback with 17 movies slated for release in 2009.
 2. Even if all cinema is not going 3D, you surely will do some 3D in the next few years.
- Current experience in 3D moviemaking in the studios is scarce.
 1. Since the 1950s, very few 3D movies where produced until this 3D renaissance.
 2. This renaissance is a side effect of the recent glass-to-glass digitization and relies on cutting-edge production techniques.
 3. The recruitment rules work against the hiring of 3D experience in a "stereographers' paradox."
- Acquiring 3D experience requires a lot more practice than you would suspect.
 1. The amount of knowledge is not that huge; it may even be possible to put most of it in a 250-page book. Knowledge is not that important in 3D; experience is the key.
 2. Nobody can give you experience but yourself, by practicing.
 3. You'll need to build or acquire some 3D tools, and use them a lot.
 4. This is the only way you'll experience, understand, and overcome the "3D learning curve."

CHAPTER 4
Tools of the Trade

Chapters 5 to 10 will study, step by step, the impact 3D has on moviemaking. Before we study the details let's have a look at the big picture. To effectively learn 3D moviemaking, you will want to go back to the basics of motion pictures, and revisit them with a 3D eye.

Cinematography is all about catching light on film and reproducing it on a screen. Stereography is all about doing it twice and get these two pictures perfectly replicated on a single screen. In a nutshell, you'll make two pictures, with perfect control of both cameras' parameters and relative positions. You'll then display those two pictures using some sort of 3D display or technology.

In the analog age, this was an extremely complex task and very few directors and DPs actually mastered it. Lens imperfections and mechanical devices' natural tendency to drift in space and time collided with stereoscopic image requirements. Digital production and postproduction provides us with the ability to control and groom the disparities to perfection.

At this point in your progress into 3D cinematography, you need to get some sort of 3D computer and 3D still camera. As you will discover, the computer can be anything from a low-end laptop you would use with anaglyph glasses to a high-end workstation with a real 3D display. As for the camera, solutions range from 10 bucks' worth of disposable film cameras up to a grand spent on a pair of high-end digital SLRs.

3D PHOTOGRAPHY

At last, shooting your first 3D picture may be a few minutes away—if you want it to be. Here's how.

1. Get your digital still camera.
2. Select a scene with no moving objects, such as the room where you are.
3. Take any picture, but avoid having an object closer than 3 feet or 1 meter.
4. Keep looking through the viewfinder.
5. Shift your head one or two inches to the right.

6. Take a second picture, trying to replicate the first one as closely as possible.

7. Congratulations, you are done!

If you can't help it, jump to your computer, do the workshop at the end of this chapter and make your picture pop in 3D.

This dual-take procedure is barely usable in movie production, other than stop-motion animation. In 2009 the studio Laika released the feature movie *Coraline*, which was shot with this procedure, using motion-controlled cameras. Any other 3D movie will need the two pictures to be shot at once, in perfect synchronization. You need two cameras to do that.

3D camera requirements

MATCHING CAMERAS

Producing two identical pictures starts with using two identical cameras. Your twin cameras will have to be exactly the same, for complete interchangeability. Considering that the manufacturing process, component outsourcing, and software microcode may change over the production of a given model, you'll want to get cameras that were produced the same year, if not the same day. If you can get them with consecutive serial numbers, you can hardly get better. If you are renting the equipment, make sure your provider knows about this requirement. A good way to make it clear how much you want the cameras to match is to ask for assurance that both cameras run the same software version and that all presets are reset to factory defaults. If you are using preset cards, make sure they carry the same ring of settings.

Then you will want the cameras to get the very same picture, using the very same settings, doing the very same image processing.

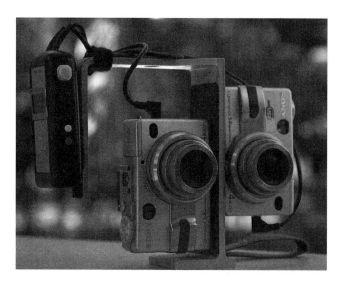

FIGURE 4.1
Coupled digital still cameras.

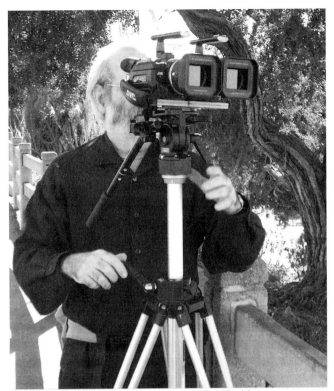

Tom Koester behind dual JVC HD-10 cameras used to shoot Ray Zone's 3D short "Slow Glass"

FIGURE 4.2
Coupled digital video cameras on location filming *Slow Glass*. Image: Ray 3D Zone.

MATCHING PHOTOGRAPHY

Digital cameras have embedded computers that control the optical and digital processing of the image, from the lens optics to the sensor data, and record it as a file, on tape, disk, or flash memory. Every parameter handled by a computerized automation is subject to drift from one camera to another. For this reason, all settings have to be set to manual. This may be easy and obvious in high-end productions. In low-budget movies, prosumer cameras are very often used, and they are not that easy to use in full manual mode, especially considering you'll have to control two cameras at once in a tight mechanical assembly.

Parameters that have to be matched include :

- White balance
- Sensitivity
- Shutter speed
- Shutter angle

- Exposure
- Aperture
- Clock, or genlock
- Frame rate
- Gain

The matching can be achieved in many ways, as explained later in this chapter for still cameras and in Chapter 7, "Principal Photography," for movie cameras.

MATCHING OPTICS

The two cameras must be optically matched in focal length and focus point. All consumer digital cameras use zoom lenses, and professional 3D rigs are, by default, fitted with zoom lenses for practical reasons. The very optical nature of zoom lenses makes them unique pieces and very hard to match two by two. Unless you are using a high-end 3D rig, it is safer to use only the extreme ends of the zoom range, where they are the most likely to match. Any intermediary value will require a postproduction pass to match the image magnification. Using motorized zooms in the course of a shot on prosumer cameras will almost certainly bring you to a full track and match pass on the images.

MATCHING GEOMETRY

In order to generate comfortable 3D, the two cameras have to be in a perfectly controlled relative position. Basically, one camera should be the reference and the second should only be a lateral translation of the first one, along the image plane width, with a possible rotation along the vertical axis. Any other discrepancy in relative position will generate inappropriate retinal disparities and damage the 3D effect. Most 3D rigs keep the cameras tightly in the correct positions, or allow for only appropriate movements.

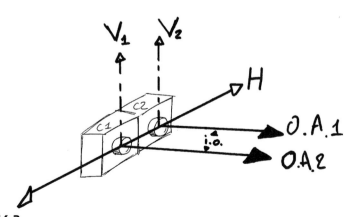

FIGURE 4.3
Cameras in correct relative positions. The image planes are in the same plane, optical centers on the same horizontal line, with parallel verticals and optical axes.

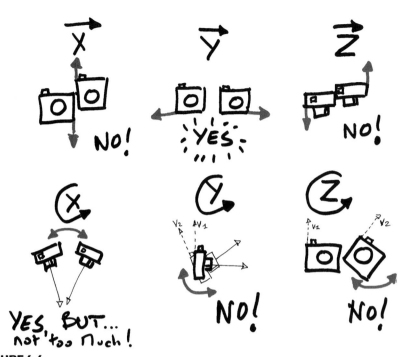

FIGURE 4.4
Of all six possible rotations and translations, only one translation and one rotation are appropriate in 3D.

3D still camera systems

You will need a 3D camera to practice 3D photography. The quality-to-cost ratio of digital still cameras and tape-less movie cameras has rendered most of the historical 24 by 36 and large-format 3D cameras almost pointless. Most of the tricks presented here for hooking together two still cameras work fine with pairs of video cameras for shooting 3D.

TECHNICAL NOTE

There's an issue about digital cameras you'd better know of right now. If you trigger the shutter on a film camera, you get the picture taken right away. That is not the case with a digital camera. The delay used to be extremely annoying in the 1990s, but is now almost nonexistent, thanks to specialized ASICs that instantly perform the needed computations. In order to minimize the effect of the computing delay, it is almost compulsory to take digital 3D pictures in two steps. First, you push the button halfway and wait for the camera to get to the point, and then, you push all the way down to actually get the picture.

Even this trick may not be enough, for compact digital cameras obey an internal clock that runs perpetually, shoot pictures nonstop, and display them as a preview on the LCD panel. When you want to shoot, the camera has to wait for the next top frame state to

take a picture. If you want two digital cameras to take the same picture, you will want to synchronize them, just as a pair of video cameras needs to be genlocked. Electronic devices like the LANC Shepherd can take care of that.

Note that this limitation does not apply to digital SLRs.

3D LENS ATTACHMENTS

There are some 3D lenses that mount on digital SLRs, like the Loreo. They offer a good solution for point-and-shoot stereo, at the cost of optical quality and fixed interocular and focal lengths. For these are two key parameters in modulating the 3D feeling of a picture, they would limit the scope of the experience you'll get from your 3D photo sessions. But you sure would appreciate them for a 3D photojournalism project.

LOREO 3D Lens in a Cap Digital (Model 9008)

FIGURE 4.5
3D lens mount for digital SLR.
Image courtesy of Loreo, Inc.

DISPOSABLE FILM CAMERAS

If you need to get shooting 3D stills right away, on a budget, get a pair of disposable film cameras, one school ruler and two large rubber bands. Try to find cameras with a bottom as flat as possible, and assemble them side by side on the ruler, holding them in place with the rubber bands. Hold your camera with both hands, fingers on each shutter button, aim, and shoot. After a while, you'll master the art of shooting both at the same microsecond. Get a digital copy of the film; never mind prints.

The additional benefit of that setup is the opportunity to use the ruler to accurately measure your interocular distance, and the rubber bands to change it according to your needs.

WEBLINK
Loreo 3D lenses and cameras
www.loreo.com

HAND-SYNCHRONIZED DIGITAL CAMERAS

Once you have played for a couple of days with disposable cameras, you may get tired of running to the shop to get them processed. Consider buying a couple of cheap digital cameras. Make sure that they have tripod bolts, and get a piece of pierced metal and a couple of 1/4-20 nylon screws to assemble them. It maybe wise to make sure you can connect them to your computer and power supply without disassembling the rig. The synchronization process can be the same press at once, with a twist. Press the shutter halfway so that both cameras process the focus and speed, and press down full only when both cameras have stopped computing the shoot settings.

WEBLINK
Example of shutter button rewiring
www.teamdroid.com/how-to-make-a-cheap-digital-camera/

LINKED DIGITAL CAMERAS

You can enhance the synchronization using two tricks. The first is to use the infrared remote, if there is one. The second is to open the cameras and pull lines from the shutter button connectors to a single two-level breaker. This option is not easy and will for sure void the warranty. Make sure you respect both the ground and hot point of both electronic boards. Some camera models behave better than others with the common shutter button hack. With enough skill, it's even possible to use one camera shutter to control the other one. Co van Ekeren can do the modification for you in the Netherlands. That's among the best quality and smallest camera rig you'll find until 3D cameras from Olympus and the like hit the market.

WEBLINKS
Camera made by Ekeren 3D equipment
home.kpn.nl/ekere002
Sold in the United States by 3D Concepts
http://www.stereoscopy.com/3d-concepts/cameradig.html

ELECTRONICALLY SYNCHRONIZED CAMERAS

In the 1980s, Sony developed a communication port for a video camera, called the LANC. This port allows for sending commands to the camera, like controlling the shutter and the zoom. What makes it suitable for 3D is its ability to switch the camera on and off and to get the video clock signal.

The LANC Shepherd and the SteFraLANC are electronic devices that switch on both cameras at once. They then check for the video clocks and display the actual synchronization delay. Within a couple of tries, both cameras will "boot" in synch, and stay close enough for shooting a few minutes of matched pictures.

Another device, the 3D LANC Master, offers to actually control the time drift and to keep the camera in synch for hours. This device is not built for sale, and

FIGURE 4.6
The LANC Shepherd remote controller for stereo cameras.

you will have to make your own based on the blueprints and source code provided on the Internet. According to its user manual included in the DVD (see

WEBLINKS
The LANC protocol
www.boehmel.de/lanc
LANC Shepherd made by Rob Crockett
www.ledametrix.com
LANC Shepherd sold by Berezin Stereo Photography Products
www.berezin.com/3d/camera.htm
SteFraLANC made by Werner Bross
www.digi-dat.de/produkte/index_eng
3D LANC Master
http://dsc.ijs.si/3dlancmaster/
3D LANC Commander by Michael Starks
3dtv.jp

in the white papers section), the 3D LANC Commander from Michael Starks seems to be able to actively synchronize camera.

MODIFIED MICROCODE FOR 3D PHOTOGRAPHY

A few years ago, a group of hackers found a way to put programs on the memory card of their Canon cameras. The project is called CHDK, and is a replacement firmware for most Canon cameras using a DIGIC image processing unit. The modifications include full scripting of the camera functions, including the presence of a 5 V signal on the USB port to release the shutter.

WEBLINKS
StereoData Maker
stereo.jpn.org/eng/sdm/
StereoData Maker Yahoo! Group
tech.groups.yahoo.com/group/
StereoDataMaker/

It was far too tempting for 3D maniacs to use this function to make stereo cameras. There's now a specialized version of CHDK for stereography. Its name is Stereo Data Maker and it has a Yahoo! Group.

PAIRS OF DIGITAL SLRS

As we have seen, digital SLRs do not need complex synchronization systems and offer good ergonomics in full manual mode. They will make a perfect 3D rig for artistic stereophotography. The main issue, if you don't mind the price, will be the size. A side-by-side mount is impossible, and a bottom-to-bottom geometry is a must, as shown in figure 4.1. This will generate vertically framed views that you'll have to crop to get horizontal 4:3 framing.

WEBLINK
Fujifilm 3D camera prototype
http://www.dpreview.com/
news/0809/08092209
fujifilm3D.asp

REAL 3D CAMERA

Fujifilm presented a 3D camera at fotokina 2008. Public prices and availability were expected to be announced at CES in January 2009.

3D DISPLAYS

All stereoscopic displays show left and right views encoded together on a 2D screen and rely on a decoding system, most likely some sort of glasses, to filter them into each eye. They will only differ in the encoding and decoding domain they use. It can be in the color spectrum (anaglyph and Dolby/Infitec), in time (active glasses with digital light processing [DLP] 3DTV and 3D projectors), in polarization (RealD, Dual projectors, dual layer LCD), or in space (3D video goggles and autostereoscopic screens).

In the meantime, it is time to introduce you to the anaglyphic system used in this book's DVD.

Anaglyphic encoding

Anaglyphic encoding is so prevalent in depth displays technologies that it's almost a synonym for 3D. If you mention 3D at a party, there will always be someone asking, "What's 3D?" and somebody else answering, "You know—that old stuff with red-and-blue glasses that doesn't work." At that point you know you are in trouble and regret you didn't chat about cars or football.

Anaglyphic encoding gets its bad reputation from the unfortunate side effects of its greatest strength. First, it's the cheapest of all 3D systems. Second, it's the most efficient for large distribution—actually the only one really available. As a result, it has been used on distribution channels where it should not have been, such as "seen on TV" over-the-air analog NTSC, and has been produced by teams that sometimes had no knowledge of 3D or had no decent budget to produce good 3D.

Basic color encoding schemes have two major limitations. They cannot reproduce the whole color spectrum, and they have a low separation power, which means there is a fair amount of leakage from one eye to another. Despite these faults, the red-and-cyan glasses are currently used by the hundred of people in studios working on 3D projects. How come? Because they happen to be extremely effective if you stay away from their weak spots, and it is an easy move in 3D postproduction. First, most of the 3D work is depth correction and depth placement—jobs that do not require looking at the pictures in color. And anaglyph is really good at black-and-white 3D. The second reason is the result of the screen size effect explained in the next pages. Basically, an image created for a theater screen will, and should, look shallow on a computer monitor, and therefore accommodate the low separation power of anaglyphic glasses.

It is for these reasons that you can confidently use the red-and-cyan glasses enclosed in this book. You'll look like a real pro from the big studios, and you'll learn how to process images that look great on large screens.

If you get bored with using paper glasses, you can find plastic glasses online. Their acrylic lenses do not have the optical quality of the tinted gels used in paper glasses, but they are mechanically much more comfortable to use. The clip-ons are especially comfortable for people wearing prescription glasses. You may even have your anaglyphic prescription glasses made to order by Alan Silliphant from Anachrome.

WEBLINK
Alan Silliphant, Anachrome
www.anachrome.com

Active glasses systems

When you will really need to see your work in color, later in the process of producing your movie, you will most likely use active glasses. Technically, these are liquid crystal shutters, or LCSs, and they blind the left and right eye in synch with a display that shows the left and right images alternately—the faster the better, because each eye sees only every other image. Until recently, your only option would have been to buy one of the very last cathode-ray tube (CRT) monitors. Some DLP-based video projectors are 3D compatible, as demonstrated by Andrew Woods in his paper, "The compatibility of consumer DLP projectors with time-sequential stereoscopic 3D visualization," presented at Stereoscopic Displays and Applications XVIII in January 2007. The situation radically changed over the course of 2008. All these solutions were, more or less, makeshift assemblies.

WEBLINKS
Andrew Woods page
http://www.3d.curtin.edu.au/
List of 3D-compatible DLP projectors
**http://www.3dmovielist.com/
projectors.html**

The year 2008 saw the announcement of many display technologies with 120 Hz capability. Basically every screen type, whether LCD, plasma, or DLP, can now switch fast enough to display 3D in active mode. In January 2008, at the Stereoscopic Display and Applications conference, Texas Instruments and Samsung presented Cinema Smooth™ an image processing compatible with 3D images. Actually, all of the third-generation DLP chips seem to be 3D compatible. As of today, all the DLP-based rear projection televisions (RPTV) sold in the United States by Samsung and Mitsubishi are 3D compatible. High-definition multimedia interface (HDMI), the digital link interface is, under extension, able to handle the additional bandwidth needed for full HD in stereo. As the last piece of the puzzle, RealD presented, in August 2008 at the SMPTE 3D Task Force's inaugural meeting, a new generation of 3D glasses that do not require any infrared link to be synchronized with the 3D display. NVIDIA, the world leader in graphic processing units (GPUs) that are the core of computer's image processing capabilities, introduced its own set of glasses in September 2008.

The year 2009 should see the first release of fail-safe active stereo consumer displays. For the first time, you should be able to buy a plug-and-play system, including computer software and hardware, a 3D display, and active glasses. If you are working on a Level 2 project, it's time to acquire at least one per workstation.

Prosumer 3D projection

The third step is to get access to as large a screen as possible, or needed. If you plan to produce a theatrical movie, you'll need a theater-sized screen as explained in the Chapter 5. Medium-cost solutions, in the $10,000 range, can be built using the new generation of 3D-capable DLP projectors. They project a 720p picture at 120 Hz and full HD models are expected for winter 2009. Prices are expected to fall as consumer products hit the shelves. They can be fitted with the entry-level RealD-LP system.

If you prefer to see stereo with passive sunglasses-like filters, you will need a silver screen compatible with polarized light. A few companies produce them, and they are fragile. You will need a pair of 2D projectors, a projector mount, and a pair of polarizing or Dolby/Infitec filters.

Professional stereoscopic projection

The technical details of a full-scale digital 3D cinema installation may be a bit much for an introductory chapter and are explored in the appendices.

3D COMPUTERS

A personal computer for experimenting with stereoscopic imaging

Any recent computer with good image manipulation capacities will make a good 3D computer, although adding a spare hard drive and some memory chips would not hurt. The real deal is to have a good display, with plenty of resolution and light. You will need extra luminosity to compensate for the loss that occurs with the 3D glasses.

If you want to go beyond basic 3D picture show and tell, you will need a real color 3D display. With the 3D gaming market coming to fruition, such displays are becoming available at sane prices, but the drivers' availability and applications compatibility remains to be cleared. For more advanced solutions, refer to the next section on 3D workstations.

At that point, you need to make sure you have a good graphics card that provides at least full DirectX 9c support. Full OpenGL support will soon be helpful to harness the GPU computing capabilities such as those found in the latest iteration of Adobe Creative Suite, the CS4. If you need to buy one, consider the NVIDIA to be sold with a pair of active glasses. This kind of equipment brings you closer to a prosumer station.

A professional 3D workstation

We will define a 3D workstation as a computer that will allow you to get through the whole production of a short 3D movie without failing you. We already know what this means in 2D: good high-end hardware, a powerful processor, plenty of RAM, fast drives, a top-of-the-line graphics card and many huge displays with accurate

everything." Because you can't double everything in a computer, at some point you will double your waiting time.

What you want to avoid is a resource hog that slow down the computer to the point it seems frozen. When a computing system designed for 2D imaging is doing 3D, it manipulates twice as much data. The basic rules of engineering ask for 100 percent headroom in capacity for smooth and safe operation of any system. That figure is precisely the amount of additional workload you are about to put on your machine.

What shall you do to avoid suffering stereoscopic freeze?

1. Fill up the memory banks (you'll hardly have too much)
2. Get a 64 bits OS and applications or your memory banks are useless
3. Get more hard drives, and pair them in RAID subsystems
4. Get a high-end graphics card

GRAPHICS CARDS FOR 3D

Of the two major graphics card makers, NVIDIA is the only one offering stereoscopic capacities out of the box. Its GeForce® consumer product used to need a specific 3D driver that was available and enjoyed for many years.

WEBLINK
NVIDIA STEREO DRIVERS
http://www.nvidia.com/
object/3d_stereo.html

The professional line, Quadro FX®, is basically the same hardware with huge a bump in the price tag and a different driver that offers many more OpenGL capabilities, including Quad Buffered Stereo. In this mode, any OpenGL application can produce an extremely efficient stereoscopic rendering that will be automatically adapted to the type of 3D display you are using. As of late 2008, a major change in NVIDIA's approach to stereoscopy was expected with the release of its own line of 3D glasses.

As of press time, AMD had not announced any stereoscopic plans and Intel was not yet a real contender in high-end graphic rendering. Besides, it is still possible to do a lot of stereoscopic 3D using software and patches on non-NVIDIA hardware, at the cost of some rendering time.

THE MATROX DUALHEAD2GO

Many 3D display technologies use two imaging systems, like the dual projector passive stereo. For many years you needed two graphics cards, one per display. Because the two displays needed to be perfectly synchronized, you ended up using high-end genlockable cards, and achieving graphic acceleration across cards was not an easy task. In the 1990s NVIDIA started to produce dual monitor cards that could work in "Nview" mode where they are perfectly synchronized and share the GPU acceleration. Then, Matrox came up with a multiple-screen solution for laptops, and this turned

WEBLINK
Matrox DualHead2Go
www.matrox.com/graphics/en/
products/gxm/dh2go/

into an unexpected blessing for 3D aficionados. The DualHead2Go is a pocket-sized box that splits a display link in two, preserving perfect synchronization. It allows perfect passive 3D projection out of non-stereoscopic computers like laptops or Macs. We recommend the digital edition, which is much more effective with DVI inputs, VGA conversion, and widescreen support.

DOUBLE YOUR SCREENS, ONE 2D AND ONE 3D

You can't work all day in 3D, and most systems' and applications' GUIs are inherently 2D. You will want to have a 2D display to work on and a 3D display to enjoy. The 2D will be a large LCD with calibrated colorimetry, and the 3D will be whatever suits your project requirements, room size and budget allocation.

GETTING A 3D DISPLAY THAT SERVES YOUR PROJECT

The first question to ask yourself about buying a 3D display is, "What size do I need?" Your options range from 15-inch 3D monitors to 30-foot theater screens. Here is a short overview of all your options.

The old tube technology was the only way to go until recently. If you still have a 19-inch *Monitorus Rex* slowly fossilizing in a closet, it's time to dust it off. Pair it with active glasses and it may act as a decent interim 3D display, as you wait for the arrival of your definitive system. If you are buying one, NEC and LIyama were among the last producers.

During late 2008, a whole new generation of 3D-capable flat panels was released: multilayer and micropolarized LCDs for passive stereo, and 120 Hz LCD and plasmas for active stereo.

The rear-projection televisions, based on the third generation DLPs and marketed under the "smooth image" brand, are 3D capable, as are some projectors. Ultimately, you may consider a 3D projection system with a single or dual projector and a silver screen.

WEBLINK
Zalman Trimon
www.zalman.co.kr
IZ3D
www.iz3d.com
ViewSonic VX2265wm 3D LCD
www.viewsonic.com

DOUBLE HARD DRIVES

Adding hard drives is probably the easiest and most cost efficient add-on to a workstation. Video editing is one of the most space-consuming of all activities done on a computer. Doing it stereoscopically means doubling the load on your drives. Furthermore, the pristine image quality required in 3D allows for low levels of compression, generating even more bandwidth.

It is therefore advisable to multiply the number of hard drives in a stereoscopic system. Drives should be paired together using the system software's redundant array of independent disks (RAID) format, under which any number of drives act together as one, aggregating their capacities and speed. Having a set of drives for reading the images while another is used to write the computation result can have a tremendous effect on rendering time. In some cases, having a dedicated ultra-fast drive for virtual memory is a good move, too.

Remember that multiplying the number of drives multiplies the occurrence of drive failure, and losing one drive in a cheap RAID 0 subsystem means losing the data on all drives. RAID 5 systems are much more secure, even more than single drives, but they are a bit more expensive. Do backups with more attention when your 3D production ramps up.

GET A FAN, CRANK UP THE AC

This is no joke: we have been fixing friends' 3D computers with a table fan for years. Increasing the load on the computing system increases the load on the heat exhaust too, especially if you are piling on hard drives by the dozen. Maybe it is time to get that AC system a retrofit. In any case, keep an eye on your 3D rig's heat, at least with a software monitor.

GET GOOD GLASSES

This is not the easiest part. As of late 2008 there were three providers of LCS glasses, as listed in the appendix. New providers are expected to present a new generation of glasses, including NVIDIA and RealD. In the meantime, the only two acceptable products are the glasses engineered by Boyd McNaughton, now under the XpanD brand, and Lenny Lipton's marvels, the Stereographics CrystalEyes, now under the RealD brand. Our less-than-satisfactory experience with lower-cost brands leads us to warn you that you would lose your money and time, if not your confidence in 3D technologies, if you try them.

WEBLINKS
XpanD
www.xpandcinema.com
RealD
www.reald.com

FIGURE 4. 7
XpanD/NuVision 3D glasses.

3D pipelines and render farms for big projects

If you are running a big studio technical operations department, addressing all your needs may not be within the scope of this chapter. It is advisable to create a 3D team and they'll likely get back to you with the following set of action items:

1. Provide all affected artists with 3D workstations
2. Double the render farm's CPU count

3. Double the network attached storage (NAS) capacity
4. Retrofit the theater with 3D projection
5. Install 3D screening room
6. Set up a 3D art exhibition at the commissary
7. Invite 3D artists to professional training lectures

3d software

FREEWARE AND SHAREWARE

The providers of powerful stereoscopic software are not that many. Here is a list of a few prominent authors of high quality 3D software. As of late 2008, all 3D specialized software runs on Windows. Most of the programs run well on a virtualized PC on the latest Intel-based Macs, with some restrictions regarding graphic acceleration.

The most advanced video player is the Stereoscopic Player from Peter Wimmer. It has the ability to convert, on the fly, movies from any 3D image format to any other format, such as playing side-by-side 3D on a row-interleaved display or in anaglyph. It relies on DirectX 9, can use the NVIDIA OpenGL 3D, and has a software mode to play active stereo on AMD/ATI chipsets. With its playlist and library functions, it is usable in a real venue configuration. Peter sells many other useful tools, including a camera multiplexer. A demonstration version of these tools are included on this book's DVD.

FIGURE 4.8
3D image processing freeware and shareware.

The most advanced 3D photographic tool is StereoPhoto Maker (SPM), from Masuji SUTO, which also offers StereoMovie Maker (SMM) and StereoMovie Player (SMP), for free. SPM and SMM are powerful geometry correcting tools that can transform poor or bad 3D into good or perfect 3D.

WEBLINKS
Stereoscopic Player
www.3dtv.at
StereoPhoto Maker
www.stereo.jpn.org/eng/stphmkr
AVISynth avisynth.org

AviSynth is not a 3D-dedicated software, but its versatility made it a perfect tool for 3D video processing. It is an image manipulation open source project with powerful scripting capabilities—think of an After Effects you can program in BASIC. Many 3D scripts circulate on the Internet.

PROSUMER SOFTWARE FOR STEREOSCOPIC PRODUCTIONS

Adobe Creative Suite is among the favorite 2D tools that are used in 3D production. Because it's the biggest tool that has never been based on any hardware equipment, it has always been resolution-independent, whereas other editors would be limited to PAL, NTSC, or HD image formats. The presence of a 3D glasses filter may have lured many artists into trying it, even if its limitations makes it barely useful in real production. A 30-day demo of the suite is available for download at the Adobe web site, and some 3D examples are included on the DVD.

WEBLINKS
Adobe
www.adobe.com
Make3D
www.medtron.org
Sony
www.sony.com

Sony Vegas is another all-software editing suite, with a much lower street price than the Adobe CreativeSuite. Make3D provides a set of productivity tools to automate the processing of left and right views in a 3D movie.

Professional systems for stereoscopic productions

Many professional moviemaking tool vendors identified stereoscopy as a key feature for their suites and are releasing a 3D-capable version or extensions for their products:

- Assimilate presented a 3D-capable SCRATCH at the NAB 2007
- IRIDAS reintroduced the stereoscopic version of its D.I. Solutions in 2008
- Autodesk included stereo function in the 2009 release of its three major products, Maya, Toxik, and Lustre
- Avid is working on a 3D capable version of its high-end edit suite, with dedicated Nitris hardware.
- Quantel is showing its Pablo 3D, along with RIS workstations
- The Foundry, maker of the compositing software Nuke, offers a powerful 3D plug-in named Occula
- EON Fusion can be coupled with Frantic Studios' Awake set of 3D tools

All these tools are presented in the second part of this book.

Exercise

Taking and assembling 3d pictures

Prepping images

The stereo prepping, or stereo balancing, is a touch-up process in which the 3D pictures are modified to eliminate all undesirable retinal disparities. In simpler terms, it turns poor 3D into excellent 3D. The process consists mostly of correcting inadequate camera alignment, such as rotation and vertical shift. It can include colorimetry and complex geometry corrections, up to full resynchronization of shots. Because no 3D rig is perfect, you can expect each and every shot to benefit from a prepping pass.

We will look at two approaches for 3D prepping: manual and automated. The manual process will let you understand the rules and be fully creative. The automated process will provide you with much better corrected images than you get manually, even after years of training. Sometimes, though, the software is unable to correlate your pictures, and you'll have to fall back on manual. What you'll learn here is what is done in real-time by a 3Ality SIP2100 or Binocle Disparity Killer.

In this chapter we'll see how to prep still pictures, as the prepping of full shots is presented in Chapter 8.

In order to see your picture in 3D, you will need to encode it for your 3D display. A 3D-aware application does this at the push of a button, offering many presets and formats. In a 2D application, you will have to manually set up the encoding, most likely anaglyphic. Unless you want to produce an anaglyph picture for distribution, the encoding should be reversible, and the saved files should always include the whole color information of both eyes.

The basic anaglyph encoding consists of replacing the red channel of the right picture with the red channel of the left picture. This process will give you a full color, unbalanced red-cyan anaglyph, which can be used for preview. Balanced anaglyph and color optimized anaglyph are complex filters that desaturate both eyes to reduce eye rivalry in the red and cyan saturated areas and level the lightness to compensate for the green and blue channels being much more luminous than the red alone.

Optimized anaglyph encoding of a movie is a complex process that should be fine tuned on a per-shot basis by a specialized color artist.

Using photo editing software

The basic finessing of a 3D picture can be done in almost any photo editing software, provided you can affect colors and geometry and blend the pictures together.

STEP ONE: ASSEMBLING PICTURES
1. Load both pictures in Photoshop
2. Select the move tool
3. Hold shift (snap to edges) and drag and drop one image onto the other
4. Rename your layers to identify left and right images

5. If you did name your original files "left" and "right," it's easy
6. If not, toggle the top layer visibility on and off
 - Determine if the point-of-view shift is to the left or right
 - Name appropriately
7. Make sure the lowest layer is not a background layer

STEP TWO: SET THE ANAGLYPH PREVIEW

1. In the Layers palette, put the right image on top.
2. In the Layers palette, double-click on the right thumbnail picture
3. In the Layer Style window, in the Advanced Blending box, at the Channels line, deselect [R] red
4. You can now see your picture in 3D

FIGURE 4.9
The easiest and fastest way to preview in anaglyph in Photoshop by using Layer Channel Blending.

STEP THREE: CORRECT THE ALIGNMENT

This operation requires you to select two reference points in your pictures. There are thin details in your images you'll be able to identify in both left and right views, like object edges or a texture detail. One will be the pivot point, the second will be the alignment point. Try to select them in the middle-left and the middle-right of your image. The pivot point could be an object you want to see at the screen depth and the alignment point either far behind or far in front of the screen.

1. Moving the top layer, make the pivot points of both images overlap
2. Select the rotation tool
3. Select the center of the rotation and move it to the pivot point

4. Rotating the top layer, put the alignment points on the same horizontal line

5. If needed, use a guideline

6. You can now see your picture in good 3D

7. If needed, shift laterally any layer to place the 3D image in depth

8. Crop your image to cut out the rotated edges of the top layer

This correction can be perfected using resize, spherical, and four-corners transformations to correct zoom, barrel, and keystone defaults.

FIGURE 4.10
Three-D geometry correction in Photoshop. The guideline provides horizontal reference. The rotation handle is on the pivot point on the left part of the image. The alignment point is on a person in the same depth plane on the right of the image.

PLAY WITH HUE AND SATURATION

The glasses included in this book are red-and-cyan paper anaglyph. You can use them to look at the 3D images, and for the workshops included on the DVD. One interesting experiment is to play with the color hue and saturation of an anaglyph 3D picture. Bring down the saturation of a 3D image and you'll see the 3D effect disappear. Try to bring down the saturation individually for each eye. First, you'll see a more comfortable 3D, as retinal rivalry is reduced, and eventually, you'll see the colors disappearing, up to leaving a black-and-white 3D picture. Keep playing with the layers, and try to apply filters to one or both eyes—you'll learn a lot about your 3D perception.

Using StereoPhoto Maker

StereoPhoto Maker, dubbed SPM by the 3D crowd, is an incredibly useful and powerful 3D-image assembling application written by Masuji SUTO. You can get the latest version at stereo.jpn.org

We strongly urge you to use the many features of the program extensively, and to read its help files, which are loaded with serious 3D knowledge.

The following exercises are a reduced to a to-do list because a full exploration of SPM features requires, and deserves, a full book.

CORRECT IMAGES WITH MANUAL SETTINGS

1. Load a pair of pictures
2. Learn about the visualization options
3. Set up your full color preview if you have a 3D display
4. Align the pictures by hand
5. Try the alignment helpers, like difference maps and grids
6. Save your files in various 3D image formats
7. Reopen them and check how the anaglyph ones are missing full color information

FIGURE 4.11
Stereo PhotoMaker interface, with alignment window.

This is a key point in 3D-image manipulation: Always save your images in a full-color, high-resolution format.

MANIPULATE A SET OF IMAGES

SPM includes a file browser you'll love. It helps in reconstructing image pairs and takes care of the needed rotations for 3D camera rigs. That autorotation is metadata that is applied at the visualization or image manipulation step.

1. Open the file browser
2. Open your folders of images in SPM
3. Search for "mishap" images, when only one camera fired, delete them
4. Set the automatic rotation flag for the pictures
5. Look at the pictures in SPM and check that the automatic rotation is working

FIGURE 4.12
StereoPhoto Maker interface, browsing two sets of pictures at once, setting the rotation flag.

AUTOMATIC CORRECTION OF A STEREO COUPLE

The auto mode in SPM uses external software to search for common features in left and right images and matches them in pairs. It filters them to keep the most accurate and searches for the optical deformations that most likely prevented them to be perfectly aligned. Based on its findings, it computes corrected left and right views that match. You will have recognized the very process your brain and eyes are doing when facing bad 3D, with the painful exception that it is mostly your eyes that try to correct the view.

Download the SWIFT program and install it according to SPM recommendations

1. Open a pair of pictures
2. Select Automatic Conversion
3. Enjoy the pristine results

FIGURE 4.13
StereoPhoto Maker, automatically correcting 3D pictures.

AUTOMATIC BATCH CONVERSION OF A FOLDER OF IMAGES

Here's the really cool thing: SPM can apply its automatic alignment to a whole batch of pictures. Your last assignment is simple:

1. Run an automatic conversion of a whole set of 3D pictures
2. Create and print a cool 3D invitation to a 3D party
3. Send it to friends, colleagues, and family
4. Run a slide show of your creations
5. Make a survey of their feedback: Audience rules

FIGURE 4.14
StereoPhoto Maker, batch processing sets 3D images.

Equipment

THERE IS NO OFF-THE-SHELF DIGITAL STILL 3D CAMERA

- 3D cameras are made of pairs of matching 2D cameras
- They are assembled in rigs that include
 1. The mechanical assembly
 2. The two cameras
 3. A synchronization system
 4. Optionally, an optical device like a mirror

THERE ARE VERY FEW OFF-THE-SHELF 3D DISPLAYS

- 3D displays are
 1. 3D-ready or 3D-compatible 2D displays
 2. Pairs of 2D displays assembled for 3D viewing
- The mechanical assembly may include
 1. Mirrors and beam splitters
 2. Alignment systems
 3. Light polarizers
- The 3D is displayed using a multiplexing system in which the left and right images are
 1. Encoded at the display level, in time, color, or space
 2. Decoded at the eye level with adequate glasses

THERE IS NO 3D-SPECIALIZED COMPUTER

- 3D computers build on high-end graphics stations
- Stereoscopic image processing requires
 1. A stereo-capable GPU (NVIDIA GeForce or Quadro FX)
 2. Hard drives able to handle the double bandwidth data stream (RAID subsystems)
 3. High-end performance-critical elements like CPUs and RAM

THERE IS NO OFF-THE-SHELF 3D-IMAGE PROCESSING SOFTWARE—YET

- Most 3D software are freeware or shareware
- Some plug-ins are available for FX suites (Fusion, Nuke, Vegas)
- Many digital cinema tool are going 3D in 2009 (Autodesk, Avid, etc.)
- Hardware-based Quantel Pablo is already 3D

Learning 3D photography

MASTERING 3D PHOTOGRAPHY IS KEY TO MASTERING 3D CINEMATOGRAPHY

- Get a 3D camera, display, and computer
 1. From now on, shoot all your pictures in 3D (worst case, they'll look okay in 2D)

 2. Assemble them in 3D

 3. Show them and get feedback from the audience

■ Train the whole crew to make 3D pictures

 1. Loan your 3D camera to any interested crew member

 2. Have a monthly or weekly review of the 3D pictures

 3. Have contests on landscape, portraits, and fast-action subjects

■ Join your local stereo club

 1. Find one on the National Stereoscopic Association web site, www
.stereoview.org

 2. Or on the worldwide International Steroscopic Union web site, www
.stereoscopy.com/isu/Exercise

CHAPTER 5

3D Cinematography Fundamentals

Setting 3D for a movie is all about adequately squeezing the real world inside the 3D screen space. That screen space is created by the interaction of the 2D screen and our eyes, and can be somewhat transformed using very specific visual effects.

HOW THE CAMERA SETUP CONTROLS THE 3D EFFECT

Interocular distance

The distance between the cameras is the single most important parameter in stereoscopy. It will regulate the strength of the 3D effect. Pull the cameras apart and your subject will grow. Push the cameras together and it will shrink. Setting this value is an artistic and technical decision linked to lens choice, desired 3D effect, and the eventual release format of the movie. It is because of this setting that you will have to remember the two most important rules of 3D moviemaking. Let's repeat them once again; it can never be too much. First, you won't trust your 2D-based experience. Second, you want to visually control your 3D, if possible on a full-size 3D display.

FIGURE 5.1
The interocular distance.

Later in this book we will learn to calculate the maximum and minimum on-screen parallaxes, and the interocular (i.o.) distances, as a function of the lenses and set metrics. In the meantime, you can use the 3 percent rule, which provides us with a rough estimate of the appropriate i.o. Experience will teach you how to increase this value when the background is close to the foreground, and how to decrease it for large screens or long lenses.

The 3 percent rule is an empiric rule used by amateur 3D still photographers. It states that, in most cases, the i.o. can be safely set at 1/30th of the distance from the camera to the foreground, or 1 inch (2.5 cm) per 3 feet (1 m). Therefore, if you are shooting a statue 6 feet away, you should set your i.o. at 2 inches. Most 3D still cameras using a 2.5-inch interocular distance take good pictures of subjects 6 feet (2 m) away. This rule is observed when shooting 3D scenes to be printed or projected on small screens. If you have to rush a setup for a movie, bring it down to 1 percent, due to the screen-size magnification of 3D, as explained later in this chapter.

A perfect way to experience the effect of changing interocular distance is to take a set of pictures of a landscape. Start by moving sideways a few inches between each picture, and eventually increase to a foot or two. When you are back at your computer, assemble the images in 3D. Begin with the first and second, then do the first and third, up to the first and last picture. You'll see the landscape unfold, from all flat to extremely deep.

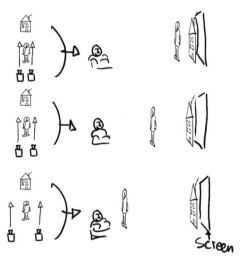

FIGURE 5.2
The concept of first plane and last plane.

Because interocular distance is the most important concept in practical 3D cinematography, it has many synonyms. You will find it in the literature under various names, such as stereo base, interaxial distance, entraxe, and so on.

Convergence

The second most important parameter in 3D photography is the convergence point, and sometimes its very absence. If your two camera axes are parallel, your 3D picture will be 100 percent in front of the screen. The only perfectly

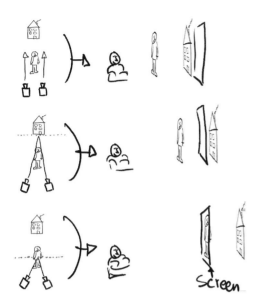

FIGURE 5.3
The optical axis convergence moves the whole 3D scene along the Z axis.

overlapping objects will be the ones at an infinite distance to the cameras. They will show no 3D disparity at all, for the interocular distance has no effect on their images.

If you want your 3D scene to be partially behind the screen, you will converge your cameras. The object on which the optical axes cross each other will show no stereo disparity on screen and will appear in its plane. If you converge the camera on the foremost object, the entire scene will be projected behind the screen.

The failing of this procedure is the keystone effect, as shown in Fig. 5.4. The left hand of the wall is closer to the left edge of the left camera, and hence appears bigger. A symmetrical phenomenon affects the right camera. When mixed together, the images will show disparities at both sides of the screen, with depth artifacts and painful vertical parallaxes.

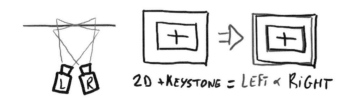

FIGURE 5.4
The keystone effect creates vertical disparities in the four corners.

Digital production allows us to accurately shift the images in postproduction rather than converge cameras. This procedure is usually part of a more complex prepping pass that fixes all the other geometrical image imperfections, like vertical shift and rotation.

FIGURE 5.5
The optical axis convergence simulated in postproduction by horizontal image translation is equivalent to shifting the cameras' image planes.

The use of converged cameras is the subject of controversy because it is sometimes used as a replacement for the correct i.o. setting. Some DPs and directors claim to control the audience's eyesight by converging on the subject and sometimes defocusing a background that is allowed to recede far beyond divergence.

Converging cameras will still be needed in live 3D, such as sporting events, until real-time image processing units can dynamically set the depth.

DEPTH PERCEPTION INSIDE THE THEATER

Watching a feature movie in a theater, on a television, or even a cell phone will drastically change the experience, with the reduction of screen size, color depth, and surround sound. And scaling a video sequence from a cell phone up to a 40-foot screen will sure look bad. In 3D, the same is true, with a 10× amplification, to the point that a 3D movie should be tuned to the screen size it's planned to be seen on and just cannot be scaled upward.

The screen-size effect on 3D

The second iron rule of 3D is "Always visually check your 3D on a full-size screen." If you can easily understand the visual-checking part, the screen-size requirement may be more obscure. To understand it, you should remember that the 3D effect is the direct consequence of the left and right images of an object not being displayed in the same relative on-screen position. Consider a 3D postcard, 5 inches wide, with an object halfway out of the card, with 1.2-inch negative parallax, or about 20 percent of the picture width. If the same picture was projected on a 40 foot theater screen, the parallax would be 8 feet. There's no way such an image could be fused into 3D. If you consider this example extreme, let's see what happens to positive parallax when you go from a 30-foot screen to a 60-foot screen. What was placed beyond stereoscopic infinity, more than 2.5 inches apart, will now be above 5 inches of parallax, requiring diverging effort to be fused and potentially generating a strong headache within minutes.

> The depth of a 3D picture increases linearly with its 2D size.
> This creates a risk of diverging parallax on large screens.

The screen-distance effect on 3D

Imagine you are in a theater, watching a 3D movie, looking at a snowball flying into the room. The negative parallax is exactly 2.5 inches, and the snowball is halfway to the screen. Because you are in the front row, the snowball seems to be 10 feet away, 2 inches wide and 2 inches deep. Pretend that you pause the movie, stand up, and walk all the way to the back of the room. The parallax is still 2.5 inches, the ball is still halfway to the screen, but it's now at a distance of 40 feet. If that snowball is still 2 inches wide, it is now an 8-inch-deep sausage. Note that the background and everything that was behind the screen did not move. Anything beyond 2.5 inches just became more comfortable to look at, because there's less diverging effort involved. And the convergence-accommodation decorrelation is now proportionally less intense.

If sitting farther away increases the size of the out-of-screen objects, sitting closer makes them closer to you, too. If you prefer the sea monsters to be huge, sit at the back. If you want to see them up-close, within arm's reach, sit in front.

> The depth of the front-of-the-screen part of a 3D picture increases with the distance to the screen, but only along the Z axis.

Effect of SCREEN SIZE

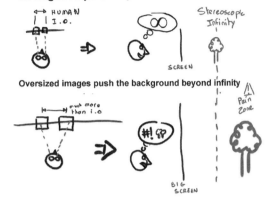

On negative parallax, or in front of the screen

Oversized images push the background beyond infinity

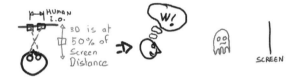

On positive parallax, or behind the screen

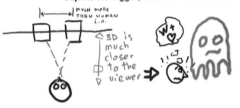

Objects are bigger, closer to the audience

FIGURE 5.6
The 3D effect increases with the screen size.

Effect of SCREEN DISTANCE

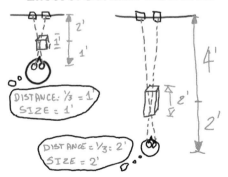

FIGURE 5.7
The off-screen 3D effect increases with the screen distance.

The off-axis effect on 3D

Sitting on the sides has never been a pleasant experience in theaters, because of strong 2D deformations of the screen. In 3D, these deformations actually affect the shapes, as cubes skew sideways.

Effect of SIDE SEATING

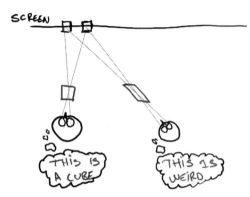

FIGURE 5.8
Effect of side seating on 3D images.

Where are the best seats?

The last row will be the most comfortable place, despite elongated in-the-room 3D and action taking place far away from you.

The front rows will be the most intense for your visual system, with the action happening closer to you, despite a compression of the in-the-room 3D effects.

The far-side seats in the first third of the room have to be avoided at any price, including coming back for the next show.

SPECIAL CASE: ORTHOSTEREOSCOPY

One of the most enduring myths of stereography is that the camera HAS to be 2.5 inches apart to replicate the human interocular distance. This is not a physical law, and, as we have seen, there are many situations where it should precisely not be the case. Nonetheless, this 2.5-inch rule is meaningful in a specific sort of stereography, called orthostereoscopy.

Definition of orthostereoscopy

A 3D image is orthostereoscopic when it perfectly replicates human vision. With this technique, it would be impossible to visually differentiate between the original scene and its representation. The geometry and perspective are natural, and the perceived sizes are equal to the original ones. As a result, the stereopsis process is much easier—more so, because it's totally natural. The brain does not have to guess the original metrics of the scene, because it is provided with them. Fusing the 3D and rebuilding the geometries are a no-brainer, and the illusion is close to perfection.

Limitations

In an orthostereoscopic movie, the conversion ratio of the filmed world to the virtual image in the theater is one to one. This is achieved by filming with a focal length that perfectly matches the human angular field when replicated in the theater. You should know the exact metrics of the projection system to achieve proper orthostereoscopy. This means that what is orthostereoscopic on one screen may not be on another. The viewer's position in the room is key part of the illusion; already part of any 3D production, it just has to be addressed more accurately.

The basic metrics are to film with a 50 mm prime at 2.5 inches interaxial, and to project on a screen regenerating this 50 mm angle of view. Upon actual screen size and average viewing distance, the field of view (FoV) will be adjusted, but the interocular distance remains the same to avoid any hyper or hypo stereo effect. The other limitation is on the subject itself. You will want it to fit in real size in the room where you are showing it. To some extent, this limits you to human-sized subjects evolving in 30-foot rooms, which encompasses quite a lot of typical shots in a contemporary movie.

According to the specialists, orthostereoscopy is hard to achieve and requires much trial and error. If you plan to produce some orthostereoscopic 3D, you will need a very short visual feedback loop to check the tests, such as having a replica of the 3D theater on set.

Examples of use

One of the sweet spots of orthostereoscopy is the presentation of objects in commercial applications, like point-of-sale kiosks. Another one is the telepresence illusion, as employed in many rides where the audience sees the action through the windshield of a doomed spaceship. In the movie *Heros de Nimes*, the trick is used to extend the museum room with the view of a perfectly symmetric virtual room where the action occurs many centuries ago. It works as a sort of time-warping mirror.

THE SCREEN IS A WINDOW

The stereoscopic window

The stereoscopic window (SW) is a very important feature in 3D photography. When you are looking at a 2D picture, you look at a flat object defined by the edges of the screen. When you are looking at a 3D picture, you look at objects floating in a space defined by the relative position of the edges of the screen and your eyes. You are looking at a 3D world through a window. Interesting effects occur at the edges of the window. Let's investigate a little bit. What happens when someone plays peek-a-boo behind the left edge of a window? Your right eye sees about half his face, including to his nose. Your left eye, blocked by the window's edge, does not see the nose. Your brain will consider that quite normal; it knows that the person has a nose and the window frame is hiding it.— "This character is behind the frame and I'm happy with it."

You should pay attention to an important detail in the process we just saw. The brain solved the riddle based on its previous knowledge of the object. This means you can push something into the single-eye viewing zone, but you should not pull it there, otherwise the brain will have to resolve the retinal rivalry. Furthermore, there are some retinal rivalries that remain uncomfortable, even after the visual cortex has solved them. High-contrast features, like light sources in the night, will trouble your 3D perception and should be banned from the screen sides.

Breaking the stereoscopic window

Now, our character walks up to the camera. He crosses the screen plane and stays on the edge of the screen. What do you see? Your left eye sees the nose and your right eye does not. How come? Because the character is in front of the screen, the left image is shifted to the right and reveals texture that is out of the right frame. The brain then faces a dilemma. The occlusion cue being stronger than the parallax, it decides that this guy can't be in front of the frame and pushes the image at last to the screen plane. This undesirable effect is called a stereoscopic window violation, (SWV), also known as window violation, and is the third most painful mistake after interocular distance and convergence errors.

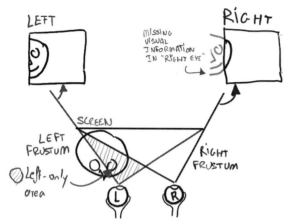

FIGURE 5.9
If an object hits the side frame when in front of the screen, it generates a stereoscopic window violation.

As a rule, you will want to avoid breaking the stereoscopic window—with two exceptions: speed and position. SWV can be forgiven if an object's moving fast enough and clearly identified as in front of the screen. Our brains recognize it as a situation used with close-up objects in real life. This applies to objects exiting the frame in about half a second. The same is true for an object entering the frame and not yet localized in 3D. If the full object is in the frame by the time the brain has localized it in front of the screen, you are safe.

Bending the stereoscopic window

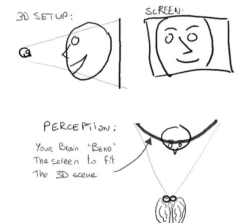

FIGURE 5.10
If the character's head hits the top of the screen, the window feels bent.

What happens if a character stands in front of the screen but does not interfere with the sides of the frame, only with the top and bottom edges? Our brain will have to handle the inconsistent cues from the screen and the character's position, but it will not deal with a conflict between occlusion and position. The brain's solution will very likely be to decide that the screen is curved toward the audience.

This arrangement with reality works better if you don't abuse it and you stay less than six feet in front of the screen. The other key factor in its effectiveness is to avoid hitting the top edge of the screen; this is most likely because we are used to seeing the heads, but not the feet, of people standing in front of us.

Floating the stereoscopic window

Drastically respecting the floating window limits you in the use of the space available behind the screen, and it really is a creative challenge, if not a technical nightmare. The other option is to move the window forward and buy some stereoscopic real estate. This is done by applying masks on the sides of the frame to hide what the eyes should not see, as you can see in Fig. 5.13.

Floating Stereoscopic Window

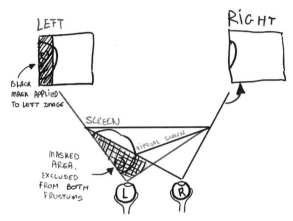

FIGURE 5.11
Top view of frustum with floating window.

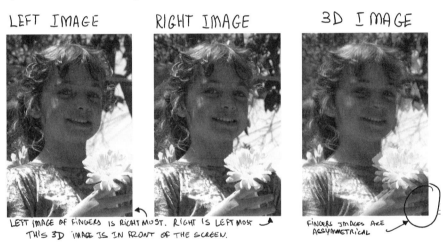

FIGURE 5.12
3D picture without a floating window.

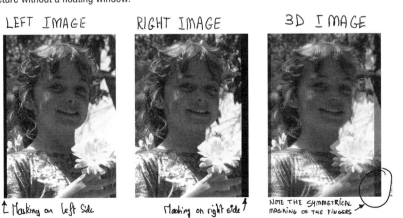

FIGURE 5.13
3D picture with a floating window.

It should be noted that this effect is absolutely unnoticed by the audience. Jump cuts, animation in time, and vertical or horizontal asymmetries of the floating SW are possible and strongly encouraged. This technique was used extensively in *Meet the Robinsons,* and you will hardly see it, unless you remove your 3D glasses and look for a thin stripe of grayed image on the sides of the screen.

THE 3D SCREEN SPACE
The 3D comfort zone

If we put together the rules of stereoscopic perception we just saw, we can draw a comfort zone, at the complex intersection of our left and right frustums, the pyramids defined by our eyes and the screen's four corners.

FIGURE 5.14
The stereoscopic comfort zone.

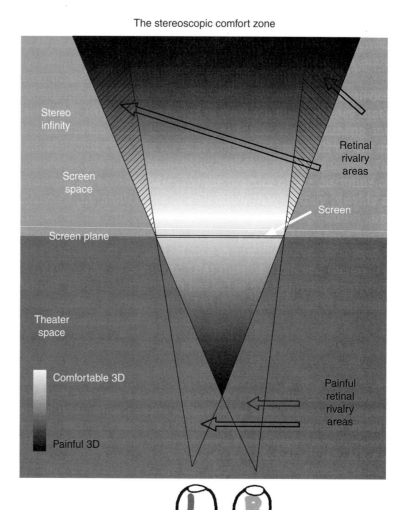

The stereoscopic comfort zone

- The stereoscopic vision area is show in white-to-black gradient
 - The comfort zone, from white to dark grey, can be freely used.
 - The duration-sensitive zones, from grey to black, is where excessive convergence and divergence may generate eye strain over time. It can be used for limited periods, interleaved with resting sequences limited to the light grey area.
- Striped areas are seen by only one eye and generate retinal rivalry; they should be used with caution.
- In the flat grey triangles in front of the eyes, objects should only move fast in or out the frame.
- Other flat grey areas are invisible to the audience.

Depth placement and perceived size

The ability to reconverge a 3D picture by sliding the 2D images allows us to move the scene along the Z axis. This ability comes with a few drawbacks. Because the image is shifted, not recalculated, abusing it would produce weird effects. The most important is called the scale-down effect and makes objects you would bring up close inside the room look like scale models. Similarly, an actor pushed back behind the screen would look gigantic. Fig. 5.15 illustrates the phenomenon.

The placement-sizing effect

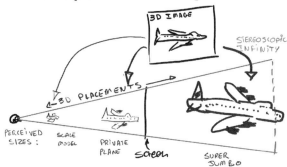

FIGURE 5.15
The jumbo jet and its RC scale model.

The image of the flying plane is shifted from background to foreground. Obviously, its on-screen 2D size does not change. But it seems to advance and resize itself along a pyramid defined by its 2D image and your eyes. As a result, a close-up plane would look like a radio-controlled scale model. At infinity, you would feel that you were looking at real jumbo jet. It's commonsense to understand that a plane flying inside a theater is not a real one. In a 3D movie, you will have to beware of this effect.

Real-world geometry and theater screen and volume

At the end of the day, what comes out of the whole set of rules we have gathered about the image geometry and depth perception? Basically, we end up with a mathematical transformation where we have to bring the whole real world inside the virtual space called the "comfort zone." The world you get

into your camera starts at the camera lens and ends at the infinity. The visual world you get out of the projector starts 30 to 60 feet (10 to 20 m) in front of the screen and ends at about 60 feet (20 m) behind.

The stereographer's main job is to artistically squeeze the real world into the reduced available depth inside the theater. This is done by controlling the cameras' relative position, and some additional postproduction passes. We have seen some of the physical limits you encounter, and there's only so much you can do in this virtual representation of the set. If these limitations were known and taken into consideration in the preproduction phases, the 3D will fray in its sweet spots and leave room for artistic creativity. If the storyboard asks for 3D-impossible shots, it will generate watchable 3D, but nothing close to emotionally moving or even entertaining. And what's the point of adding a new layer of technical complexity if it does not bring more emotion to your audience?

Until now, almost no feature 3D movie was a 3D project from the very beginning, and it shows; more accurately, they have not yet harnessed and shown the full potential of 3D cinematography. In order to reach it, you need to learn and use new scriptwriting tools and concepts, like the ones we introduce in the next chapter.

NEW CONCEPTUAL TOOLS FOR 3D CINEMATOGRAPHY

We have established that 3D cinematography affects the whole production process, from project submission to exhibition. The industry needs to define and agree on a couple of new conceptual tools and the adequate vocabulary to communicate them among crewmembers. The first tool is a digitization of the concept of parallax, allowing modern stereographers to accurately count it by the pixel. The depth budget refers to the overall 3D of a movie, allotted by a depth script, with respect for depth continuity among shots that exploit a depth bracket inside a given depth position.

Parallax counted by the pixel

Opticians and trigonometry lovers refer to parallax as an angular value. They are definitely right, and this is the way you should compute adequate stereoscopic settings. After all, this is the way our visual system handles it. On the other hand, in 3D cinema we generate pictures, not charts. We don't even know for sure how big the screen will be and how far the viewer will be from the screen. Besides, trigonometry tends to be even more painful than bad 3D, and there's a natural tendency to stay away from it. Old-time stereographers, using film stock, used screen percentage parallax as a unit, and tried to keep it under 1 percent by the use of the trigonometric tables.

When it comes to actually and accurately setting depth on a movie, we need to be able to refer to numbers anyone in the crew would understand in the same way. We have seen that the relevant information is the size of the on-screen disparities, in inches. We are working on an image that used to be a piece of film and now is a set of numbers. With film and digits, there's no such on-screen-size

figure anywhere in the pipeline. We first have to decide what will be the reference screen size for the project. In feature animation, the current standard is to set the movies for a 30-foot, (9-meter) screen.

In the modern time of stereography, we are more used to manipulating pixels than mathematical formulas and we have managed to devise a pixel parallax unit. It is simply the number of pixels that separates the left and right images of an object when the left and right views are blended together. On an anaglyph image, you would count the pixels separating the red and cyan edges.

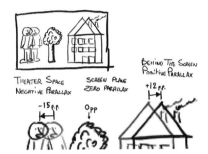

FIGURE 5.16
Example of pixel parallaxes.

This figure is not yet universal, because projects can be produced in ATSC (640 pixels per line) HDTV (1280 or 1920 ppl), 2 K (2048 ppl) or 4 K (4096 ppl). The current standard in feature movies is to use either 1080p or 2 K, ignoring the few percents of difference.

Based on such an agreement, we can draw a numeric chart of digital 3D depth. On a 30-foot screen, the human 2.5-inch interocular gives 2.5/360 or 0.7 percent. At 2 K resolution, the native pixel parallax (NPP) is 14 pixels. It is considered acceptable to go temporarily up to double eye-width in the background, or 28 pixels. In the foreground, action scenes can use huge HPP, up to hundreds of pixels, like the flying gun in "My Bloody Valentine" which flies up to 400 pixels.

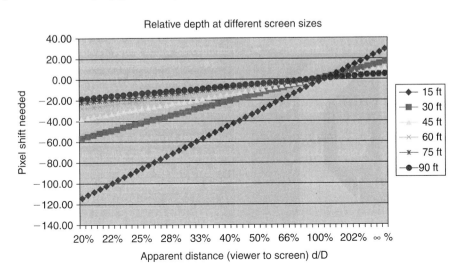

FIGURE 5.17
Depth charts from In-Three.

FIGURE 5.18
Depth charts used in 3D CG animation.

This system has some limitations. You have to know the relationship between the pixel number and the perceived distance. As you can see in Figs. 5.17 and 5.19, this relation is not linear, nor even symmetrical. One pixel parallax in the background, in the +20s, has much more effect on depth than one pixel in the foreground, in the −40s. If we had to name this unit, it would be HDTV pixel parallax (hpp).

Exercise

Calculating Parallax

We have seen that a 30-foot screen at 2 K has an NPP of 14 pixels. What is the native parallax of the screen you are using? First, you will need its width, in inches or centimeters. Most screens are referred to by their diagonal size; some are 4/3, some are 16/9, and you may even find some 5/4. At this point, you can either solve the equation based on the square triangle diagonal formula

$$\text{Diagonal} = \sqrt{(\text{Width}^2 + \text{Height}^2)}$$

or get a ruler and measure your screen. The notebook I'm using has a 13-inch screen with a base dimension of 11 inches.

The native parallax is the human interocular of 2.5 inches in the United States and 65 mm in the rest of the world, divided by the screen size. You'll get a number in the low percents—in my case it's 22 percent. Multiply this number by your screen resolution, and this is your screen NPP. In my case, a 1280 × 800 matrix has a NPP of 290 pixels.

Before you start making pictures with such a huge parallax, I must warn you of a couple of side effects of doing 3D on computer screens. You surely remember the focusing-convergence decorrelation stuff. Because we are looking at our computers, especially laptops, up close, there's no way we can fuse a picture that is set at infinity. If we get to a foot behind the screen, that's already quite an achievement. The same is true for television, to the point that audience tests have shown that the 0.7 percent or parallax we set up for movie theaters is usually preferred to the 2.5 to 3 percent dictated by pure math. Based on his experience, Alain Derobe suggests that for screens under 6.5 m, the reference NPP should be reduced from 65 mm down to 10 mm for a 1 m screen.

The depth budget

Based on the screen size and production resolution, you can compute the infinity and half distance parallaxes in hpp. They are symmetrical numbers defining a 2.5-inch or 64-mm, onscreen parallax generating parallel view toward infinity and crossed view converging at 50 percent of the distance to the screen. This number can be called native screen pixels parallax. This will be your golden number, defining your comfort zone's sweetest spot, your area of *almost* absolute 3D creativity.

Depending on the type of movie subject and the target audience, you will expand this range, up to double eye-width in positive parallaxes behind the screen, and five to ten times negative parallaxes in front of the screen for in-the-room effects. In a handful of shots, negative parallaxes could be bumped up to 20 times the native parallax. This setting should be used for a dozen frames maximum, and for fast-moving objects typically reaching to the camera. The brain may not fuse the 3D, but just considers them to be projectiles flying by, and this is perfectly fine.

The depth bracket and depth position

The amount of 3D space available in the theater, often called stereo real estate, is actually larger than the comfortable fusion range. Even if you stay inside the absolute comfort zone, within the native screen positive and negative parallax, the audience may have trouble fusing both foreground and background at the same time. Depending on your shot composition, you may or may not need it. If you go beyond these parallaxes, you are ensuring the audience will have to choose what they're looking at in 3D. Ultimately, extreme positive and negative parallaxes in a single frame composition will be uncomfortable, or even impossible to scan in 3D, and should be avoided.

The amount of 3D space used in a shot does not cover all the 3D real estate available in the Depth Budget. The portion of 3D used in a shot or sequence is called the depth bracket. The placement of that bracket inside the real estate is called the depth position. The depth bracket is determined by interocular distance and cannot be changed. The depth position is determined by the convergence point, if any, and the reconvergence in postproduction.

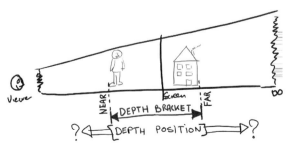

FIGURE 5.19
The depth bracket and depth position.

The depth budget, depth script, and depth chart

The depth budget can be linearly distributed along the story line, or allotted unevenly, according to the unfolding of the plot and plot surprises. The distribution of the depth budget over the course of the story is described in a depth script. It can be represented on a time chart, where acts and scenes get their depth allocation on a rough 0 to 10 scale, from flat to barely supportable for more than a couple minutes. Powerful 3D setups should be interspersed with low 3D sequences, sometimes nicknamed "rest areas" because they allow the audience to give a break to their visual system muscles.

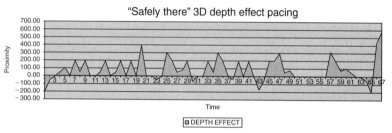

FIGURE 5.20
Example of a depth chart. Image courtesy of Lightspeed Design.

Depth continuity

In 3D, some jump cuts are referred to as "depth jump cuts" because the depth bracket actually jumps from one position to another. This forces the viewers to readjust their convergence, based on the double vision they got at the cut. Too big a jump cut is impossible to follow for the average moviegoer and will be felt as disturbing the suspension of disbelief. Jumping from foreground to background is less stressful than the other way around.

The respect of depth positions from shot to shot is called depth continuity. It can be taken care of by selecting shots appropriately, using cross fades or active depth cuts. In an active depth cut, the outgoing and incoming shots are reconverged toward each other over a few frames around the cut. As a result, the audience's convergence is led from the out-shot depth to the in-shot position.

Key Points

The basic rules of 3D cinematography

A 3D picture is made of two 2D pictures, shot and projected in perfect coordination.

The depth effect is a function of

1. the relative position of the two cameras
 - Interocular distance generates the overall volume of the scene
 - The crossing point of optical axis defines the screen plane
2. the projection screen size and the viewer's relative position to the screen

Left and right cameras should be optimally matched in

1. photography (exposure, aperture, focus, depth of field, and focal length)
2. cinematography (frame rate, time reference, and synchronized movements)
3. geometry (parallel image planes, optical axis in the horizontal plane, and crossing at a controlled distance)

Left and right assets should be edited and posted in perfect coordination

1. All postproduction effects should be perfectly replicated on left and right shots
2. All edits, points, and transitions should be applied symmetrically to left and right views

Left and right movies should be shown using a 3D display system that preserves

1. matching image lightness and colorimetry
2. images geometries, with pixel-accurate vertical and horizontal alignment, keystone, and rotation control
3. frame-accurate image synchronization

Digitization of cameras, postprocessing, editing, and projection make these matching requirements much easier to achieve.

Controlling 3D in the camera

SETTING THE 3D EFFECTS AT THE CAMERA LEVEL

1. Cameras should be side-by-side, as on a flat plane, or in other words;
 - with both image sensors' verticals on parallel axes,
 - with their optical axes forming a plane.
2. The distance between the cameras is called the interocular distance, or i.o.
 - The i.o. is the single most important parameter in 3D cinematography.
 - Increasing the i.o. increases the image volume, inflating objects.
 - Reducing the i.o. reduces the image volume, flattening objects.
 - It can sometimes be fixed in postproduction with various levels of success.
3. The camera optical axes can be parallel or converge on a point.
 - A parallel camera setup will place the whole scene in front of the screen.
 - A converged setup will gradually push the whole scene beyond the screen.
 - The object on which the axes cross will appear at the screen depth.
 - Converging does not affect the overall depth of the shot.
 - Convergence can be achieved
 1. by converging the camera
 2. by shifting the image planes on set
 3. by shifting the image planes in postproduction.

CHAPTER 6
Preproduction

The sooner you think about 3D, the better your movie will be. The impact of sound and color on preproduction is obvious. You could argue that a movie script is not written specifically for a black-and-white or color treatment. That's far from the truth, and the impact of color and widescreens on external location cameras has been documented over and over.

General comments on script writing are usually made by old men on the mountain, writing from an office filled with awards, posters, and statuettes. We will try to deal with this subject from the point of view of a technologist with only a few years of feature movie experience. We will analyze the impact of 3D on script writing, storyboard drawing, and art direction. Most of our comments bring into the preproduction context some stereoscopic concepts that are presented in detail in other chapters of the book.

WRITING FOR 3D

A good story is not bound to the way it's told. A good novel or graphic novel will make a great movie if it is adapted by a scriptwriter who understands the new visual support. Here is the whole issue: You need to understand what works and does not work in any artistic medium. In the silent era, sharing your sentiments of love was expressed with a wink to the loved one, who would answer by opening her arms. That was it. One or two shots. Bring in the voice, and the same scene turns itself into a lengthy static dialogue over a restaurant table, and still a lot of winks.

Thinking about writing for 3D is envisioning the depth medium's effect on the interaction between your audience and your images.

What is a 3D movie all about?

Making a movie can be reduced to two gestures, framing and cutting, or to two acts, shooting and editing. We get this quote from David Mamet, who wrote in *Bambi vs Godzilla: On the Nature, Purpose, and Practice of the Movie Business,* "You do not have a movie until you have shot it, and then you still have no movie

until you edit it." We will stand on this giant's shoulders to get a detailed look at the specifics of a 3D movie.

HOW DIFFERENT IS A 3D MOVIE FROM A 2D MOVIE?

Basically, where you used your camera to define a universe enclosed in a frame, you now have to think about a volume. Everything in the camera axis was making its way onto 2D in your picture. Now it's the camera axis that transports itself into the 3D theater, with all its components and elements, accordingly spaced along the projection axis.

The frame is now a volume, that obeys spatial geometry rules. You were used to handling 2D projections; you will now practice with 3D transformations.

The borders of the frames are not frontiers anymore; rather, they are dangerous places where images can be painful. The scene volume has two more borders, the planes at the infinity behind the screen and the audience's lap. All six faces of this truncated pyramidal stage have new behavioral rules and violations. This space, defined by its borders, has a sweet spot called the comfort zone at its center.

The screen itself is no longer the universe where the story lives. It's now a window. This window is the pivot point, or pivot surface, of a space where your story lives and evolves. It is not a physical one, but rather it's a virtual one and you can, and will, dynamically move it around, to create and animate the volumes you need to tell your story.

You have to think in terms of volume composition, instead of picture composition. You will box the action more than you will frame it.

Movie editing is affected too, by new image reading and transition rules. The main new concept is depth continuity. It says that you cannot cut between any random depth compositions. You have to script the depth strength and placement of your scenes and images. Write down the depth story of your movie, just like you will comment on musical and visual ambiances surrounding your protagonists.

HOW MUCH 3D AND WHAT SORT OF 3D GETS INTO A MOVIE?

Ennio Morricone says, "What is important in a film is that the spectator doesn't perceive when the music enters and leaves." That should be the same for the depth in a 3D movie. The 3D helps you tell a story but 3D is not *the* story.

For many years, 3D was trapped in the "special venue" business where the audience waited in line for a 15-minute ride, or was loaded in a yellow bus to get 40 minutes of spectacular images on a scientific theme with a voice-over. Such audiences want a dose of thrill, a once-a-year fix, an end-of-year reward, and they deserve not to be disappointed. Go, flying rocks! Go, octopus tentacles, go! It's your 15 minutes of fame—you are the hero of the day, so go fly inside the room!

Digital 3D cinema audiences are not on the same trip. They come on Saturday afternoon to immerse themselves in a well-told story, to identify themselves with the protagonists. They are here for a cathartic moment with a climax, not

just an adrenaline rush. As Philip "Captain3D" McNally, stereographic supervisor on *Chicken Little* and *Meet the Robinsons* says, "The first rule of 3D is 'do not harm.' Do not harm the audience. Do not harm the story."

You will modulate the strength of the 3D effects you use in the course of your movie. For example, you can set sad chapters almost flat, and happy and dynamic sequences beyond normal deepness. The most important objective is not to let the 3D effects remain free wheeling. Make a depth treatment statement in your intention note. Include a depth script in your submitted projects.

Remember that the amount and placement of 3D affects the story just like sound, light, and color do and should be planned in your depth script.

DEBATE ON 3D MOVIES VS 2D MOVIES

Just for the purpose of fueling the debate, we want to share with you two opposite analyses of the relationship between the 2D and 3D versions of a specific movie project. Basically, they are two ways of looking at the question, "Why and how should I make this movie in 3D?"

Opinion one is to consider that "If you would not make this movie in 2D, don't shoot it in 3D." It seems obvious, but we feel some producers may benefit from knowing beforehand that "A bad 2D project will not make a good 3D movie."3D is not magic that turns lead into gold. In this approach, 3D is just another tool in the filmmaker's arsenal. It's the 3D-is-a-spice school, where 3D is a part of the recipe, not the main ingredient.

Opinion two considers that "If you could shoot it in 2D, don't make it a 3D movie." This approach argues that burlesque movies did not improve with the addition of recorded sound. Burlesque evolved later into new comedic styles. If your movie makes sense in 2D, why would you impede yourself by making it in 3D? This vision sees 3D as a whole recipe, as a new media with a purpose of its own. This extremist approach makes an excellent exercise for film school students. It's a challenge to imagination and creativity.

Reality is somewhere in between these two positions. Audiences want pop up and in-your-face 3D, with no headaches or obvious gimmicks. We'll see the 3D craft evolve from being a full recipe to being used as a mere spice as did color, sound, and widescreen. We've had our share of musicals, outdoor movies, color-saturated sets, and red-and-green monsters. We will enjoy a first generation of 3D movies with all sorts of objects purposely flying inside the theater.

3D CONSTRAINTS ON YOUR CINEMATOGRAPHIC GRAMMAR

Most 3D constraints apply to the DP and the movie editor. They are referred to as stereoscopic window and stereoscopic continuity, and they are both studied throughout this book, from the many points of views of the whole movie crew. The entire book is about these two limitations, their causes, their effects, and the control you can have over them.

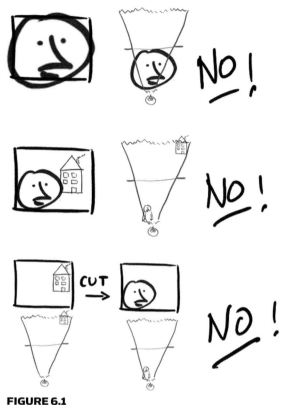

Here are the prominent visual constraints you should be aware of for now:

1. Objects can't cross the edges of the screen. As an example, an extreme close-up with the talent's face reaching all four sides of the frame must be set behind the screen.

2. You can't look at something reaching far inside the theater, in front of a background that is far behind the screen.

3. You can't jump cut, such as from a shot centered inside the theater, to a shot far behind the screen.

We just saw what you should know about 3D when developing your film project. Let us now investigate the tools you have to do the job right.

THE DEPTH SCRIPT

The 3D effect has to be modulated throughout the story, and that modulation has to be scripted. A depth script is just the description of the amount of depth throughout time. It can be a chart or a text description. A chart can show

FIGURE 6.1
Three visual constraints that stereoscopy imposes on cinematographic grammar3D cinematographic tools.

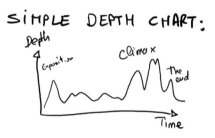

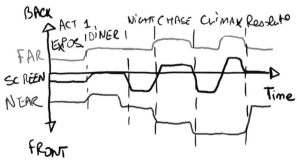

FIGURE 6.2
Simple and detailed depth charts.

a single "depth strength" curve or include the details of closest, farthest, and attention point waveforms.

The depth script can also be a set of notes spread throughout the script or the screenplay. You do not need to be too precise; simple art directions may suffice. The action will be described as shallow, deep, close, far away, in front of the screen, at infinity, and so on.

THE 3D STORYBOARD

When the visual structure of the movie is inked on the storyboard, the depth will be present in the drawings.

Put some depth in your storyboard art

For crude drafts, a brush thickness code is sufficient. Thinner lines are behind the screen and bolder lines are in front of it.

FIGURE 6.3
A simple 3D storyboard image.

Top or side views of the set

You can use side or top views of the stereoscopic volume to draw depth layouts of the scenes. Figs. 6.4 and 6.5 present two examples, one for draft settings and the other with a parallax ruler for detailed instructions used in GCI 3D productions.

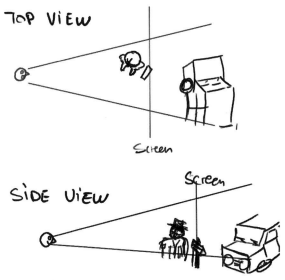

FIGURE 6.4
A simple 3D shot layout.

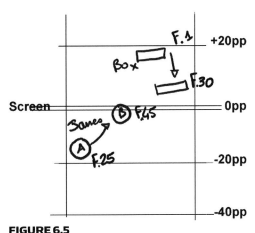

FIGURE 6.5
A detailed depth sheet for CGI shot.

Color encoding the story depth

For detailed art, you can color-code the charts, using cold-to-warm conventions. Blue is the farthest, green is behind the screen, yellow is at the screen plane, orange is in front of it, and red flies in the theater room. Such color choices rely on depth cues and make the pictures self-readable in 3D. Furthermore, there's one 3D print process, the ChromaDepth, that uses special glasses to turn this color scheme into actual depth. A properly colored storyboard, drawn with pencils whose pigments respond correctly to the glasses filters, will be seen in real 3D.

3D ART DIRECTION

While you start envisioning your movie, you start making choices that will most often stick until the end of the project and eventually show on the screen. If you make artistic choices that run against 3D effects, mood, or quality, you'll have to work around or even against them. Art decisions affecting 3D relate mostly to lens choices, action framing, and set dressing.

Transposing 2D art direction into 3D cinematography

You'll discover that some cinematographic rules seen as stable in 2D are drastically changed when they are transposed into 3D. And some are not. Digital stereoscopic cinema is too young an art form to have created a list of changing and unchanging rules, and the previous 3D waves did not leave us with such intellectual property in the formerly established form. It is up to you, the reader, to establish that knowledge on the course of your 3D moviemaking experience.

A REVERSED RULE: THE CLARITY OF CLUTTERED COMPOSITIONS

A cluttered composition in 2D will produce a feeling of uneasiness in the audience. It is complex to read and the visual cortex struggles to identify every object in the scene. This process, called image segmentation, matches every visual feature to an identified object. The original *Alien* is a poster-child example of an overcluttered visual universe where it is almost impossible to be sure there's no monster hiding among the clusters of tubes and cables.

In 3D, it is the other way around. Cluttered images are read as continuous gradients of details along the depth axis. Clean-shaven universes leave us with scattered depth cues that we struggle to position relative to each other.

AN AMPLIFIED RULE: THE IMPORTANCE OF MOTION DEPTH CUES

The cumulative effect of lateral camera movement and stereoscopic vision is stunning. When you experience the reciprocal confirmation of monoscopic and stereoscopic depth-placement cues, 3D perception turns into a highly rewarding brain activity.

Contradictory depth cues make the world look flat or disorienting in 2D. In 3D, if they run against the stereoscopic perception, they create an even more powerful disturbance. Bring them back into describing the actual depth layout, however, and the audience will feel a much stronger mood improvement than they would in 2D.

AN UNDECIDED CASE: SHALLOW AND DEEP FOCUS

You may decide to provide infinite focus and full-scene depth reading to the audience. You may prefer to use shallow focus as a strong depth cue, just like in 2D, and restrict the acute stereopsis to a narrow depth plane. You may even take an entrenched position on either side of this aesthetic battle, and you won't be alone holding the position. Equally respectable 3D cinematographers are brilliantly making the case for each approach, and we would be surprised to see this debate settled in the near future.

Close-ups and the stereoscopic window

DEFINITION OF STEREOSCOPIC WINDOW

We have already seen that because of stereoscopy, the screen is no longer a plane on which the world is projected. It's now a mobile window that defines a space where the world is projected via a homothetic transformation.

You will tell your story through that window, and the relative placement of the universe, objects, and subjects of your movie, relative to the window, is the main tool you'll need to master in the 3D cinematography.

STEREOSCOPIC WINDOW VIOLATIONS

Stereoscopic window violations (SWVs) occur when an object is wrongly placed relative to the stereoscopic window and as a result generates incoherent left and right images.

The most often encountered SWV is in close-up and medium close-up. There's a tendency in 2D to cut out the top part of talents' heads. This is actually a plague in 3D, because you want the actors to be in front of the screen and the SWV projects the actor behind the screen. Remember to always leave some space above the heads.

The second most common SWV is an over-the-shoulder point of view in a two shot. The listener's silhouette is almost always breaking the window on one side of the screen.

FIGURE 6.6
A close-up in 3D should never reach the top edge of the frame.

You have to imagine that your camera has a giant matte box that reaches the screen plane. Anything hitting the side and top is a potential troublemaker.

FIGURE 6.7
A medium close-up, or an over-the-shoulder two shot in 3D should not cross the side edge of the frame.

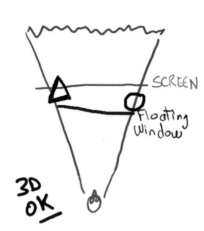

FIGURE 6.8
Floating the SW provides good damage control
if the violation is moderate.

FIGURE 6.9
Floating the SW is not an option for huge violations.

3D GIMMICKS AND OTHER UFO ATTACKS

If someday a museum of stereoscopic cinema opens on Hollywood Boulevard, there will be a room dedicated to all the flying objects, pointing knives, and poking poles that were thrown at the audience. Even if we are steering away from that 3D cinematography where the story is an elaborate flight schedule, the audience asks for it.

The important point is to stay away from uncomfortable fusion objects, or UFOs. UFOs are objects improperly displayed inside the theater space. The rule

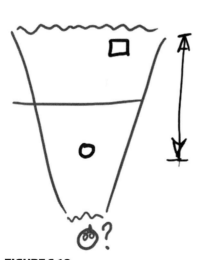

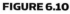

FIGURE 6.10
This ball stands by itself and is hard to fuse
in 3D.

FIGURE 6.11
This set of balls helps the viewer build up the 3D fusion.

is that an object reaching far inside the theater should be brought in one way or another. This can be done by movement, like a ball flying at a sustainable speed toward the audience. Or it can be provided by the image construction, like a ball held in a hand, with the arm reaching from the screen plane.

The long shots and the stereoscopic real estate

The question of the lens choice discussed in Chapter 7 is dedicated to principal photography. All you need to know at this point is "Long lenses make poor 3D; short lenses makes great 3D."

YOUR STEREOSCOPIC REAL ESTATE

The stereoscopic real estate is the 3D space you can use to set your scene. It is a pyramid-shaped comfort zone that starts somewhere in the middle of the theater and extends a few tens of feet behind the screen. You can stretch it for a little while, up to the second or third row of seats. To actually extend the real estate behind the screen, you will have to virtually move the screen toward the audience, by floating the stereoscopic window.

3D SPACE CONTINUITY

Long lenses are used to either separate the subject from the background, with focus blur, or to make subjects appear closer than they actually are. Neither effect works in 3D. As Rob Engle, senior stereographer with Sony Pictures Imageworks, says, "You cannot cheat the space when you shoot 3D, period." Long lenses flatten the actors and make them look like cardboard stand-ups, and 3D reveals the actual distance between scene elements.

The other issue is that you can't fuse close-up objects and faraway landscape at the same time. This can be solved by optically compressing the depth, hence flattening the 3D even more. For this reason, you will prefer to set your action in front of a bush or a wall, rather than a distant forest, skyline, or mountains. The exception is a lasting picture, which the audience is invited to scan, as is typically done with Imax3D landscape shots.

FIGURE 6.12
Short lenses and compact setup will give you great a 3D imagery.

FIGURE 6.13
Long lenses' effects and faraway backgrounds will look bad on the screen.

WORKAROUND

Actually there's a workaround called multi-rigging shots. Multirigging is a CGI-based visual effect that can be applied to live action shots on green screen. The foreground and background plates are shot with two separate lenses set and composited together. It is a complex process that can be achieved on a couple shots on low budgets, but should be considered for massive use only on heavy VFX movies produced by experienced teams.

The relationship between size and distance

In 3D the objects shown on-screen have an actual perceived size that they did not have in 2D.

HOW ARE DISTANCE AND SIZE LINKED TOGETHER IN 3D?

In a classic 2D movie, the size of an object is mostly perceived relative to the other objects in the scene, or by other size cues such as apparent weight and inertia. We know perfectly well that the images seen on the screen are projections, in the mathematical sense. If an actor's face fills the screen, it does not mean he is as big as a skyscraper. It means that we are so close to him that his face occupies the whole field of view.

In 3D, we have an actual perception of the size of an object because we know how far away it is. If the actor's face covers the screen surface and is kept behind the screen to preserve the stereoscopic window, it means that he actually is as big as the screen. This effect is called gigantism.

HOW CAN YOU CONTROL OR USE IT?

On-screen magnification needs to be controlled through depth placement in order to provide realistic sizes. If that depth placement can't be achieved for some reason, the object is subject to a size magnification. A plane flying inside the theater is a scale model. The very same image, pushed far away behind the screen, will show a jumbo jet.

If you need to enlarge an object, it is easy to push it away, as long as you don't push the background beyond the comfort zone. If you need to shrink it, bring it in the room.

The 3D sizing effect can be used with a storytelling purpose. Say the heroes embark on a boat trip and get caught in a hurricane. You will start the sequence with a massive boat, far behind the screen. When the weather turns bad, bring the boat forward, it will shrink to the size of a train wagon. At the screen plane, it is the size of a van, much weaker in the moving waters. By the end of the sequence, bring it further in front of the screen, where it looks like a small toy, and all its might has vanished.

—Tim Sassoon

Sets for 3D

What can possibly be 3D specific in a set-dressing decision? Anything that interacts with depth cues, comfort zone, or stereoscopic technology. This could be existing 2D rules, like color cues, or relating to 3D rules, like ghosting, patterns, and depth bracket.

DON'T FAKE THE DEPTH

Two rules of 3D come together here: "What you get away with in 2D will hurt you in 3D" and "You can't fake depth in 3D." Beware of all the "old guy" tricks on set. First on the list: the matte paintings will need some sort of 3D treatment. If you don't fake them in 3D in post, make them at least multilayer, or paint them on a slope or a curved support. Second on the list: the window backlights, especially the colored glasses effects: Don't expect them to be read in correct 3D space in the theater if they were faked on set.

COLORS AND DEPTH

The warm colors advance toward the audience while cold colors recede toward infinity. Try not to go against this rule, unless it is requested in the script, just as in a 2D movie.

CONTRAST AND DEPTH

Try to avoid any high contrast in the background and foreground, because this will generate a lot of ghosting on the theater screen. Keep a black-and-white-checkerboard in the center of the stage. Put drapes on a faraway backlit window.

POLES AND ROPES

Having a pole cross the frame extremely close to the camera while the camera pans sideways is quite common in 2D, and a definite no-no in 3D. Because that pole, lamppost, or mailbox has to be within the fusion range, it will define the stereoscopic setting for the rest of the shot. As a result, the overall depth will be shallow to accommodate that object. The closer it was to the camera, the bigger the damage to your stereoscopy, up to having to remove it in FX.

Even if you manage to get some correct 3D camera settings, this foreground object will bring attention to itself.

NEED FOR PATTERNS

Stereoscopic perception requires patterns to be matched between the viewer's two eyes. If you use flat colors, only the edges of the objects will be identified in 3D, not their shapes. The patterns need a vertical component, because horizontal lines generate no readable parallaxes. Horizontally repetitive patterns can produce a false depth reading when the brain does not know to which left feature it should match to the right pattern.

Put a depth cue on that white wall, like a poster or a projected shadow. On location, you may encounter the disappointing fact that a blue sky is a flat sky. And flat skies are in the screen plane. Sometimes a polarizing filter may help get some detail and volume in the clouds.

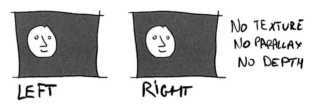

FIGURE 6.14
Flat colors and horizontal patterns are not readable in 3D.

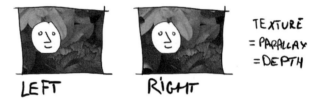

FIGURE 6.15
Random patterns are readable in 3D.

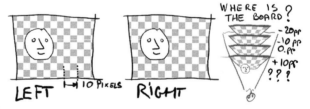

FIGURE 6.16
Repetitive patterns can generate false depth readings.

Key Points

Including 3D in preproduction is key to 3D quality

- The sooner you think 3D, the better for your movie.
- Not thinking about 3D is the closest thing to a counterproductive 3D preproduction.
- Wrong 3D decisions in preproduction will strongly affect 3D quality-to-cost ratio.

Before going into preproduction, be aware of

- how 3D affects all phases of production
- the new 3D storytelling constraints and related tools
 1. the stereopsis process and the depth script
 2. the stereoscopic comfort zone and floating window
 3. the focal length effect on 3D and the multiple rig FX.

When developing your movie project, deal with 3D as you would with color, sound, and light

- Decide on a treatment for the whole movie
 - gimmicky, realist, unnoticeable, and so on
- Specify depth stamina for various acts and
 - chapters.strong, intrusive, smooth, flat, disturbing, and so on
- Think about depth placements and effects for special scenes and shots.
 - gigantism, dwarfism, close-up, far away, window breaking, and so on
- Integrate the 3D into the artistic development and storyboard production.

Gimmick 3D, like objects ostensibly reaching the viewers' personal space

- disturb the suspension of disbelief
- affect the storytelling pace.

To achieve better, rounder, more realistic 3D, emphasize the use of

- short lenses over long lenses
- shallow sets and depth continuum over deep spaces with detached foreground
- textured and colored universes with large amounts of light.

CHAPTER 7
Principal Photography

Principal photography is the harder task of stereo cinematography, and this subject could fill up a whole book by itself. The point is, if you get it wrong at the camera stage, all the following steps will turn into a nightmare. Furthermore, the usual damage control tools that work in 2D to correct damaged footage will not work in 3D or will require tremendous additional manpower to look nice. Perfect stereo photography is not an easy task, and we'll see how you can approach it and, eventually, reach it.

FIGURE 7.1
Digital 3D cinema camera.
Image courtesy of Binocle.

This chapter has three sections: A short introduction is followed by an overview of the theory of 3D principal photography. Then you'll be introduced to methods to set up your 3D camera.

INTRODUCTION TO 3D PRINCIPAL PHOTOGRAPHY

3D still photography prerequisites

Before venturing further into 3D cinematography, you should have thoroughly read Chapters 4 and 5, gotten a camera, and taken quite a lot of 3D still pictures. Among the 2D rules that translate pretty well in 3D, there's "You can't shoot a good 3D movie without being able to shoot nice 3D stills to begin with."

When you feel that you've mastered the key issues of matching geometry, photography, and synchronism with still images, this chapter will extend the concept of a camera rig to linked pairs of movie cameras. You will go from getting a scene right to capturing a movement in the right volume. And eventually we will extend the control of the interaxial distance to the notion of animated interaxial and convergence.

The main challenges you will face

Shooting 3D is not an easy task, with many pitfalls awaiting you on set. Here is a laundry list of the most annoying features of 3D photography you will have the pleasure of meeting. Make sure you are ready to tackle them and add them to your 3D been-there-done-that list.

MATCHING LENSES

Due to manufacturing processes, lens makers cannot make two exactly identical lenses. Working closely with manufacturers, roaming through their inventory, and testing tons of lenses could get you "paired enough" sets. It's not an easy task, and you have to have a really famous 3D name to be allowed to give it a try. For the majority of us, our task will be to eventually make the lenses match with production and postproduction tools.

USING ZOOMS

Professional primes can offer the level of accuracy you will need in stereoscopy. Their use is somewhat limited to parallel camera rigs where their small form factor offers thinner interocular settings. Most beam-splitter rigs are fitted with zoom lenses, which have progression and optical axis inconsistencies that are a problem for 3D photography.

MATCHING FOCUS AND IRIS

You will need to link the focus and iris of both cameras. On professional lenses, this is done by motorizing the optics and controlling them with a single remote. On prosumer cameras, there are some electronic remote solutions that are much less accurate.

USING MIRRORS AND HALF MIRRORS

You will see that the most-often-used 3D camera configuration has half mirrors. They obviously are fragile and dust prone. Furthermore, they limit the field of view to their size and reduce the light by one f-stop.

FIGURE 7.2
3D camera rig using a half mirror.
Image courtesy of Binocle.

POLARIZATION, REFLECTIONS, AND FLARES

Any image artifact based on the viewer's and the light source's position is a 3D hazard. Water reflections, light polarization, and flares will never show up symmetrically on your left and right footage. There's no magic trick here, other than being aware of the danger, looking for it, and, as always, checking your 3D image on a 3D display.

SYNCHRONIZATION ISSUES

When you run two sets of cameras and recorders at once, and you want them to run in perfect synchronization, there's no such a thing as a small glitch. If any piece in the shooting gear has a minor hiccup, you take a chance that the whole system is out of synch.

STEADICAM USE IN STEREOGRAPHY

Three recent digital 3D movies have used Steadicam shots. The increased presence felt by the perception of depth calls for the use of this perfect PoV camera. Yet the issues are multiple. First is the bulkiness of most 3D rigs, and the one used with Steadicam had to be especially designed for 3D use. Second is the cable snake linking the camera to the recorders and motion controllers taking care of the 3D settings. Third, with motorized rigs offering dynamic convergence

FIGURE 7.3
3D Steadficam.
Image courtesy of Binocle.

and interocular, the camera operator's balance is shifted by the animated interocular during the shot.

OPTICAL EFFECTS IN 3D

Somewhere in the first part of this book there's a rule that says, "Everything you get away with in 2D will kill you in 3D." The whole business of most 2D optical effects is to get away with something that is not in the right depth. Backlight effects, matte paintings, foreground scale models, and all sorts of fluid sources can be conveniently hidden behind the faked source. All those optical 2D effects have to be banned from a 3D set. In most cases, they will be replaced by digital effects.

MATCH MOVING IN 3D

We just saw why camera rigs are not perfect, and why most 3D assets would benefit from being corrected in postproduction. This has consequences when a CG camera is matched to a 3D shot. Both eyes need to be tracked and tracking imperfections shall be addressed because we are much more sensitive to them in 3D than in 2D. In *Journey to the Center of the Earth*, the visual effects team had to fine-tune the integration of the actors into virtual backgrounds to a quarter of a pixel.

THE THEORY OF 3D PRINCIPAL PHOTOGRAPHY

In this chapter we often implicitly consider, for simplicity and clarity's sake, that the cameras are converged on the main subject. As you know, physically converging the cameras generates some undesirable keystone artifacts, and it may be preferable to translate the images horizontally in postproduction. Whatever converging choice you make, it will not affect, in most cases, the notions you will be introduced to in this chapter.

Cinematographic depth style

There are many technical and artistic approaches to stereography. You can try to replicate human vision, and move the cameras as you would move your eyes. This creates a very directive imagery in which you should not, and usually cannot, look anywhere but where you want the audience to look. Or, you could try not mimicking human sight, but instead replicate the scene as a three-dimensional world in which the audience can freely scan the image and follow whatever part of the action it likes.

These two approaches will have distinct uses of the main 3D directing tools, as shown in Table 7.1.

Table 7.1	Replicating human vision	Replicating the 3D world
Depth placement method	Converge cameras	Translate images
Focus	Shallow focus	Infinite focus
Depth bracket	Larger than fusion range	Limited to fusion range
3D continuity	Full-time, always on 3D	Scripted on-and-off 3D
3D style	Deep 3D	Shallow 3D
Stereoscopic window	Break if needed	Float if needed
Depth realism	Orthoscopic 3D	Scaled world
Favorite screen size	Giant screen, IMAX-like	Regular D cinema screen
Typical movie	Rides and scientific movies	Hollywood feature

This classification is obviously rough because you build your graphic style by cherry-picking visual tools, and both approaches will be used in a single movie for subjective or objective camera treatment.

Lens choices for 3D

Short or long, prime or zoom, the lens choice you would make in 2D may be different in 3D for artistic and technical reasons. The art calls for short focal length and the gear leans toward zooms. Let's see why and how.

FOCAL LENGTH AND 3D QUALITY

The lens choice is critical because it is linked to the distance to the subject for a given on-screen size, and the distance to the subject is linked to the interaxial for a given 3D effect. This means that changing the focal length changes the 3D effect.

For a fixed focal length, the 3D effect on the main subject is fixed by the angle formed by the two optical axes. The larger the interocular distance, the bolder the angle and the stronger the 3D. If you pull the camera back and zoom in, you need to widen the interocular distance to compensate for the increased distance. Because you are zooming in, you are magnifying the background. This has a cumulative effect on the parallaxes, pushing the background further away. In order to keep the depth inside the comfort zone, you would actually have to reduce the interocular distance when using longer lenses. This effect is

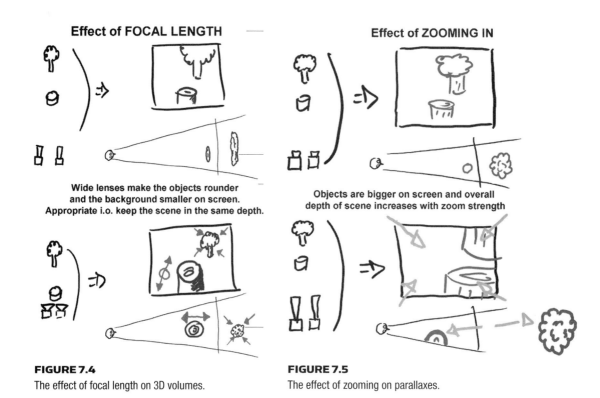

Effect of FOCAL LENGTH

Wide lenses make the objects rounder
and the background smaller on screen.
Appropriate i.o. keep the scene in the same depth.

Effect of ZOOMING IN

Objects are bigger on screen and overall
depth of scene increases with zoom strength

FIGURE 7.4
The effect of focal length on 3D volumes.

FIGURE 7.5
The effect of zooming on parallaxes.

known as cardboarding because it makes characters look like they are cut out of cardboard. They will be distinct and detached from the background, but all of their bodies will be in a flat plane. On the other hand, using short lenses allows you to come closer to the subject and have it looking well shaped, with a detailed depth structure. Overall, the best 3D comes with focal lengths under 30 mm.

VERTIGO SHOTS IN 3D

In an animated feature I worked on, we had to set the stereoscopy for a vertigo shot. In such a shot, also called constrained zoom, the cameras back up in synch with a zoom in, keeping the character's head unchanged when the background is zoomed in and blurred. In 3D, in order to keep the background inside the comfort zone, the interocular distance has to be reduced as we pull back the camera. The 2D vertigo effect is so polluted by the flattening of the actor's face that the resulting feeling is actually inverted. Rather than seeming to have a "Eureka!" moment, the character seems to be crushed by the complexity of the world. The problem was solved with a special effect using a multiple 3D rig rendering.

3D cinematography formula: Short Lens = Round World
3D cinematography formula: Long Lens = Flat World

USING ZOOM

Why would we use zoom lenses in cinematography? The problem comes from the complexity of changing lenses on a 3D rig. This is a time-consuming operation because of the mechanical complexity of the rigs, especially the beam splitters. First, you need to change two optics, and you can't really have two people working at once on a rig. Second, because of the fragility of the mirror, it may be safer to remove the whole camera rather than manipulating the lenses inside the rig. After disassembling and reassembling a 3D rig, you need to reassess its mechanical integrity and optical perfection. Experienced stereographers say that if changing lenses in 2D is a matter of minutes, doing so in stereo can be a matter of hours. For this reason, most 3D beam-splitter rigs are fitted with zoom lenses.

Zoom progressivity

Our usual experience with a zoom lens is that, for any given angular position of the zoom ring, we get a magnification factor. The more we turn the ring, the bigger or smaller the image. As most of us are aware of, this is not a linear progression. This would not be a problem if two identical zooms had the same progression curve. They do not. If you set two zooms to the same progression along their course, you will not get the same magnification factor. This is a problem in 3D because the size disparities generate vertical parallaxes and depth artifacts.

The solution is either to use computerized rigs that use zoom look-up tables to compensate for the optics discrepancies, or to run a correction pass in postproduction.

Zoom teledecentry

If you zero in on your subject and zoom in, you would expect it to stay in the center of the frame. Once again, that's almost the case, but not enough for 3D. A zoom's optical axis has the tendency to roam around as you progress along the magnification factor. And, as you may expect, this roaming is inconsistent from one lens to another. As a result, your 3D image suffers vertical disparities and convergence artifacts.

FIGURE 7.6
The sockets under the camera control the interaxial distance, convergence, and zoom teledecentry.
Image courtesy of Binocle.

Correcting this default is much more complex because it needs a computer and motorized camera support. High-end 3D rigs have such three-axis motion control on at least one of the cameras. The three axes are X translation for interaxial control and Y and Z rotation for the lenses' teledecentry compensation. Note that the Y rotation also provides convergence control if necessary.

Focusing for 3D

All sort of blurs have a specific touch on 3D. Because we rebuild shapes by matching textures from the two images, blurs will prevent good 3D perception. This can be a blessing as well as a curse, and it should be used on purpose and under tight control.

BACKGROUND OUT OF FOCUS

We are used to this configuration in our everyday life. Our visual system convergence and accommodation reflex blurs the background, typically when it is stereoscopically distant from our attention point. This function helps us tolerate too big a retinal disparity. In a 3D image, it will work fine as long as nobody in the audience tries to fuse the background, which is an unwarranted assumption. Because it will prevent the scanning of the 3D image and visually exploring the set, some 3D-DPs strongly argue against it.

You should be especially cautious with grainy patterns, such as concrete walls, that turn into flat color when they are out of focus. A uniform color patch will look flat and settle in the screen depth, creating potential depth-cue conflicts.

FOREGROUND OUT OF FOCUS

This is a situation we are much less likely to encounter in real life. We would spontaneously exclude the interfering object from our visual field. Either by moving sideways or by forgetting it, we actually erase it from our vision, as we wipe out our own nose from our visual stimuli. The same may be advisable in stereoscopy. Move the object or the camera, and if you really can't, you may have to correct it in post.

In Disney's *Meet the Robinsons,* we had a couple of heating pipes on a roof that we had to refocus on, and then move them back into the fusion range.

MOTION BLUR

You will want to avoid horizontal motion blur because it adversely effects stereoscopic depth perception. When a background is blurred, as in a side shot of a character driving a car, 3D perception is impaired because the horizontal disparities disappear and the image seems to be in the screen plane.

Lighting for 3D

Lighting for a 3D movie obeys three basic rules: First, get more light; second, get more light; and third, apply it according to the comfort zone.

GET MORE LIGHT, EVEN MORE LIGHT, ALL THE LIGHT YOU CAN GET

In Ray Zone's fabulous book, *Interviews with 3D Cinematographers,* we hear world-class stereographers talking about their experience in lighting for 3D. It's almost always "The grill was fully loaded with all the lights we could find," "We had to shut down the lights after a few minutes, or the fire alarm would ring,"

"We had to bring in more generators, for the studio grid was not powerful enough," and even "We had to fly generators from London to Italy." Why is it that 3D sets have to be flooded with light?

Get more light for infinite focus

In the 3D debate about shallow focus and infinite focus, the latter school gathers the most proponents. And infinite focus comes with an infinite amount of light, or close to it. Be prepared to set new personal records on the amount of light you will be using.

Get more light for the beam-splitter mirror

The 50/50 half mirror used in beam-splitter camera rigs cuts the light in two even shares, one half per camera. Expect one f-stop loss on each camera.

Get more light into the shadow areas

The big issue with black shadows is they are flat and in the screen plane. Because you want your whole image to be defined and placed in depth, no area should be too dark, and not too bright either.

> **3D cinematography formula:**
> **3D = Light + Light + Light**

MAP THE LIGHT TO THE COMFORT ZONE

Soften the light in the foreground and background

Both ends of your depth budget deserve soft lighting. In other words, objects eventually shown far in front or far in back of the screen will have to be softly lit. The reason is because high-contrast images, with high frequencies, are hard to handle by a 3D display system. Because no system is perfect, there will always be some sort of leaking from one eye to the other. The leaking light shows up as duplicated objects, called ghosts, in the high-contrast areas. And ghosting is a very noticeable and disturbing form of retinal rivalry that affects 3D perception. Note that high contrast in the screen plane will not generate any ghosting because the left and right images perfectly overlap on the screen. Beware that, later in postproduction, the depth placement of a shot may have to be changed for continuity.

You can use the comfort zone as a map of high-contrast compatibility. The more on-screen disparity, the softer the shadows should be, almost to a pixel-for-pixel rule, to avoid ghosting and double imaging.

> **3D cinematography formula:**
> **High Contrast + Big Parallax = Ghosting = Headache**

Low light on the frame edges

The left and right edges of the frame are sometimes referred to as discomfort areas because they are prone to retinal rivalry. If you strongly light the sides of your camera visual field, you take a chance of having a well-lit, well-defined object that is seen by only one eye. This will attract the viewer's attention, but he will be unable to fuse this object's images because he does not see it with both eyes. To prevent such retinal rivalry, keep the frustum borders under low contrast.

Motion artifacts in active stereo

If you are shooting a digital 3D movie, you are most likely using synchronized cameras. Your movie will be eventually shown in triple-flash active stereo projection, like RealD or Dolby. This detail is very important if you plan to have fast horizontal movement. Let's see why, using a simplified left-and-right alternative projection for clarity purposes.

Say that you are shooting a chase on the roof scene. On a large shot, a cop is running on the edge of the building. The camera is static, the cop runs toward the right and the building edge is right at the screen depth. Both images are shot at the very same instant.

Now, we are in dailies in the theater. The images are projected in order: L1, R1, L2, R2, L3, R3, and so on. You can easily see that the right movie is projected half a frame later than the left movie. Because your brain has no reason to correct the delay affecting the right, it will consider that the right was shot 1/48th of a second after the left. The brain will expect the cop to be, on image R1, halfway between his consecutive positions on images L1 and L2. Yet that's not the case because L1 and R1 were shot in synch. Here comes the fake 3D effect: If the cop's image in R1 is farther left than its logical position, he is fused in front of the screen (and thus in front of the building), and you see him running over the cliff like Wile E Coyote. Half the motion parallax is interpreted as a depth parallax by the brain.

In triple flash, the effect is less important, because 1/6th of the motion parallax is actually turned into depth. This effect is noticeable in the digital version of *Hondo*. There are some shots where horses run behind a fence, and we clearly see them stereoscopically in front of the fence, despite the occlusion cues placing them behind. Quite disturbing.

THE 3D CAMERA SETUP

The purpose of the stereoscopic setting of the camera is to scale the real world inside the screen's 3D volume. You control this with three optical parameters; interocular distance, convergence, and focal length, in relationship to the distance to your subject. You can prepare your equipment and settings using stereo computation tools, as well as rely on some proven rules of thumb. You will eventually fine-tune the 3D settings on set to reach the type of depth feeling you are looking for.

Mathematical formulas and software computation

MATHEMATICAL FORMULAS AND 3D TABLES

There have been many excellent books on stereoscopic photography that provided extensive mathematical formulas and tables. Lenny Lipton shows in his book *Foundations of Stereoscopic Cinema* an impressive and extensive knowledge of the matter. His book is a must-read and I invite you to get a print copy, or to get it on the internet, at the Stereoscopic Display and Applications virtual library.

I confess I have never been able to apply the formulas to my projects, despite repetitive tries. It's easier to say so, because I'm far from being an exception. Most stereographers consider themselves as visual artists, not opticians or trigonometric mathematicians. Truth is, gaffers and DPs do not use mathematical formulas and skin-reflectance factors to compute the amount of light needed on a shot. They use their experience, some preplanning software, final adjustments, and the help of a light meter on set. We will use basically the same tools on set: plan, prepare, setup, control, and adjust.

WEBLINK
The Stereoscopic Display and Application conference virtual library
www.stereoscopic.org/library

Obviously, if you are TD coding a virtual camera for a CGI movie, you will need to know all about this formula. I invite you to look for the abundant literature in Siggraph and SPIE proceedings.

STEREOSCOPIC PREVISUALIZATION

Big-budget movies use a lot of CG-based preproduction rendering. For complex shots, it is wise to leverage the 3D nature of these tools. A fast rendering pass in a 3D-modeling tool like Autodesk Maya can help you determine the best 3D settings. If you do so, make sure you are working in real scale and rendering test shots to validate your virtual camera model against real images. Frameforge, from Innovative software, offers a full set of 3D-specific tools, with 3D rigs models and live stereoscopic preview. It generates 3D setting sheets with inter-ocular and convergence values.

OPTICAL 3D COMPUTATION SOFTWARE

Three-D camera computing systems existed even before computers were available. In the 50s, there were rotating paper disks created to help 3D camera crews figure out the interocular and convergence settings they should use.

In 1983, Dan Symmes started working on SPATIAL efx, a program that he eventually ported to Palm and Windows computers. Andy Millns from Inition released StereoBrain for Windows and announced Mac and Linux versions for 2009. Florian Maier, created Stereoscopic Calculator, available via his website.

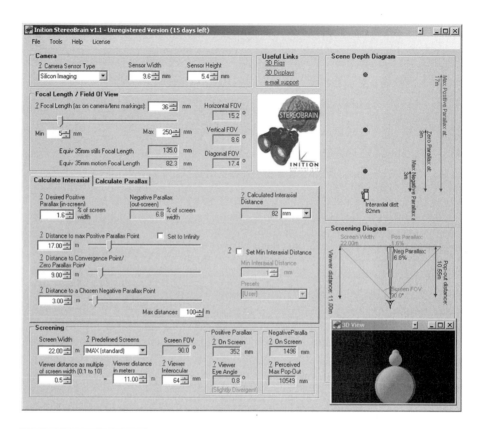

FIGURE 7.7
StereoBrain and Stereoscopic Calculator screenshots.

Empirical configuration on location

STEP ONE: THE 1/30TH RULE OF THUMB OF 3D

The 1/30th rule stipulates that the inter-axial distance should be 1/30th of the distance from the camera to the first fore-ground object. It is widely used in stereo photography, especially for landscapes and large buildings where a roughly estimated distance provides an easy computation of the appropriate interaxial separation. If you use a fixed interocular stereoscopic camera, this will tell you how close to the subject you can go before getting too much separation.

WEBLINKS
SPATIAL efx:
www.3dcompany.com
StereoBrain:
www.inition.co.uk
Stereoscopic Calculator:
www.stereoscopic-calculator.com

The rule can be used in 3D cinematography, under the condition you adapt it to the actual focal length and the screen size. The large size of a theater screen will amplify the depth and will linearly reduce the interaxial distance ratio down to 1/100th. The use of very short lenses will increase it up to 1/10th.

This rule is used to select the type of rig needed for a shot, and as a starting point for the 3D camera setup.

STEP TWO: INITIAL 3D CAMERA SETUP

A 3D camera setup follows the steps of a 2D setup. You start by choosing your camera axis and composing your picture. When the lens and camera position are set for the shot, you do your stereo setup.

Start by setting the interaxial distance to generate the needed amount of paral-lax, according to the depth direction found in the script and the depth budget. If you are shooting parallel, the whole depth bracket will show up in front of the screen. If you decide to set a camera convergence, do so physically on the rig. If not, virtually converge the optical axis by digitally shifting the images in your on-set 3D monitoring system.

You have now defined your depth bracket with the interaxial distance, and your depth position via the convergence. It is time to check the depth quality on your large screen. Many a camera crew does not bother going through this additional step of finessing. While the resulting 3D may be technically correct, it would not be artistically optimized.

STEP THREE: VISUALLY EVALUATING 3D VOLUMES

Run to your makeshift 3D theater in the basement or in the parking lot and look at your 3D picture. Check once again for the maximum positive and nega-tive parallax. If they are out of the depth bracket allotted to the shot, get back to the camera and correct it.

When the near and far parallaxes are correct, it is time to check on the round-ness factor, or the shape realism of your 3D picture. The method explained here was crafted at Disney Animation, during work on *Meet the Robinsons*.

1. Close one eye and look at the screen.
2. Look at the object you want use to evaluate your 3D settings.
3. Imagine it in 3D and see the volume it would occupy if it were 3D.
4. Open your other eye and see how much depth it actually has in 3D.
5. The ratio between the volume at 3 and 4 is your roundness factor.

Don't expect to get a roundness factor of 1 on each and every shot. To begin with, it's not a given that you can reach it within the average depth budget. It's not a must, either, for two reasons. Stereoscopic depth perception forgives a lot of flatness before starting to complain, and you may even not want to present a perfect, happy, round, and smooth world. The roundness factor is part of the artistic palette in stereography. Flattening the characters has an emotional impact and can be used as a statement of their inner feelings. If you want to adjust the roundness factor, go to Step Four.

STEP FOUR: FINESSING DEPTH EFFECTS

Fine-tune the depth bracket by increasing or reducing the interocular distance, and readjust the depth position as needed. If your overall 3D is okay, but objects look flat, you know your roundness factor is too low. Fine-tuning it is more complex. You need to increase your interocular without pushing the background farther away. The only way to do so is to increase your field of view, so that the gain in stereo base is compensated by the reduction in apparent size. Because you probably don't want to change the apparent size of your main subject, you need to get a shorter lens, push the camera closer to your subject, and increase the interocular distance.

Table 7.2

Roundness Factor	Effect	Correction toward roundness factor of 1
>1	Exaggerated volumes	Reduce interocular distance, get a longer lens, move camera backward
1	Orthostereoscopic condition, with perfectly shaped volumes	N/A
0.7 to 1	Generally not discernible from orthostereoscopy	Not necessary
0.5 to 0.7	Sensible flattening of the objects	Increase interocular distance, get a shorter lens, move camera forward
0.3 to 0.5	Very sensible flattening, risk of conflicting depth cues	Change the scene composition or use dual rig special effect
0 to 0.2	Very cardboarded scene, like 2D layers overlapping each other	Change the scene composition, use dual rig special effect or consider 3D conversion.
0	Flat movie	Take a break, have a coffee, and check your equipment

Animating the 3D effect

On animated shots, when the focal length or the subject distance changes greatly, the 3D setup should follow the action.

ANIMATING THE CONVERGENCE

Convergence evolution along a shot, including H.I.T. post convergence, is more common than dynamic interaxial. It still is a delicate tool to use because it will shift the whole world along the Z axis. We will see in Chapter 10 how it is used in postproduction to smooth jump cuts.

There are two main classes of convergence animation: for live 3D and for feature movies. On live 3D, like sports events or wildlife documentary, a convergence puller who follows the action will handle convergence, just like a focus puller. On some rigs, the two functions are linked and the focus follows the convergence. On a feature production, the camera will most likely be set to shoot parallel for later convergence in post. In that case, a slight overscan should be arranged, because the image will be magnified, horizontally shifted, and then cropped. Because the correction will never exceed twice the native parallax of the screen, its maximum can be precalculated.

ANIMATING THE INTERAXIAL

Shots with a static universe and camera position do not require any dynamic adjustment of the interocular distance. Only complex shots with important camera movements will need it. Because the interocular distance has a scaling effect on the perceived size of objects, it may need to be synchronized with some dolly or zoom progression, or it may not blend in and may be noticed. Used alone, its magnification effect on the volumes will be felt and should only be applied with an artistic intent.

Some basic 3D rigs have a roughly adjustable interaxial that is not suitable for dynamic adjustment during a shot, whereas high-end rigs have motorized controls that can be slaved to a motion control system for complex shots.

KEY POSITIONS AND VELOCITY

When rehearsing a complex camera movement, the 3D setup should be repeated at every key camera or actor position. Animating the interaxial and convergence between the key positions will generate smooth 3D. If a shot opens on a wide landscape and pans down to a close-up, the interocular and convergence point should be animated. If the camera movement starts and stops during the shot, the 3D setup velocity should follow the camera velocity, or it will generate noticeable discontinuity in the perceived depth and volumes.

Recap

- The fixed parameters are
 1. the camera sensor size
- As in 2D, you control
 2. the distance between the foreground and the background

CAMERA SETUP RECAP

PARAMETERS: FIXED
2D
3D

1 Camera
2 Location
3 Screen
4 Camera Position
5 Lens
6 Inter Ocular
7 Convergence

RESULTS

A: Depth Bracket
B: Depth Position
C: Roundness

UNKNOWN:
VIEWER POSITION...

FIGURE 7.8
3D camera setup.

3. the screen size
4. the distance to the foreground
5. the focal lens
- You also control these 3D-specific parameters
 6. the interocular distance
 7. the convergence
- As a result, you will have
 - A depth bracket
 - the virtual foreground-to-background distance
 - generated by the interocular distance
 - B depth position
 - the depth bracket placement along the Z axis of the comfort zone
 - generated by the convergence
 - C roundness
 - the apparent volume of objects
 - generated by the focal length

Key Points

3D Do's

THE MAIN RULE TO GET GOOD 3D IS TO GET A PERFECT PAIR
OF 2D IMAGES

- Always check the picture; look at the 3D as much as possible, on as large a screen as possible.
- Always remember you are shooting for specific screen size, and your field monitor is not that big.
- Always check the equipment; because you're using double equipment, you double the risk of equipment failures and triple the risk of human error.
- Always enforce file naming, glue left and right tape boxes together, write "left" and "right" on hard drives.
- Always use the lowest compression factor to record your movie, as 3D prefers a low resolution than a high compression.
- Always get some "safety area" on the edges of the frame, you'll need it for H.I.T, rotation, and zoom corrections.
- Always get as much light as possible, unless you are breaking a 3D rule, and need to hide it.

3D Don'ts

THE MAIN RULE TO ENFORCE IS "DO NOT HARM" AND THIS
INCLUDES:

- Do not go against 2D depth cues, especially motion depth cues.
- Do not create too strong a 3D effect.
- Do not push the background too far away.

- Do not create "stereoscopic window violations," keep the action behind the screen edges.
- Do not create highly contrasted images in the high parallax distances, they will generate ghosting.

REMEMBER TO STAY AWAY FROM 2D TRICKS THAT MAY DAMAGE YOUR 3D IMAGES

- Do not let your cameras automatically figure out the light, focus, color temperature, etc.
- Do not use any fake perspective trick that worked in 2D.
- Do not shoot with long lenses.
- Do not zoom in and out unless you animate the interocular distance.
- Do not use your actors or props to "frame" the picture, keep the over-the-shoulder and two-shots inside the frame.

CHAPTER 8
CGI and VFX

Stereographers who used to work with classical cameras and projectors state that the film-based 3D production and exhibition could be flawless if properly handled. According to them, stereoscopic digital postproduction is the only root cause of the 3D renaissance, leveraging CGI animation, 2D/3D conversion, and in-depth compositing.

And they may be right, because digital stereoscopic postproduction, through post prepping, is the magic Pandora's box that makes perfect 3D a reachable goal to most crews, not just the few geniuses who do not make a single mistake in a whole movie production cycle.

Before you jump into that land of milk and honey, listen to the experts in the field:

"Stereoscopic visual effect? It's twice the amount of work for half the money."

—3D VFX guru Tim Sassoon

This chapter benefited from the advice of Rob Engle, VFX supervisor and senior stereographer with Sony Pictures Imageworks, Tim Sassoon, CEO of Sassoon Film Design, and Kommer Kleijn, stereographer of *Haunted Castle* and *Devil's Mine—The Return*. We would like to thank them for sharing with us their tremendous knowledge on the subject.

MAKING 3D IN 3D: STEREOSCOPIC COMPUTER-GENERATED IMAGES

Following the release of *Toy Story*, we have seen a massive shift from hand-drawn pictures to 3D modeling and rendering techniques in animation studios. In a 3D animation movie, all the scenes and actors are already computer

FIGURE 8.1
Stereoscopic features are now part of visual effects packages.

models evolving in a 3D world, and the camera is just another set of numbers among others. Duplicating that camera is a very easy move that will provide you with stereoscopic images. This procedure was actually patented by IMAX Corporation in 2002 after they used it to repurpose CG contents in 3D for *Cyberworld* in 2000.

Virtual camera rig: Specifics and benefits

None of the defaults of real-world 3D rigs affect their virtual counterparts. The interocular and convergence animation is perfect, they suffer no physical limits, and they opened the path to new visual effects, like multirigging shots. We'll present three levels of virtual rig complexity, two built as 3D models and one scripted.

ORTHOSTEREOSCOPIC RIG

Before venturing into complex CG camerawork, you can make an extremely simple setup that will generate foolproof orthostereoscopic images. Rather than scaling the camera to fit the scene in the theater, do the opposite. Knowing the metrics of your screen and the theater room, or the monitor on your desktop, replicate them in a 3D model and squeeze the scene in the camera's field of view.

1. Create a wall and dig out a rectangle the exact size of the screen, 20 inches diagonal or 30 feet wide.

2. Place two cameras at the average viewing distance, another 20 inches or 30 feet away.
3. Set the interocular to the average human distance, 2.5 inches.
4. Set the field of view to match the screen window in the wall.
5. Converge cameras on the screen plane.
6. Scale your models so that they fit in the cameras' frustums.
7. Remember to stay inside the comfort zone.

You have replicated human vision and created an orthostereoscopic condition that will generate immersive stereoscopic images. Objects will appear sized exactly as they are in the CG models, scaled to the screen width, with a perfect roundness factor of 1:1. If you want to animate the rig, you can move it around the scene and scale it proportionally, to the effect of actually scaling the displayed models.

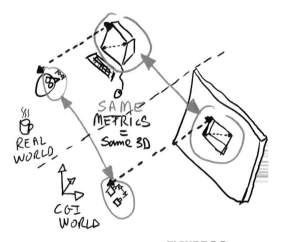

FIGURE 8.2
The orthostereoscopic rig reproduces the human frustum for a specific display geometry.

A SIMPLE CG CAMERA RIG: THE STICK RIG

You can create a 3D rig with no programming knowledge, using only a 3D modeler. Here's how:

1. Create a cube, then elongate it symmetrically along the X-axis into a long stick.
2. Create one camera, looking along the Z-axis, and attach it at one end of the stick.
3. Duplicate the camera and attach the duplicate at the other end of the stick.

You're done: the stick is your rig. Remember to always animate the movement and the size of the stick, not the cameras. Do not rotate the cameras; always rotate the stick around its pivot point. This will maintain proper alignment and geometry. The creation of the second camera as a duplicate of the original should have linked the optical parameters like focal length and distance.

You will most likely keep your camera parallel and use horizontal image translation (HIT) convergence in post. In order to have faster preview, you may want to create a second right camera and attach its aiming point to the left one. This will provide you with an automatically converged camera for rapid 3D control, if you place the aiming point at the desired screen plane distance.

The other potential improvement of the stick-rig method is to make it an inverted T with the proportions $Z = 30 \times X$. When first setting your shots, resize the whole rig to make it reach the first foreground object. This will automatically generate an interocular of 3 percent as per the rule of thumb of stereography. When attaching the stick, keep the rig's pivot point at its original position, $Z = 0$.

Variants can be built using pyramidal objects, replicating the camera frustums and retinal rivalry zones. The main point is to remember the following.

1. Create them according to the 3 percent rule.
2. Adapt that 3 percent rule to the camera's focal length and final screen size.
3. Set the interocular by resizing in XYZ proportional mode.
4. Make them invisible to the render and camera view ports.

FIGURE 8.3
Stick rigs: Simple, T shaped and with a preview camera.

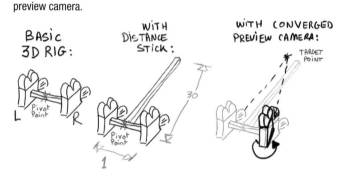

A COMPLEX CG CAMERA RIG: THE SCRIPT RIG

In the mathematical realm of programmable computer models, it is tempting to create a 3D rig that takes care of itself and provides you with the result you want, bypassing most of the guessing games of 3D setups. Such rigs are called result-driven rigs and are widely used in animation studios. They are controlled on three planes—near, far, and screen—all perpendicular to the camera axis. The user places the near and far planes on the closest and farthest object seen by the camera, and sets near and far parallax values. The rig computes the interocular distance, the convergence angle (most likely applied via image plane shift), and the position of the screen plane.

If you don't want to program your script-rig yourself, you can get it from companies selling it for various 3D packages.

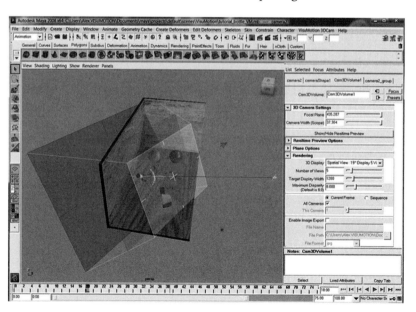

FIGURE 8.4
A result-driven 3D rig with visible near and far planes.

Live 3D previews

If you jumped directly from the foreword into this chapter, you may have escaped one of our regularly repeated mantras of 3D "You can't make good 3D without looking at your work in 3D." This applies to CG layout and animation, even if the modeling can be done in 2D, as artists excel in extracting 3D cues from cameras orbiting around the scene. You would immediately feel the need for real 3D viewing, and we'll see what tools it needs.

HOW TO SEE 3D IN YOUR MODELER

Up to the 2009 release of Maya, there was no built-in 3D viewer in any major 3D modeler. In order to see the 3D, you had to devise a makeshift solution. The easiest to implement was to put two camera view ports in a side-by-side layout and free-view them. This provided minimum feedback, but it was impossible to free view and modify a layout at the same time. Once again, the anaglyph is the most affordable solution, at a price of slowing the software rendering and mixing the camera views. Louis Marcoux has a full set of videos explaining how to create an anaglyph preview in Max on its web site.

Weblink
Louis Marcoux videos
www.louismarcoux.com

The native stereoscopic view port in Maya 2009 brings hardware acceleration, along with various flavors of 3D, and allows for full-color and full-motion live 3D preview.

FIGURE 8.5
Autodesk Maya 2009 includes a 3D camera module.

ENHANCE 3D PREVIEWS WITH ADAPTED TEXTURING

By default, CG previews are rendered with a top-left light, shed on objects textured with flat, neutral gray. This will unfortunately greatly reduce the efficiency of binocular depth cues, as only the objects' edges will be identified in depth.

In order to generate stereo-optimized previews, you will have to do the following.

1. Use some sort of procedural texture as a default material for the objects.
2. Use a checkerboard for the sky, the backdrops, and the topographic elements like the ground, hills, and mountains.
3. Make the procedural textures and checkerboard light gray and dark gray to reduce ghosting
4. Adapt the texture's tile size for faraway objects, like buildings and planets
5. Even better, make your procedural texture a function of the camera distance

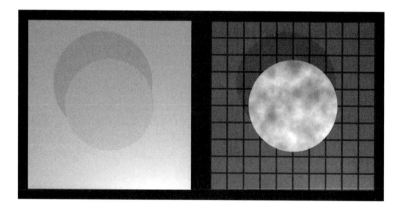

FIGURE 8.6
Stereoscopsis requires some texturing for comfortable 3D reading of the scene.

Advanced Techniques

ANIMATING THE CAMERA RIG

Long shots and complex camera movement are common in CG animation. They will most likely require some sort of interocular and convergence animation. The cleaner the camera track, the better, for you will want to animate the stereo parameters at the camera motion key frames. In almost all shots, if you set good stereo parameters at the camera motion key frames, the interpolation will generate a clean stereography. Remember to match the type of key (Bézier, NURBS, Flat, etc.) and the in-and-out velocity.

If the camera does not move, but the action does and affects the stereo, you will set up the shot for the "worse" frame, the one with the minimum interocular. Otherwise, animating the stereography when the camera is fixed will generate inappropriate sizing artifacts.

THE MULTI-RIG TRICK

We have seen that long lenses kill the 3D, and you will most likely encounter one of these telephoto shots with the character's head detached from a blurry background. Beware. The only way you'll get his head round is by rendering it separately, with a huge interocular, and then composite the image with the background. This technique is called multirigging and was intensively used in *Meet the Robinsons* and *Beowulf*. The overall process is relatively complex.

1. Make sure your shot requires a multiple rig by trying the widest interaxial possible.
2. Make sure your shot can be divided into two sets of object with depth discontinuity.
 - You need a clearly identifiable foreground and background and a gap between them.
 - A single character isolated from a landscape is okay for multirigging.
 - A scene of a crowd scattered along the depth bracket will not be okay.
3. Divide your shot's depth budget in three: the foreground, the background and the gap.
4. Select the objects that will be part of the foreground.
5. Make the back part of the scene invisible.
6. Set up the front camera rig according to the front depth budget.

ex 1: Linear

ex 2: Complex

USE THE SAME KEYS AT THE SAME FRAMES

KEY FRAMING YOUR 3D CGI CAMERA

FIGURE 8.7
Examples of 3D camera animation tracks.

FIGURE 8.8
A dual-rig configuration, with the simulation of the single- and dual-rig renders.

7. Render the foreground with the alpha channel.
8. Isolate the objects that will be part of the background.
9. Make the front part of the scene invisible.
10. Set up the back camera rig according to the back depth budget.
11. Render the background.
12. Composite front and back, placing them at appropriate depths.
13. Adjust the gap between them to make the scene look coherent.

Rendering stereoscopic CG

Rendering for stereoscopy requires a few tweaks beyond computing two views. You will need to do the following.

1. Render wider than your final image format to accommodate the HIT convergence.
2. Optimize the renderer for stereoscopic efficiency.
3. Record the Z buffer as a depth map for all produced images.
4. Take care of a couple of details, like mirrors and reflections.

RENDER WIDER IMAGES FOR HIT CONVERGENCE

Even if you render converged stereo or use shifting lenses, you will have to adjust the depth placement later in the production. For this effect you'll need additional pixels on each side, approximately the size of your screen native parallax. Modify your rendering parameters to get the following:

> **Rendered Image Width = Final Resolution**
> **+ 2 × Screen Native Parallax**

FIGURE 8.9
On an HDTV rendering for a theater screen, the HIT over-rendering requires 14 pixels on both sides. Final image size is 1948 by 1080.

OPTIMIZE THE RENDERING FOR STEREOSCOPY

A few years ago, you had no choice but to render twice and composite the images together, with a time-to cost ratio slightly above 2. Object movements, light and shadow casting, and particle and physics simulations are time-consuming processes that should not be computed twice. Just by grouping the two cameras inside a single rendering task, you can compute the scene only once per frame. For example, *RenderMan*® has had a stereoscopic rendering mode in its Pro Server version 13.5 since 2007. These implementations can bring down the 3D versus 2D rendering time to 1.3 or even 1.1. Because multiple camera rendering isn't exclusively a stereoscopic feature, many a renderer will offer this function.

GET THE Z BUFFER AND KEEP IT AS A DEPTH MAP

Every time you create a CG image, the render produces and trashes a depth map of some sort, sometimes under the name of Z Buffer. You will soon see in

the compositing chapter how much you need this information later in your stereoscopic production. Think of it as the alpha channel of 3D. Imagine what would happen to a render wrangler who said, "That alpha thing? I trashed it to make some room on the disks." You get an idea of how much you will need the Z information, how much you should care for it, and how you should keep it available for the compositing.

You can save the Z information as an independent file, or along with RGBA layers in a complex Tiff or DPX file. Remember to document the presence of the Z channel explicitly because this is not yet a fully standardized procedure in VFX.

MIRRORS AND REFLECTIONS

For an unexplained and intriguing reason, most people in CG consider reflections to be flat images. Unfortunately, that's not the case, and if you doubt it, get a mirror, bring it close to you, and look at a faraway object. If it's not yet obvious, alternate looking at your fingers in the glass and at that distant object and pay attention to how your visual system accommodates and converges.

In stereoscopy, if a reflection is not treated as a 3D image, it will be seen as a flat animated picture—like a TV screen, not like a mirror. If the reflection may be looked at by the audience, pay attention at the position of the virtual image beyond the mirror plane. It should stay closer than the far screen distance and within a parallax not wider than the divergence limit.

In most cases, reflections on convex and concave surfaces like cars and glasses can be rendered as flat, for we do not really read off them in our everyday life, as they generate false depth cues. The case of flat glossy surfaces, like marble floors or lacquer painted furniture, is different, as we are used to reading them as 3D reflections, differently than 2D light refractions.

Commercial products

As of fall 2008, Autodesk, with Maya, 3ds Max, and the recent acquisition of XSI, was the leading, if not the sole, provider of 3D animation tools, and the 2009 releases of Maya, Toxik, and Luster include stereoscopic tools.

Maya 2009 includes some elements of the stereoscopic camera and OpenGL "stereo-in-a-window" modules that have been developed over the years in collaboration with 3D animation studios, mostly Sony Pictures Imageworks, Disney Feature Animation, and DreamWorks. Unfortunately, the result-driven camera that the studio 3D supervisors have shown us at conferences is not yet part of the code included in the public release. A very versatile scripted camera that includes all the parameters you may need, like convergence, image plane

translation and interocular, replaces it. You can get a personal learning edition version of Maya on the Autodesk web site.

On the DVD that comes with this book you will find movies and scripts from Louis Marcoux of Autodesk that bring a lot of 3D functions to Max.

COMPOSITING 3D IMAGES

With the existing compositing solutions, artists have no choice but to composite both eyes and assemble them in a 3D-viewable mode. The main objective is to be able to create, control, and relate both the 2D and 3D in real time.

In the near future, 3D-dedicated compositing packages, using depth maps and 3D layouts and cameras, will make 3D compositing much simpler.

Theory of stereoscopic compositing

In 3D compositing you will face three new challenges:

1. Quantity: Shot prepping makes virtually every 3D shot an FX shot.
2. Quality: Binocular vision requires higher 3D coherency of the compositions.
3. Complexity: Every stereoscopic FX involves two 2D and one 3D compositings.

SHOT PREPPING, OR 3D PERFECTION FOR ALL

The second mantra of 3D says, "There's no 3D but perfect 3D." Because perfection does not exist on set, we have to groom pristine pictures in post. Motion picture prepping is an extension of the 3D stills alignment you have been learning and practicing in Chapter 4.

Fixing convergence

The most-used stereo shot fix is to reconverge the images using HIT. A shot with a single camera position will be fixed once and for all, just like a still picture. If the action comes so close to the screen that it breaks the stereoscopic window, you will have to push the whole depth bracket in deeper, or float the stereoscopic window. Even if the camera position is animated, it's worth trying to make a single correction on the whole shot. If it does not work, or if the camera position and the interocular distance were both animated, you will have to select key frames. Correct the image geometry at these key frames, and let the software interpolate the correction for the whole shot. Typically, key frames are the ones with extreme camera positions and maximum parallax.

Most simple vertical parallax can be fixed at once, along with the depth placement, unless it is part of a more complex system of disparities generated by the imperfections of the 3D camera rig.

Fixing camera rig imperfections

Typical imperfections, especially with prosumer cameras, include exposure and color, which can be easily fixed in post. Don't wait for final grading to fix

this because you will be in trouble with FX shots that mix correct and incorrect color matching. Another typical imperfection is asynchronous images, which can sometimes be fixed with retiming effects.

If your image is rotated, keystoned, or shows spherical deformations, you will need to perform complex corrections. StereoPhoto Maker includes an automatic correction mode that uses the SWIFT algorithm under a noncommercial usage license. It can give you a lot of information on the actual optical condition of the shot. In most cases, the correction can be applied to the whole shot.

If you run into a complex set of corrections, you should try to fix it using simple track points to keep the left and right views together.

Using track points to fix shots

Track points are extremely powerful tools for 3D correction. They are so powerful that they can ruin the 3D effect if they are not used appropriately. The use of unmatched zooms, especially, will require finessing the correction settings at every other frame, and the use of tracking points may be a better solution. As for any tracking job, half the magic is in the choice of the points and the other half is in the accuracy of the computation.

- A one-point track will correct vertical alignment and keep that point in the screen plane.
- A two-point track can correct vertical disparities and rotations, and keep one point in the screen plane.
- A two-points track with resizing will also correct zoom discrepancies, if the two points are in the same depth plane.
- A three-point track will also correct keystoning. The points have to be in the same depth plane.

GLOBAL OR LOCAL, SYMMETRIC OR ASYMMETRIC, ABSOLUTE OR RELATIVE 3D SETTINGS

Setting up effects in 3D may affect one or two eyes in many different ways. Horizontal translation is a perfect example, because you may want to

- move both eyes absolutely, to place the picture somewhere in the screen frame
- move only one eye, to adjust the depth placement
- move both eyes relatively, to move the 3D image to the left, keeping the same depth placement
- move both eyes in opposite direction, to adjust depth placement, equally affecting both eyes

The same set of options will occur in color correction and most effects controls. When setting up an effect, and especially when writing automatization scripts, you should ask yourself if the modifications will affect one or two eyes, and if

it affects two eyes, does it affect them absolutely or relatively and in the same direction or in opposite directions.

COMPOSITING A COHERENT 3D SPACE IN STEREOSCOPIC FX

Compositing a shot in 2D includes matching the color, grain, and dynamic of the layers, plus making them "optically coherent." They should seem to have been shot with the same camera lens and position. This is why we track and motion-control FX shots. In 3D, you will have to repeat this matching twice, and the audience will have the most perfect tool to check the quality of your job: stereoscopic vision. Not only is 3D compositing twice as complex, it should also be 10 times as precise as 2D. In *Journey to the Center of the Earth*, the compositing team sometimes had to nudge layers a quarter of a pixel on a 2 K frame to stick actors on the CG ground.

As 3D guru Tim Sassoon explains, "In visual effects, we sometimes use optical flow algorithms. You need to understand that this is only accurate to a few pixels. On a 2 K digital cinema screen, four pixels are a couple feet out of the screen, and on large format, like IMAX 3D, it sometimes is half the distance to infinity. As a result, subpixel precision is more that the norm in 3D, it's a must."

For all these reasons, real 3D effects, rather than tweaked 2D effects, are more effective and will eventually yield a better quality-to-cost ratio, despite the additional complexity of stereoscopic camera tracking.

Camera Tracking in 3D

High-quality camera tracking in 3D is a very complex task that we will introduce here by listing the challenges.

1. You need to track not one but two cameras.
2. Cross-camera tracking accuracy is key to 3D perception.
3. The cameras are mounted on a three-axes dynamic control.
4. The relative position of the two cameras changes on purpose.
5. The relative position of the two cameras changes accidentally.
6. The relative position of the two cameras changes in post.
7. Removing track targets from plates generates depth artifacts.

Green screening and rotoscoping in 3D

Setting the threshold and spilling control in a green screen effect will change the alpha mask, up to a few pixels expansion for blurry edges. And the words "edges" and "expansion" should ring a warning bell in a stereo FX artist's mind. Any edge shift, even at the subpixel level, could potentially be detected in stereoscopic cinema.

The same is true with rotoscoping. When you replicate a mask from one eye to another, the cutout is in the screen plane and should be adapted to the edges of the object on the second eye. That adaptation will eventually place the cutout piece in depth, and should be done by stereoscopically aware artists working on 3D stations.

Other 2D-based effects

Basically, you can't go wrong if you assume that any 2D effect is a hazard in 3D. There's no point listing them here, for their implementation and use will render any listing useless or obsolete. The only advice we can provide you with is to always check for depth artifacts at the first use of an effect in 3D. As an example, effects that include some sort of randomization will generate dusty eye rivalry that shows up as a brushed glass effect in the screen plane. In most cases, using the depth map as a modulator or as a displacement map applied to the effect fixes the issue, because it projects the effect onto the objects' surfaces.

THE MAGIC DEPTH MAP

The depth map is to 3D compositing what the alpha channel is to 2D: the cornerstone of undetectable image mixing, nice-looking effects, and efficient workflows.

What is the depth map?

The depth map is an image in which each point is assigned a value describing its distance to the camera. The depth map will typically be shown in gray levels, the lighter the gray, the closer to the camera. In CG slang it may be referred to as the Z buffer. In stereoscopy it is sometimes called a correspondence map or disparities map because it describes the distance, in X coordinates, from one point to its homologous point on the other view. Homologous points are the two pixels showing the same object detail on the left and right views; they will typically have the same RGB values and the same Y coordinate, but different X positions.

FIGURE 8.10
Image and its depth map.
Image courtesy of Philips.

Depth maps computed from actual stereoscopic footage will have two components, the X and Y because the image will most likely include some sort of vertical disparity. They may even have a Z component, in a perfectly 3D-reconstructed scene using complex coplanar geometry computation.

How to get or make a depth map

Getting a depth map from CG animation is easy, and we have seen that it should be a must-have. For real images, it has to be computed or created. The video compression, motion blurs, and retiming effects are among the biggest

users of depth maps, where they are computed against time, not viewpoints, and are called "motion vector maps." This is called optical flow computation or full-frame tracking and delivers imperfect results. Smoothing the results or reducing the map to half or quarter resolution hides the computational errors. Retiming and motion estimation software can be used and optimized, like in the stereoscopic Ocula plug-ins for Nuke. It is the only product we have seen that increases reconstruction precision by consolidating motion vector computation in both time and in space.

FIGURE 8.11
The Foundry's Ocula plug-ins for Nuke include a powerful optical flow tool to automate 3D processing.

If you need the highest-quality depth maps, the solution is to create them, as explained in the third and last section of this chapter.

Depth map resolution and precision

In most cases, like simple effects tweaking, the image resolution of the depth map can be much lower than the 2D picture, unless you are doing a full 3D conversion. The question of the precision and accuracy of the depth value is more complex.

Most depth maps are 8-bit bitmaps, without absolute reference. They only describe relative depth inside the picture, offer no absolute reference, and are usually linear. Their 256 values will typically encode $+/-30$ pixels parallax with a quarter-pixel resolution, and a half-pixel resolution for -120 to $+30$ pixels, providing just enough precision for most simple 3D effects at 2 K. You will need a depth look-up table (LUT) to get absolute values of on-screen parallax or on-set distance to camera. If you want to have accurate depth positioning, especially in the background, you will need more than 8-bit integer precision. Because 16-bit, 32-bit, or floating-point depth maps and depth LUT are not yet standard in the commercial tools, you will have to write your own

tools and converters. Here again, it is very important to document your work and make the data description travel along with your images. The guys at the compositing stations will need it.

Each camera has its depth map

You could believe that, if a depth map described a scene, a single depth map could be adapted, if not directly used, for points of view close enough to each other. This is false—each camera position needs to have its own depth map. The left depth map describes the left-to-right projection but does not describe perfectly the right-to-left reverse operation. For the same reason, every modification of the view, like geometry correction in the shot-prepping phase, should be applied to the depth map. If you have a doubt about the depth map relationship to its linked image, think of it as a sort of alpha channel.

Using the depth map in FX settings

The depth map is the cornerstone of 3D effects systematization. Because it's a correspondence map, it can be used to automatically translate effects parameters from one eye to the other. Apply the correspondence values to the handles of a cropping mask, and you will have the homologous mask cutting out the object on the other eye.

Depth map, view synthesis, and roundness factor

Because the depth map describes the on-screen parallax, it can be used to easily generate new points of view. Use a depth map as an X-only displacement map and you will generate new points of view. The effect slider will act as a virtual interocular controller. On one hand, the effect is crude, generates imperfect images, and has a limited range. On the other hand, it is a cheap and fast process that can be perfected with additional work. Use a nonlinear LUT on the depth map, just by giving it a gamma boost, and you will change the depth volumes of objects. Reassigning the 8-bit space of a depth map histogram will synthesize dual-rig effects on preexisting 3D.

How accurate should a depth map be?

When consulting on 3D projects, and needing to keep all available depth information as maps, we are often told that the resultant data will be of poor quality due to computational limitations, or incomplete renders or subsequent effects not shown on the map. The answer is "There's no bad depth information, but the one you don't have." Always record and keep it. You will be surprised how resilient to low quality it may be.

Methods: How to compose 3D with 2D tools

There are a few 3D-dedicated post tools, but they lack the efficiency and versatility of big post suites. In most cases, you will be better off using 2D tools with some tricks and tweaks to make them 3D capable. Basically, you need to be able to process and see in real time the effects for which you did setup on both eyes.

The tasks to perform are as follows.

1. Set up the left and right 2D compositions.
2. Assemble them in a 3D stereoscopic composition.
3. Finesse the effects in 2D and the 3D layout at once.

STEP ONE: SET UP THE TWO 2D COMPOSITIONS

The left and right trains have to be processed independently, by replicating the setups from one eye to the other, and in most cases adapting them.

Option A: Duplicate two 2D compositings

There's no easy solution to processing two sets of pictures, beyond setting two jobs. With node-based compositing software like Combustion, Shake, Nuke, or Fusion, you can duplicate the three into left and right branches atop a 3D viewing trunk. On timeline compositing software like After Effects, the left and right compositions are assembled into a third stereoscopic one.

The basic method is as follows.

1. Set the left-eye composition with all the elements and effects.
2. Duplicate the left composition into the right.
3. Replace all the left assets by right assets.
4. Adapt all the effects settings.

Step One is a regular compositing task that can be done in 2D by an assistant TD. Step Two can be scripted to perform Step Three automatically, based on the file naming convention. A typical script will run through the asset list and search for *.Left.* or *.L.* in string names and replace them with right equivalents.

Another way to do Step Three is to create compositions that include both left and right assets, and to write expressions that control object opacity or effect activity. The expression hides or disables the layers upon correspondence with the composition name. Such compositions can be replicated and renamed, or rendered twice with a side-explicit render name.

Step Four is the most difficult, because it goes beyond technical work and infringes on artistic creation. Some adaptations are obvious, like reversing the direction of displacement maps or setting the color channels in an anaglyph preview. More complex adaptations will use the depth maps to affect the masks and power windows of the effects.

Option B: Stack the images together

Sometimes you may not want to run duplicated processing. Your option is to stack images, in side-by-side or above-under format. The benefit of such a system is its simplicity to implement. The limitation comes from the spilling occurring along the stitched edge, typically with blur, or any area-based effect. To avoid the spilling, or reduce its effects, you can flip one image along its axis, parallel to the stitched edge. Note that it may slightly increase the complexity of automation scripts. Another option is to create an empty gap between the images.

FIGURE 8.12
Stacked 3D images sim-
plify 3D compositing.

FIGURE 8.13
Flipped 3D images
reduce cross-eye
spilling.

FIGURE 8.14
Frantic Films Software presented its Awake plug-in for Fusion at the NAB 2008. They used stacking and unstacking nodes to process 3D images in a 2D pipeline.

TECHNICAL TIP

One of the unexpected drawbacks of image stacking relies in the often-undocumented 2 K limit in desktop computing. Personal-computer engineering relies on hardware and software designs that were either beefed-up from consumer equipment, like the GPUs, or cloned from 1980s-era workstations, like the 32-bit operating systems and memory models. In both of these domains, nobody ever seriously thought that an image would be anywhere bigger than 2048 by 2048 pixels. After all, that's more than twice the pixel count of HDTV. You will find this 2 K limit in many places, like OpenGL texture size or video decoding acceleration. Breaking this barrier will force the system to fall back to software only, and sometimes cause it to hit bottlenecks in memory access or driver design. If you try to stack two HDTV images, you would either get a width of 3640 pixels or a height of 2080 pixels—both out of the 2 K limit. If you experience unexpected resource hogs in your image processing when going into full-resolution renders, give a try at reducing the stacked image size to less than 2048 pixels, and check if the velocity increase is consistent. If not, you may have hit the 2 K speed bump.

STEP TWO: FINESSING IN 3D

Once the effects are set up on each eye, in flat view and in full color, the stereoscopic layout must be finessed. The 3D job consists in nudging elements horizontally, and adjusting the edges' positions and sharpness to mix them in

place, which can be done in gray anaglyph. A last final finesse pass will require large, or even full-size, full-color, full-motion screen depth placement.

Creating an anaglyph preview

Generating an anaglyph preview is done by changing the RGB channel affectation. For full color anaglyph, blue and green are shut down on the left eye and red is killed on the right eye. To generate more comfortable gray anaglyph, use luminance to source the RGB channels. Composite the final view by adding the pixel values, sometimes called screen mode. Do not do a 50 percent mix because you'll lose half the dynamic and get a grayed and decontrasted picture.

The Adobe-provided 3D glasses effect is not really useful because it does not take into account any geometry modification of its left and right sources. Rather than getting inside the nested comps to be able to adjust such a simple thing as depth placement, you're better off making your own 3D mixer. This is presented in the compositing examples included in the DVD along with side-aware visibility and depth placement expressions.

Creating full color preview

On a row-interleaved 3D monitor make a comb filter which alternates black and white lines, multiply the pictures, and add them together. This technique can be used with flat screens with Micropol filters and CRT monitors and line-blanking or scan-doubling VGA pass-through. It can be adapted with a checkerboard filter to rear-projection 3DTV. Beware that moving the preview window on the desktop may shift the image and generate inverted stereoscopy.

To use a passive polarization system, like dual layer and beam split monitors or dual projector installations, compose the 3D preview in side-by-side and output in full screen via an electronic screen splitter like the Matrox DualHead2Go.

Dealing with the GUI

Working in 3D and reading the computer's graphic user interface may be a nightmare.

1. Most full-color 3D displays asymmetrically cut the resolution in half, turning texts and buttons into a painful retinal-rivalry extravaganza.
2. Dual projector passive stereo misalignment or digital keystone correction blurs the GUI.
3. Any colors but yellow and purple create rivalry in anaglyph.

You may mitigate the issue with a selected desktop scheme, like using yellow and purple for a red-and-cyan anaglyph, or larger text and buttons for other solutions.

The panacea: OpenGL preview on full 3D

The ultimate goal is to have the stereoscopic display managed at the GPU level, in OpenGL quad-buffered stereo on a Quadro FX graphic card. First, you will experience much better response time than in any 3D software. Second, the OpenGL display is free of most inverted-stereoscopy artifacts that may plague other makeshift real-time 3D viewing. Third, its stereo-in-a-window mode makes it compatible with the software and system GUI. Coupled with a full resolution 3D display, like beam-splitter LCDs or 120Hz active projection, LCD, or plasma, it provides the best 3D working environment.

THE FUTURE: TWO CAMERAS IN A 3D LAYOUT

Compositing packages have long integrated the option to layout the compositions in a real 3D model, with 3D lighting and OpenGL implementation. It is tempting to use such volumetric layout to render stereoscopic effects. If a stereoscopic display is available, this is perfectly fine and very effective as long as you use monoscopic content. If you are using stereoscopic footage in a unique 3D compositing, you need to make sure that each camera sees only its own dedicated eye assets. When you have achieved this, you will have a coherent 3D layout of the many pictures you are mixing. This is the best configuration for 3D quality and productivity. The natively stereoscopic compositing packages yet to be released will rely on such fundamental design.

FIGURE 8.15
In this *Slow Glass* title sequence, an After Effects 3D layout is used with two cameras to render a 3D FX scene. The After Effect project is included in the DVD.

SYNTHETIC 3D: 2D-TO-3D CONVERSIONS

Cheating entered the history of mankind the very day someone invented a game, and fake 3D is just as pervasive as real stereoscopy. While working on vintage 3D pictures of the 1906 San Francisco earthquake, we discovered many a stereoscopic pair that were false. In one stereogram, a building, a fire truck, and some smoky sky had been cut and pasted together. On another, a flat view of the city had been placed in depth and tweaked into a 3D perspective. Besides the fact that we can do this digitally, the technique is the same one century later.

> It really is easy to know when you should use 2D-to-3D conversion. For it cannot cost less than $15K a minute; if you can shoot it for less than that, shoot it in 3D. If not, we'll convert it for you.
>
> —Tim Sassoon

Introduction to 3D conversion

CONCEPT AND USAGE OF 3D CONVERSION

A 3D conversion creates 3D footage out of plain 2D assets by recreating the second eye, or sometimes both views. Its main use was supposedly to repurpose assets, to re-release movies into a new 3D life, like Disney did with *The Nightmare Before Christmas*. Its use has since been extended to salvaging damaged 3D shots and producing heavy VFX shots. And with the massive use of faked optics like dual rigging in stereoscopic animation, 3D conversion is now presented as a solution to multirigging live action footage.

Like most 3D techniques, conversion starts with a cheap entry price and usually ends with a very expensive exit strategy when you reach large projects. You will find many post shops offering it, but the truth is, there are very few teams that do it perfectly and that can actually deliver the real deal of converted images at a given time and price.

A 3D postproduction team needing to convert a couple of shots can improvise a conversion shop and get acceptable results at a reasonable cost. Don't get fooled by this, and do not engage in full-length movie conversion without serious consulting on the subject. As the experts will genuinely tell you, the difficulty is not in the conversion itself but in the management of the project. Exponential complexity killed many a newcomer, leaving a handful of conversion experts in their place.

THE EXPERTS

The best-known conversion shop is In-Three, raised to fame by their work on converting milestone blockbusters like *Star Wars* and *King Kong*. They have devised a conversion pipeline based on proprietary software. Their process, branded Dimensionalization, relies on isolating the most important visual elements in the picture and placing them in depth, warping them around, using a database of 3D shapes or custom-made models. After years of secrecy,

they are now very open to presenting their technology and the work they are doing for Lucasfilm.

The large-format inventor IMAX 3D has always been at the forefront of 3D cinema, with the first re-rendered 3D animation and the first 3D-converted feature movies. They release at least one feature movie a year, with 20 to 40 minutes converted in 3D, like in the IMAX version of *Superman* or *Harry Potter*.

Tim Sassoon, owner of Sassoon Film Design, is recognized as the one of the foremost large format 3D FX experts. In 2007, his company was working on four of the five large format 3D movies slated for release. His most famous work was the special effects on *U2 3D*. He directed the 3D conversion of many IMAX 3D movies, and many 3D plug-ins now integrated in compositing suites were initially created under his roof.

WEBLINKS
In-Three
www.in-three.com
Sassoon Film Design
www.sassoonfilmdesign.com
IMAX
www.imax.com

ABOUT AUTOMATIC CONVERSION

The 2D-to-3D automatic conversion is the Holy Grail of stereoscopy—the most sought-after and the most elusive of all stereoscopic sciences. If you were to find it, every movie studio and every TV station in the world would pay you a substantial fee, and every TV set sold on earth would bear a sticker with your name on it. You would be among the Fortune 500, and have a chance to become *Time*'s "Person of the Year."

Sound tempting? Sure. This is why the graveyard of 3D startups is filled with "3D automatic conversion took his wealth and his mind" tombstones. There is a very good reason for that. The underlying problem with 3D conversion is called image segmentation in scientific circles. It has the very same objective as being able to assign each and every pixel to an identified object in a scene. What is a tree, a car, a person walking by the car, a person sitting in the car, a portrait sticker on the car windshield, and a reflection of the driver's face in the rear window? Quite complex, isn't it?

This segmentation, if it were possible to perform, would allow a computer to drive a car, fly a plane, guard a road, run a factory, and cook your meal. Be assured that all the armies in the world with a scientific program are looking into this. And, so far, nobody has made it, and human pilots still remotely fly the U.S. Air Force drones. Why is that? Because understanding the picture is not a visual process. It's a cognitive process. It involves being able to understand the world and the story behind the picture. Automatic conversion to 3D will be real when your TV set will be able to tell you who the murderer is before the end of the movie. Not quite soon.

Right now there are a couple of 3D conversion set-top boxes, chip sets, and software. As one of the world's top 3DTV R&D executives told us, "They are, at the very best, not too annoying. And not wanting to throw them through the window is quite an achievement."

3D CONVERSION METHODS

There are basically only four methods for creating artificial depth in a picture:

1. Cutting out pieces of the image and nudging them around
2. Using depth maps as displacement maps
3. Projecting an image on a 3D model
4. Turning motion parallax into stereoscopy

FIGURE 8.16
Example of automatic image segmentation for 3D conversion. Image courtesy of In-Three.

The cut and nudge method

Cutting out pieces of the image and pushing them around is the cornerstone of conversion, because it generates parallax and occlusion revelations by the tens of pixels. The depth placement is simply done by moving the front object left or right. It requires a lot of work to perform the frame-by-frame rotoscoping and the inherent background painting.

The step-by-step process is as follows:

1. Cut out the objects that have to be placed in depth.
2. Push the background behind the screen using HIT.
3. Shape the background by skewing or mesh-transforming one eye.
4. Put the objects into their depth positions.
5. Create perspectives by asymmetrically moving the corner handles of the objects.

- This is called horizontal image skewing.
- Reshaping or shape interpolating effects creates complex shapes.
6. Repeat the operation on the next frame.
- Obviously, use interpolation and feature tracking to reduce the workload.
7. Fill in revealed background areas, as explained later.

The depth and displacement map method

Depth maps are the second most powerful 3D conversion tool. They cannot really create any occlusion revelations, but they allow for much finer and complex depth shaping of objects. In most cases, you don't already have a depth map and you have to create one. The easier process is to paint it on a 50-percent opacity layer on top of the original picture. You can create simple volumes with linear and radial gradients. Highlights and shadows are depth cues and you can reuse them as a source for fine depth texture. Adequate use of horizontal blurs will help a lot, too.

The problem in view synthesis quality is more often the pixel computation than the depth map itself. Most displacement maps are pulling pixels. For a given [X, Y] position, they get the Z value and fetch the pixel at the [X + Z, Y] position to be placed at the [X, Y] coordinate. This creates depth artifacts on the edges of objects by pulling the texture of the background over the object shape while, on the other end, the object colors are projected onto the background.

Accurate view synthesis uses push algorithms, where the [X, Y] pixel is sent to the [X + Z, Y] position. If the pull process is inaccurate, the push generates incomplete results, because not all pixels in the computed picture are covered by pixels coming from the source.

$$\text{PUSH displacement: } RGB_{(x, y)} = RGP_{(x+z, y)}$$
$$\text{PUSH displacement: } RGB_{(x+z, y)} = RGP_{(x, y)}$$

The 3D reconstruction and projection method

Rebuilding the 3D geometry of a scene, projecting the original image on it, and rendering other points of view is the most complex and the most powerful of all 3D conversion systems. This is the actual production method for most 3D animation because it reduces the rendering time. It is the most-often-used method for feature movie conversions. Industrial Light and Magic (ILM) modeled in 3D the sets and puppets Tim Burton created for *The Nightmare Before Christmas*. The method is accurate to the point that ILM artists detected and digitally corrected a slight collapse of the sets that occurred during the weeks of the original stop motion shooting in 1993.

The motion parallax method

Turning motion depth cues into stereoscopy is the easiest of all 3D conversions. Every time a director generated depth feeling by moving a camera, he made your day. All you have to do now is to delay one eye or the other to regenerate a second stereoscopic point of view. This conversion process is called the Pulfrich effect, after its inventor, Carl Pulfrich, a researcher at the Carl Zeiss Company.

Because of all the action occurring on screen while the camera moves, this effect is mostly used to convert backgrounds, in coordination with cut and nudge, or to generate depth maps based on motion vectors.

Gap filling and background painting

All the four above-mentioned conversion processes create potential holes in the image, where foreground objects moved away and revealed unknown background. In-painting these areas is a long and fastidious process that is already well known to FX artists. In this case, the difficulty, as usual, comes from comparisons the audience will make between the original and the modified pictures. Because the original picture fills one eye and the modified picture is seen in the other eye, the reconstructed areas are actually used in the depth perception process. Masks should therefore protect the original pixels from being affected by the gap filling. For the same reason, the in-paint stamping should use content from previous and subsequent frames, rather than in-frame cloning. Stamping from the frame itself presents the risk of generating depth artifacts due to repetitive patterns.

Mix and match

As in any FX, whether 2D or 3D, visual or digital, each shot has its specific needs and set of solutions. A typical shot conversion will use at least two, if not all four, of the basic conversion methods.

Shall we recreate one or two eyes?

When converting in 3D, one has the choice to recreate the left eye, the right eye, or both. The choice depends on the shot structure itself.

Here are the reasons for recreating only one eye

 1. The unmodified eye will have pristine resolution, and it usually shows.
 2. It is simpler than recreating two eyes.
 3. There is only one image to paint in.

The reasons for recreating both eyes

 1. The tweaking is evenly affected to both eyes.
 2. The painted areas are half as small, and automatic filling works better
 3. The perspectives are less affected.
 4. The Pulfrich effect is evenly weighted in both directions.

3D CGI

- CGI 3D is the easiest form of 3D.
- CGI 3D is produced with virtual 3D rigs.
 1. Simple rigs use two cameras linked together, with interocular and convergence settings.
 2. Complex rigs provide pixel parallax settings for front and back planes.
- CGI 3D requires adapted view ports with
 1. 3D preview in anaglyph or active stereo
 2. textured preview modes
- Shifting lenses are simulated by
 1. asymmetrically over-rendering left and right images
 2. shifting the image planes in the virtual cameras
- The rendering engine should be adapted to 3D to reduce incremental workload.
 1. Scene layout and physics should not be re-rendered for each camera.
 2. Reflections should be rendered asymmetrically to be seen in depth.
 3. Specular highlights should be rendered symmetrically to avoid retinal rivalry.

3D Compositing

- 3D Compositing is basically asymmetrical 2D compositing of left and right footage.
 1. It requires real-time 3D viewing, on a large screen for final pass.
 2. It uses the depth map as a key element for effects stereo-adaptation.
- The process is:
 1. Set up the effects on one eye.
 2. Replicate and adapt the effect on the second eye.
 3. Finesse the depth settings in a 3D view of the shot.
- Assets can be processed
 1. tiled together in a large stacked 2D image
 2. as two separate image flows
 3. as stereoscopic footage in a few upcoming 3D-capable FX suites
- Classic 2D image processing reveals caveats in 3D
 1. Procedural selections are more adapted to 3D that rotoscoping.
 2. Background in-painting requires 3D-aware brush strokes.
 3. 3D-based atmospheric effects will yield better results than 2D effects.
- Expect to process a lot of 3D shots to fix stereo imperfections.
 1. Most corrections are a simple HIT for depth placement.
 2. Some corrections include vertical translation and rotation.
 3. A few shots may need zoom and keystone corrections.
 4. Severely damaged 3D can be salvaged by a 2D-to-3D conversion.

- 3D match moving is much more complicated than 2D match moving.
 1. Analog readings of interocular, convergence, and focal length are barely accurate enough.
 2. Zoom imperfections generate barrel and pincushion deformations.
 3. Physical limits of rig rigidity yield intercamera shaking.
 4. The same track points should be used in both eyes.

2D-to-3D conversion

- 3D conversion turns 2D footage into 3D by generating the second point of view
 1. is a labor-intensive process that can't really be automated
 2. is more efficient with footage intended to be eventually turned into 3D
 3. should be considered for FX-heavy shots, scenes, or movies
- The four basic processes are:
 1. Turn movement parallax into viewpoint parallax.
 2. Cut and nudge layers.
 3. Use a depth map as a displacement map.
 4. Project the 2D image on a 3D model of the scene.
- Converting is a simple process but a complex project.
 1. Give it a try in your free time. It's fun and easy.
 2. Don't be fooled; converting full scenes or movies is exponentially complex.

CHAPTER 9
Editing 3D

3D editing is the fastest-changing subject in the stereoscopic field. The debate is fierce among directors about the specificities of editing for 3D. It's a hot topic because it's deeply linked with the debate on convergence and the control you have on the audience's sight. We will see how the 3D edit style and pace is a continuation of the 3D photographic style.

While waiting for the market to come up with edit stations designed for 3D movies, you have to edit movies with the current generation of 2D tools. A range of existing makeshift solutions make that possible.

Eventually we will have a look at the effect of 3D images on sound mixes, even if this is a barely explored subject.

THE THEORY OF 3D MOVIE EDITING

Is cutting 3D different from cutting 2D?

The big question about editing 3D is quite simple: Do you cut 3D just like 2D? There has been a long-lasting consensus that 3D should be cut its own way. *Which* way was not really defined beyond being at a slower pace than 2D, considering that 3D images are more complex to process visually. Not only is 3D reading time longer, but the audience tends to scan the whole scene before going back to the subject. The detractors of such an approach believe that the technique should not influence the art, that it's the DP's job to make images that match the script's intended rhythm, and that converged stereo with shallow focus reads just as fast as 2D. We see here that this debate on editing style was most likely decided one way or the other when the picture was shot. You will either adapt the edit to the depth or adapt the depth to the edit.

We would like to emphasize that the debate is still very open, and most of the debaters have made mostly short, large-format 3D movies, with either scientific or amusement purposes. You can hardly debate drama edit conventions based on theme-park rides or documentaries about the octopus's life. Since the 1950s golden age of 3D, the edit culture has shifted from classical settings to the so-called

MTV generation, where two frames make a shot and two shots make a scene. Today's teenagers definitively do not read pictures in the way that most movie executives do. As another element to the debate, we would like to mention that most 3D movies we have seen in digital 3D for the last few years were 2D projects that have been upgraded to 3D very late in their creation cycle, sometimes even weeks, if not years, after the 2D movie was finished. Under such circumstances, it is really hard to have an honestly definitive opinion on 3D editing.

OPTION 1: EDIT RULES, AND 3D FOLLOWS

Under this approach, the 3D-ness of its images is not considered a major characteristic of the movie. It is edited, most likely in 2D the same way a 2D movie is. At some point, the 3D version is generated and checked on a 3D screen. It's up to the stereoscopic artist working on the 3D version of the edit to make sure the depth continuity is respected. The artist's tools are the use of depth placement, active depth cuts, and floating windows to adjust depth strength and smooth the oculo-muscular activity of the audience. Many a 3D animation movie was produced this way.

When the 1400 shots of *Chicken Little* were re-rendered in 3D in 14 weeks, after the 2D render and edit was done, they were set up in a one-size-fits-all 3D. All along the movie, the maximum positive and negative parallax remains the same. *Meet the Robinsons* benefited from a much better production schedule, with more than a year spent on the 3D version. All the camera positions and edit points were done in 2D, and the director just checked that the 3D was okay with his vision. The intense use of multirigging and floating windows made a final product that only very astute stereographers would detect as a movie that was actually created in 2D.

The edit-rules-3D-follows approach should not be frowned on—it provides the greatest amount of creative freedom to the director. As much as we want to see 3D movies, we don't want the reputation of stereoscopic direction to be a collection of "I can't do this, I can't do that, I wonder if I can make a movie." After all, 3D is only a tool and as such should be able to make itself invisible on set, smooth in the production schedule, and not too painful on the time budget.

OPTION 2: 3D RULES AND THE EDIT ADAPTS

A 3D editing rule, as the direct child of the third mantra, "Always check in 3D," would read like this:

> **The images that read like 2D images should be edited like 2D.**
> **The images that have a strong 3D character need to be dealt with as 3D.**

There's an obvious meaning of strong 3D, and that's strong parallax. If you are expecting your audience to move their convergence point around the place,

you have to make sure it is physiologically possible to follow your visual discourse in 3D. You should consider the rapid exhaustion that comes with such exercising.

We would like to suggest an additional meaning for a strong 3D: an image that bears much more emotional content because it is 3D. It may come from a strong 3D setting—a huge parallax, but not always. To evaluate the impact of 3D on an image, show it in 2D to an audience, switch to its 3D version, and listen. The louder the "Wow!" the stronger the 3D character. If an image can carry more emotion by the mere presence of depth, it is a complex depth image. Its reading in depth is just not the same as in flat. How can you edit in the same way pictures that read so differently?

If you are working with images that have strong 3D stamina, you have to curb your editing pace. This may not be pleasant, but that's the truth. And the situation is not as bad as it may seem, for you have powerful 3D tools to help you subdue wild 3D images.

Conducting research on that very subject at DreamWorks, Phil "Captain3D" McNally reedited a scene of *Kung Fu Panda* exclusively for 3D. In the very dynamic prison escape scene, he created as strong as needed 3D camera settings. Then he used them in a remake of the sequence, changing the edit points as needed. His findings were that one-third of the 2D cuts were just as fine with unleashed 3D. Another third needed minor shifts to accommodate the longer reading time of 3D images. The last third had to be trashed and replaced by other edit decisions because they would not line up in 3D unless the 3D quality and impact were reduced. The number of shots in the sequence, and therefore the overall cut speed, was eventually the same, despite not being an objective of the project. Phil considers this proof that **3D can be cut just as fast, if you think 3D from end to end**.

Depth continuity

Stereoscopic cinema adds depth to all the continuities a movie editor has to take care of. It states that one should not cut between shots if their depth does not match. What does depth matching mean? It means that the audience will immediately fuse in 3D the incoming left and right images. Otherwise, if the stereopsis were to be interrupted, the suspension of disbelief would be endangered.

CUTTING IN DEPTH AND DEPTH JUMP CUTS

A cut from a wide shot behind the screen to a close-up inside the room is a good example of nonmatching depth cut. The convergence point of the in shot is too far away from the convergence point of the out shot. The audience loses 3D perception for a second and has to search for the correct convergence point.

Forward and backward jump cuts are not equals. In a backward depth jump, the incoming convergence point is closer to the audience. We have to squint to

FIGURE 9.1
Overlapping depth brackets and nonoverlapping depth brackets determine if a jump cut will work or not.

restore stereopsis. This is more disturbing than a forward jump cut, where we would just relax our visual muscles. Actually, forward jump cuts can be used as a disturbing effect, under tight control. You can use a jump cut to beyond the screen in order to generate a feeling of vertigo, as in an unexpected opening on a landscape.

ACTIVE DEPTH CUTS

An active depth cut is a way to cut between two shots that do not line up in 3D. The solution is to dynamically match the convergence point of the two shots. Here's the modus operandi:

1. Bring the attention point of the out shot up to the screen plane.
2. Cut to the in shot, with its focus point placed in the very same depth.
3. Keep moving the convergence point, up to the in shot's correct position.

The audience will follow your convergence directions without a blink. The movement should be just fast enough not to be detected, and slow enough to be easily followed. The depth transition point does not have to actually be in the screen depth plane. You can cut the shots with their point of attention anywhere in the comfort zone. The point is to bring them to common ground and keep the dynamic convergence at constant velocity.

This technique, named "active depth cut," was introduced by Steve Schklair in *U2 3D*. In subsequent debates on 3D directing, he mentioned audience test results showing that active cuts generate a feeling of a faster edit. This compensates for the often slower pace of 3D cuts.

Transitions in 3D

Most edit points in movies are clean cuts, but you may want to explore in advance the effect 3D has on other transitions like fades, cross-fades, wipes, and split screens. They read very differently in depth.

Cross-fades are much more powerful tools in 3D than in 2D if you use them to mix shots that are occupying the same depth area. The incoming protagonists will actually seem to materialize inside the outgoing scenery, creating a stronger connection or continuity feeling between the two shots than in a regular 2D mix. *U2 3D* makes extensive use of this effect.

Wipes and split-screen effects are intrinsically 2D effects that will explicitly append in the screen plane. Vertical split screens bring the stereoscopic window constraints in the middle of the screen, with all the retinal rivalry issues increased. When they occur at the screen edges, they are close to our peripheral vision, which is not stereoscopic at all. We are bothered, but we can manage it to

a certain extent. If they occur in the middle of our visual field, right where our attention is, they are much more disturbing.

Your options are to build the scene so that both sides of the split are in the same depth, and pushing or pulling the cut line in depth. You will need to smooth the split edge by a few pixels to accommodate for the depth discontinuity between the in and out images.

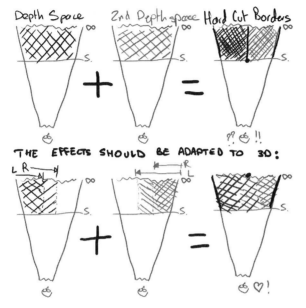

FIGURE 9.2
An example of an in-depth image split.

FIGURE 9.3
The sound and image volumes do not perfectly match in a 3D movie.

Sound for 3D

The sound was 3D long before the pictures. Multichannel surround sound is the norm in theaters and gaining ground in living rooms. Now that the images have caught up, how do both 3D volumes interact with each other? The new sound-image space relationship has not yet been explored and discussed in open forums and conferences. We have gathered here the bits of information 3D directors and producers have shared with us over the last few years in regard to sound and image volumes and relative placements.

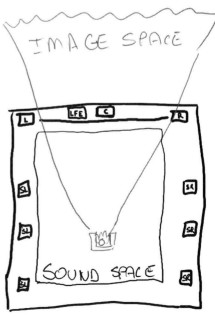

The first observation is that the 3D volumes do not perfectly overlap. The multichannel sound occupies the theater room, with left, center, right, and LFE sources right behind the screen, and one or two layers of stereophonic sources along the room length. The stereoscopic image occupies a volume designed by the comfort zone, a truncated triangle that extends a long way beyond the screen.

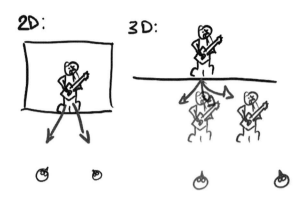

The second observation, brought to our attention by Laurent Verduci, is that the sound would not follow a 3D picture as you move from a center seat to a position in the aisle. In standard cinematography, if you have a one-shot of someone speaking right in the middle of the screen, it would be heard and seen at the same position from any seat. In 3D, unless the speaker is in the screen plane, he would shift sideways, as shown in Fig. 9.4.

FIGURE 9.4
A sound source in a 3D movie will not follow the image if you sit in the aisle.

The third observation is from Thierry Barbier, 3D producer at AmaK Studio. His direct experience is that a 3D movie sound mix is more of a quadriphonic mix, with emphasis on front-to-back effects, rather than a surround mix with stereophonic voices and ambiance effects.

Rob Engle, with Sony Pictures Imageworks, confirms that the typical use of the back channel mostly for ambient sound is outdated. More of the voice tracks should make it to the surround channels to fill up the room space with the actors' lines, along with their images popping out of the screen.

We wish we could provide you with more insights on sound mixes for 3D, and we will be glad to hear about experiences in the field at moviemaking conventions and conferences.

PRACTICAL 3D EDITING

With the lack of dedicated stereoscopic tools, editing 3D is the most sluggish of all postproduction phases. There is an obvious conflict between the need for real-time response from the edit station and the additional overload of a stereoscopic dual stream. It was solved only recently on high-end editing systems, and is far too costly to be used by the independent filmmaker who wants to take time to learn and experiment on his own. This is why we will present the existing solutions to edit 3D using regular 2D tools. Such ad hoc procedures on makeshift equipment are only being deprecated with the release of entry-level all-software 3D editing solutions. A handful of new solutions, which were released after this book was written, are listed at the end of this chapter.

We will see how such procedures use 2D-compatible stereoscopic image formats to process the rough, fine, and final cuts in incrementally increasing picture quality.

Working with 3D footage in the edit room

3D editing benefits from having a maniac taking care of asset management. A meticulous data wrangler will save your movie, riding daily on the edge of nervous breakdown. To exist in left, right, and 3D, assets must have proxies in various stereoscopic encoding formats and many generations of fix-up and applied 3D effects like reconvergence and floating windows.

GROOMING SHOTS IN THE EDIT ROOM

For optimal editing speed, all 3D shots should be checked for 3D quality and, if needed, corrected of any vertical parallax and SWVs before they reach the edit room. If you prefer, you can plan to integrate that treatment in the 3D editing process. In that case, you accept the risk of encountering shots that look bad in 3D and require interrupting the editing session to groom the 3D. Furthermore, the edit station may not be the best place to fix complex shots that require tracking points to be fixed. The use of tools integrated in a post suite, like Adobe Premiere and After Effects, can mitigate the difficulty, especially if you work in tandem with 3D artists on networked VFX stations who can correct the 3D while you keep editing it.

THE IMPORTANCE OF NONDESTRUCTIVE IMAGE MANIPULATION

In the process of editing, you will actually manipulate the images, at least changing the convergence point with HIT. Such manipulation may involve a slight zoom-in. Later in the mastering process, at the color grading and final packaging steps, you will once again have a chance to change these settings. Multiple iterations of HIT may imply multiple iterations of zoom-in, to the point some objects in the scene will reach the stereoscopic window's borders and eventually break it. To this effect, you may want to work in a slightly overscanned mode, either by rendering larger images than your final output or by working inside a safe zone that will be scaled up at the final render. Preserving a surrounding area that accommodates your screen native parallax (SNP) on each side of the frame should suffice.

IRIDAS's digital intermediate (DI) solution leverages their OpenGL architecture to provide nondestructive 3D realignment. All corrections are recorded, like an EDL, on a depth decision list (DDL) in a separate file. The images are rendered in real time in the computer GPU when you play the movie or export it to another application.

If you set up floating windows during your edit, we do recommend creating them as an additional layer atop the edited footage to preserve the underlying visual information.

Using 2D tools to edit in 3D

Typical 3D movie editing using regular 2D tools starts with draft cuts in 2D and ends up with two full-resolution movies. At some point in the process, the edited material gets into 3D, at various levels of quality. The sooner the better, and at the highest 3D quality, the better, too.

WHY DO WE USE 2D COMPATIBLE FORMATS?

You want to use an actual editing system, not visual effects software that re-renders every editing decision or an improved frame server that can hardly perform a time split. Editing requires real-time response, immediate replay, sound synchronism, and the ability to ingest huge amounts of footage and stay stable over long plays. This is provided by software and hardware built around specific time-critical design optimizations.

The issue with 2D editing systems in 3D is precisely their tight optimization. Most of them use a fixed-size video format and encoding system, like DV, HDV, or HDTV in MPEG-2. They are sometimes hardware based or use some proprietary compression codec. All these features are resolution-bound and do not handle dual screen or stacked images well. Their user interface does not provide any space for double-sized footage, let alone a real 3D display.

The only solution is to encode the stereo in a monoscopic-compatible format, and decode it on the fly to immediately watch 3D when you hit the play button. This will be good enough to cut the rough edit. Then the fine cut should be done in the highest draft quality before a full resolution is rendered.

Big-budget projects will get the final cut done at full resolution, on a dedicated 3D-capable editing system, or use a high-end lossy spatial compressor designed for 3D.

2D-COMPATIBLE 3D IMAGE FORMATS

A 2D-compatible format is a 3D format that fits and survives inside a 2D hardware and software environment. Typically, these are half-resolution formats, with variants in the selection and rearrangement of the pixels coming from left and right images into a single image. Currently used formats are side-by-side, over/under, rows and columns interleaved, quincunx, the proprietary system from SENSIO, and last but not least our good old friend of cheap 3D: anaglyphic encoding.

FIGURE 9.5
3D formatted in 2D compatible formats.

Table 9.1	3D image format compatibility with legacy 2D systems						
	Principle	Anamorphic	Viewed with	YUV and DCT compatibility	Chroma sub sampling compatibility	Notes	Resolution
Side by side	Images are squeezed in the left and right halves of the screen	Yes	Compatible TV or decoder	Yes	Average	DualHead2Go as decoder	Half
Over/under	Images are squeezed in the top and bottom halves of the screen	Yes	Compatible TV or decoder	Yes	Average		Half
Row interleaved	Every other row of each eye is selected to compose the image	Yes	Interleaved 3DTV, Polarized flat screens, CRT monitors	If recorded as interlaced video	If recorded as interlaced video	CRTs require pass-through and active glasses	Half
Raw checkerboard	Every other pixel is selected	Yes	Rear projection 3DTV	No	No	Requires 4:4:4 subsampling	Visually 70%
SENSIO™	Proprietary optimization of quincunx	Yes	Proprietary decoder	Yes	Yes		Said to be over 70%
Anaglyph	left and right are encoded in color spaces	No	Any display and colored 3D glasses	Poor	Yes	Benefits from RGB encoding	Not usable unless the final master is anaglyph

INCREMENTALLY INCREASING THE 3D PROXIES' QUALITY

It is very efficient to work your way through 3D editing by increasing proxies' quality. Here are all the steps from lightest to heaviest 3D proxies you can use in your editing journey.

1. Lowest resolution proxies
 - Encode them in anaglyph 3D.
 - Set the resolution as low as you want.
 - Watch them on any display, even on a laptop screen.
 - Do your shots and take selection and rough cut.
 - Flag all the takes that look bad in 3D for grooming.
2. Midrange proxies
 - Encode them in row-interleaved 3D.
 - Set the resolution to HD or SD.
 - Watch them on CRT with LCS glasses or on a micropolarized 3D LCD.
3. Full-resolution proxies
 - Encode them into side-by-side 3D or other spatial compression.
 - Set the resolution to full HDTV or 2 K resolution.
 - Watch on full 3D displays with decoding electronics.

Full 3D displays include dual projector rigs, 120 Hz projectors, and dual-layer and beam-splitter monitors. Conversion electronics are the Matrox DualHead2Go or proprietary 3D systems from SENSIO or 3ality.

There's an obvious overlap between the steps. You will select which intermediary quality level you will use based upon your project budget, timelines, and quality requirements. Available equipment and technical proficiency will direct your choices, too.

You can render 3D movies from 2D full-resolution 3D proxies. They are finely enough defined for most validation screenings, and they may even max up the actual bandwidth of the 3D display itself. In some cases it is useless to render 3D movies from full resolution left and right assets, unless you need the extra resolution and quality for a theatrical release.

MAKESHIFT SOLUTION ISSUES WITH MIXED FORMATS

The use of 2D-compatible 3D formats is an undocumented and unsupported feature of editing systems. It requires some knowledge of the video encoding and compression schemes that will be used, in order to avoid unwanted resolution loss or color smearing. Some transitions and effects will need to be adapted, too, and the expertise of a VFX artist may be helpful to tackle the issue.

Interlaced and interleaved

When using row interleaved 3D format in 2D systems

- Set the video format to "interlaced" to get field separation at the encoding process and avoid compression crossover artifacts.

- Set the effects computation to "progressive" for time-sensitive filters like wipes.
- Set the effects computation to "interlaced" for area-sensitive filters like blurs.

For interactive 3D preview inside the GUI on a 3D display

- Set the rendering precision and zooming factor to equal level, like quarter and 25 percent or half and 50 percent to get appropriately interlaced vignettes.
- Set the monitor resolution to its native resolution.

Chroma subsampling and spatial compressions

Beware of the 4:2:2, 4:2:0, and 4:1:1 chroma subsampling if you work in row interleaved formats, and even more so if you work in checkerboard formats, because they will generate color artifacts in high frequencies.

Anaglyph will look much better with a RGB video compression than in a YUV color space. In low-end editing systems, like notebook edit stations, never look at anaglyph images on an external TV monitor using a video composite cable; instead use at least an S-video connection.

Editing your 3D movie

The choice between editing in 2D or in 3D is tightly linked to the imagery-versus-edit ascendancy debate, and to the type of production and budget you are running. It is a technical and workflow decision, too.

EDITING YOUR 3D MOVIE IN 2D

Process

The 2D-first editing process runs as follows:

1. The director or the production studio does the edit in 2D.
2. The EDL is transferred daily to a 3D editing or DI station.
3. An assistant or the stereo contractor runs the EDL on 3D assets.
4. The director sees the 3D edit at dailies.
5. Any changes in the edit are applied in 2D.
6. The 2D EDL runs through another 3D conforming loop.

Advantages

The practical reasons to work this way are as follows.

1. The edit stations and user interfaces are currently 2D.
 - Even if they may be tweaked into 3D capable systems, their ergonomics will not handle 3D perfectly.
2. During the rough cut, you can access all the footage.
 - You do not have to wait for the assets to be 3D groomed.
 - You do not have to prep all the shots and takes you will not use.

Drawbacks

The main drawbacks of this method are as follows.

1. You cannot infer the 3D from the 2D.
 - You risk misevaluating the 3D look of a shot.
 - You risk using a take that has a 3D default.
2. The result may feel more like a 3D-converted movie than a natively 3D movie.
3. The edit is not optimized for 3D.
4. The number of round trips between 2D and 3D can be daunting.
 - *U2 3D* was edited this way and ended up with more than 60 cut versions.

EDITING YOUR 3D MOVIE IN 3D

Process

The 3D-first editing process runs as follows.

1. The 3D shots are groomed.
 - Vertical disparities are corrected.
 - If needed, depth position is adjusted to fit in the comfort zone.
 - Noncompliant shots are eliminated or sent to 3D depth fix-up.
 - If needed, 2D-compatible 3D proxies are generated.
2. The director supervises the cut directly done in 3D
 - using a 2D editing system with 2D-compatible 3D proxies.
 - using a 2D editing system with a 3D plug-in.
 - using a 3D-capable editing system.
3. 3D dailies are available.
 - immediately in half resolution, if using 2D-compatible proxies.
 - in full resolution, after 3D conformation, if using 2D-compatible proxies.
 - immediately in full resolution if using a full 3D editing system.

Advantages

The practical reasons for working this way are as follows.

1. The third mantra says you should watch in 3D what you do in 3D.
2. You will not use shots that will eventually not work in 3D.
 - Shot prepping is a marginal cost for big-budget productions.
 - Modern 3D rigs and computerized real-time correction makes it a nonissue.

Drawbacks

The main drawbacks of this method are as follows.

1. All takes have to be 3D groomed before they make it to the edit room.
2. 2D-compatible assets look awkward in the 2D edit preview, even if they are fine on the 3D-capable external monitor.

Rendering full-resolution 3D

When you have reached the maximum possible quality with 2D compatible formats, you now have to render the full 3D movie, composed of two full-resolution 2D movies. This phase, which leads to the final master, in most cases does not include any edit modifications. What looks nice in half 3D should not be problematic at full resolution, provided that you checked it on a full-sized screen.

STEP ONE: DUPLICATE THE EDL INTO LEFT AND RIGHT EDLS

The dual stream rendering is explained at length in the compositing and visual effects chapter. When it comes to editing, the main objective is to make it fast and streamlined. You will generate two EDLs, one per eye. All the cut and fade points can be replicated as is. Depth placement and geometry correction setting and scripting that you used need to be adapted to generate proper left and right settings in two separate EDLs. If you used the side-by-side format, effect placements need to be translated into nonanamorphic settings. Playing with the pixel aspect ratio and anchor points values may give you great mileage in such conversion.

STEP TWO: RUN THE EDLS

In order to run the EDLs, you will replace the 2D-compatible proxies with full-resolution assets. Depending on the software you are using, that may be a snap or a hurdle. You may have already encountered in your 2D life the need to replace all the footage of a project with another version, another file set. If not, here are the ugly tricks we play on our computers to make them behave.

Trick one: swapping the assets

This trick works with root-eyed file structure, where left and right are arranged in two separate file structures. The trick is to close the application and rename the assets root folder to logically replace the left assets with the right assets, reopen the projects, and let the system load the new shots. If you complement the root-eyed structure with side-explicit file naming, you need to rename the files in the EDL.

The trick works with swapping external drives, changing mounting points in UNIX or the drive letter assignation in Windows, and with local as well as network storages. If you have two final rendering stations, a network drive swap allows for parallel rendering over the network.

Trick two: renaming the source files in the EDL or project file

This trick works with leaf-eyed file structure, where left and right assets are stored together in one single file structure with a side-explicit file naming. All you have to do is to run a renaming script on your EDL. You may not need to master C++ or JavaScript programming to run it. Opening the file as a text file in a word processing software and running intelligent find and replace swaps with regular expressions may do the job just fine.

3D EDITING EQUIPMENT

3D-capable editing software

SONY VEGAS PRO

You will find a full suite of tools to use with Sony Vegas Pro as a 3D editor at www .medtron.org. Vegas Pro costs $550 and the plug-in is free for individual users.

Make3D requires Sony Vegas Pro Version 8.0 or later. Make3D is designed to work with hi-definition (1440 by 1080) NTSC video files. Standard definition (720 by 480) and PAL video files are not supported. The information can be found on their web site.

- Software features
 1. Automatic Make3D tool management
 2. 3D video pair creation tools
 3. Camera start time correction tools
 4. Camera alignment correction tools
 5. 3D timeline creation tools
 6. Timeline 3D format conversion
 7. Automatic 3D timeline rendering
- 3D timeline output file types
 1. Anaglyph (red and cyan)
 2. Side-by-side 2:1 compressed
 3. Interlaced (field sequential)
 4. Dual stream

FIGURE 9.6
The Make3D plug-in for Sony Vegas Pro.

ADOBE CREATIVE SUITE

Adobe CS Premiere and After Effects enjoy great popularity among 3D movie-makers because they were among the first affordable resolution-free video production tools with tight integration between the video editor and the visual effects compositing software. The presence of a 3D-glasses filter is a marginal bonus because it rapidly shows its limitations and can be easily replaced by an in-house 3D mixer with much better performance.

The extensive use of the OpenGL library in the upcoming CS4 release sparked great expectations for real-time 3D and stereoscopic previews and renders. At the time of writing, there is no accurate information available on the subject. If the suite doesn't include such functions, independent developers will most likely release some plug-ins, like the one created by artist/programmer gl.tter and presented at http://gl.tter.org/LumaChroma3D/.

LumaChroma is a high-quality, GPU-accelerated, multieffect plug-in for Adobe Premiere and After Effects (Windows).

The plug-in is an entire effects pipeline, designed to correct, enhance, stylize, and color-grade video, and to produce master render output and real-time previews. LumaChroma also brings features like 3D LUTs and color fingerprinting to Premiere and After Effects.

Effects include staple enhancements like chroma reconstruction, unsharp masking and lens distortion correction, many color adjustments, high-quality keying with automatic chroma key spill removal and recoloring modes, HDR gradients, and advanced noise and grain.

LumaChroma 3D is the stereoscopic-enabled extension of the standard plug-in. It builds on the existing feature set by accepting, aligning, enhancing, and outputting a variety of stereoscopic formats.

Alignments (2D offsets, rotation, and keystone correction) are fully key frameable, allowing you to adjust convergence dynamically. The secondary view has its own color and sharpness offsets so it can be matched to the primary and includes an automatic color-balance matching feature. Frame edges can also be brought in and out of the screen separately for simple or advanced floating windows.

Many stereo input and output formats are supported, including dual stream, interlaced, over-under, side-by-side, and checkerboard. Anaglyph output is also possible with extensive options, including support for all common lens colors (and even custom ones), full-color, half-color, or monochrome modes, and simple or advanced retinal rivalry reduction (including an RGB source to an anaglyph channel mixer for ultimate Photoshop-like control).

Everything is previewable in real time (on a suitable setup) in the chosen output format, including anaglyph previews (support for previewing on stereo displays is under consideration).

FIGURE 9.7
The LumaChroma plug-in for After Effects.

In the meantime, you can find files from the many 3D projects we produced using the Adobe suite on the enclosed DVD.

Compatibility hardware

MATROX DUALHEAD2GO

The Canadian graphics-card company Matrox sells a multiscreen adapter box for laptops that spreads a single screen source across two or three displays. It has rapidly been adopted by the 3D crowd as the best passive stereoscopy adapter. It's the must-have tool for dual-screen 3D display owners. It will transform side-by-side stereo in dual-stream 3D that feeds active projectors like DepthQ, Projection Design, dual projector setups, and beam-splitter monitors like Planar and True3Di. The digital version, with DVI input, is obviously preferred and can be used to feed analog and digital displays.

Sensio

The Canadian company SENSIO Technologies developed a proprietary 2D-compatible encoding that seems to be an optimization of the checkerboard spatial subsampling. SENSIO offers a consumer implementation of the codec, in 3D DVDs and 3D Blu-ray disks. SENSIO also offers a production encoder system that allows real-time 2 K encoding and decoding for digital 3D cinema live events. At the time of writing, the availability and pricing of the encoder was not public. Because it's an encoding system that claims no visual loss in 2D-compatible encoding, and it is to be embedded in the next generation of

3DTV chip sets, it deserves scrutiny from anyone planning to build a 3D editing pipeline.

We direct you to the company web site www.Sensio.tv.

Real 3D editors and beefed-up DI solutions

The 3D editing systems listed here are high-end systems that cost tens of thousands of dollars and are currently under development. It would make no sense to detail their features because they are undergoing perpetual evolution. Furthermore, if you are considering buying one, you will likely not rely on this book to make your choice. The contact information for the companies providing these systems are on the DVD.

AVID

As of this writing, Avid is working on a stereoscopic-capable Avid DS 10 that uses stereoscopic containers for dual-stream 3D. The assets are stored on an Avid Nitix server in NX HD format. The image format used is a regular 2D resolution at a double frame rate of 48 fps. This alternative frame 3D is actually output as passive stereoscopy via a dual-link video card. The system is integrated with MetaFuze asset management and is announced at about $60 K.

FIGURE 9.8
The Avid 3D editor uses stereoscopic containers.

ASSIMILATE

Assimilate SCRATCH was the first 3D edit solution presented at the NAB in 2007, when it was used by 3ality on the *U2 3D* production. It is actually a DI system able to process two streams at once, with enhanced edit functions.

FIGURE 9.9
U2 3D edited on
Assimilate SCRATCH.

IRIDAS

IRIDAS developed stereoscopic extensions of its SpeedGrade and FrameCycler products in the early 2000s. Nobody was interested, so IRIDAS withdrew them. A few years later, 3D was the hot thing in postproduction, and IRIDAS was more than happy to reintroduce them. The main quality of the system is its reliance on GPU processing and the nondestructive stereoscopic corrections saved in an SDL file.

QUANTEL

Quantel is currently the big player in 3D postproduction stations with Pablo 3D. This hardware-based DI solution can play two 2 K streams at once and has been retrofitted with 3D-specific functions. It offers split-screen displays, depth adjustment, and floating windows functions.

Quantel also offers Sid, an online finishing system with previz, assembly, edit, VFX, Paint and mastering tools, and Sid VCM, an entry-level system for viewing, conforming, and mastering 3D. Quantel announced new versions of iQ will be 3D and a 3D plug-in for Max.

They are distributing 3ality's real-time depth grooming and encoding hardware solutions under the SIP2100 name.

FIGURE 9.10
Quantel's Pablo is the most-used 3D DI and editing solution as of late 2008.

Note from the Author, as of October, 2009.

As expected, we saw many major announcements in the 3D editing field since that book was sent to press early 2009. We will only list them here and invite the reader to get more information directly from their vendors.

Offline editing saw the release of a major tool, Cineform's Neo3D. This video encoder records both eyes at full resolution, but presents only a single 2D stream to the host application. That 2D being any form of 2D-compatible 3D format. This clever trick allows you to edit 3D in any 2D application.

Tim Dashwood released it's Stereo toolbox, a plug-in powered by FxFactory and designed to work with Adobe® After Effects® CS3 / CS4, Apple® Final Cut Pro®, Apple® Motion® and Apple Final Cut® Express applications. Find out more at http://www.timdashwood. com/stereo3dtoolbox

Online editing saw Avid's announcement that all versions of media[name] are 3D-capable using 2D-compatible stereo formats, and offline full resolution renders.

Quantel, Iridas, Assimilate and Autodesk kept updating their stereoscopic offers, with more 3D-dedicated functions, improved ergonomics and optimized code.

SGO offers its high-end solution, Mistyca, with stereoscopic editing functions. You'll get more information from http://www.sgo.es

Key Points

- 3D editing requires 3D visualization and super-meticulous asset management
 - using 2D editing systems for low-budget movies.
 - using state-of-the-art 3D editing stations for high-end projects.

- 3D shots should be groomed and depth placed by the time they are edited
 - Simple balancing, like HIT can be done at the edit station.
 - Complex alignments should be processed at a nearby VFX station.

- 3D edit pace should be adapted to 3D images
 - 3D images take longer to read and may require a slower cut.
 - The cut pace reduction is a factor of the 3D strength.
 - The edit speed can be as fast as 2D with fast-reading and depth-matched 3D shots.

- 3D depth continuity should be preserved
 - A jump cut is a cut between shots not depth-matched but rather placed at different depths.
 - An active jump cut uses HIT to match shots dynamically around the edit point.

- Consider incremental proxies' quality in practical 3D editing
 - Rough cuts can be done in anaglyph and rendered in low-resolution 3D.
 - Fine cuts can be done in half-resolution 3D, on as large a screen as possible.
 - Final cuts should be done in full-resolution 3D, on a full-size screen.

Grading and Packaging

Now that your movie is ready for release, here comes the last grooming step before it meets its audience. This chapter will cover

1. the subtleties of color grading for 3D
2. the new concept of depth grading
3. the various packaging and releases options for
 - cinemas and special venues
 - optical disks and home cinema

> This chapter was greatly enhanced and expanded with the help of Jeff Olm, freelance stereo colorist, who is arguably the most experienced color artist in 3D. His credits include *Journey to the Center of the Earth, Monsters vs. Aliens,* and *My Bloody Valentine.* He is a RED stereo workflow consultant, too. We would like to thank him for sharing with us his tremendous knowledge on the subject. The section on Stereoscopic Floating Windows is based on Brian Gardner's work. More details on his contributions to 3D storytelling can be found in his white paper included in the DVD.

COLOR GRADING FOR 3D

The color grading of a 3D movie is quite a complex operation because the various display technologies have different light efficiencies and color shifts. Some recent 3D releases have included up to 14 different digital packages for a single title. The situation is expected to be settled in the future, with the pressing request from the studios to have only one 3D master for all systems. In the meantime, it's the color artist's duty to adapt the color look of the movie to the many distribution channels it will use.

FIGURE 10.1
For further information on the subject, see *Color and Mastering for Digital Cinema*, published in 2006 by Focal Press.

Understanding 3D projection systems

No 3D projection system is neutral as far as image quality is concerned. Image quality is the key factor in 3D perception, and the color artist is on the front lines in the battle for image quality. Understanding how projection systems split the original 2D resolution, lightness, and color density into two even shares is key to making it produce a good 3D image.

THE PROCESSES

Stereoscopic projection relies on an encoding-decoding process that assumes the function of exposing each eye exclusively to its intended image. This encoding, also called multiplexing, can be in time, light, or color.

Time multiplexing

Active stereoscopy separates eyes in time, with alternative projection of the left and right images on the screen. Viewers wear liquid crystal shutter (LCS) glasses that alternately blind each eye in synch with the projection. It is mostly deployed in Europe.

Light polarization

Polarized stereoscopy uses neutral gray filters that orient the light waveforms at the projector output. The screen should be silver-coated to preserve the light polarization. The viewers wear sunglasslike plastic glasses that block the light that is not in the appropriate orientation. Linear polarization is more discriminating, but the viewer needs to keep the eyes level. Circular polarization systems are generally less discriminating, and leaning your head will only slightly shift colors.

Wavelength multiplexing

In wavelength multiplexing, the projector's light source is divided into six narrow bands, organized in two discrete sets of RGB lights. The left eye uses one RGB set, while the right eye uses the second one. No special screen is needed, and special glasses filter the needed wavelengths.

Dual projection

Nothing seems simpler than one projector per eye. That's not that simple, for it requires perfect synchronization and geometric alignment of the projectors, just like pairs of cameras. It was the favorite projection system in the 1950s,

with polarized filters and glasses. Most IMAX 3D movies use dual 70 mm film projector setups.

Beam splitters

The beam-splitter projector is the equivalent of a camera 3D lens. Images are stacked together on the imaging device, and the optical attachment unsqueezes and overlaps them on screen. This method was often used in the 3D systems of the 1970s. The beam splitter is making a comeback as a light efficiency optimizer for RealD and on Sony's 4 K projectors.

Mixes and matches

You can mix and match 3D projection technologies. Active stereoscopy is used with polarization or wavelength filters for single-projector 3D. There are more unexpected systems, like active stereoscopy using dual projectors with mechanical shutters in some large-format venues.

Color multiplexing

The most infamous color filtering is the anaglyph encoding discussed at length in this book. Despite all its faults, anaglyph encoding is still a distribution format, especially for the home market under its modern green-magenta and yellow-blue incarnations. It is not a projection system by itself, but we want to mention it. Despite being crude and ugly, it works all around the world, from the richest home cinema installations to the poorest venues with legacy 16-mm projectors.

DIGITAL 3D CINEMA PROJECTION SYSTEMS

RealD Z-screen and RealD XL

RealD sparked the whole 3D renaissance with its system that uses an active circular polarizer, the Z-screen, synchronized with a single projector. The system requires a silver screen and disposable glasses with a very slight green tint. Because of its high crossover ratio, Real-D requires a ghost-busting pass that makes its deliverables incompatible with other systems. We will review ghosting and ghost-busting in the next section. RealD claims more than 90 percent of the North American market, excluding IMAX and other large format venues. The prototype XL system uses a beam splitter to recoup part of the light lost in the polarization process.

FIGURE 10.2
The RealD Z-screen mount in front of the projector lens.

Dolby

The Dolby system is built around a license from INFITEC, a German spin-off of Benz. The system uses a color wheel that drops in the projector between the light source and the DLP, and glasses whose manufacturing is very complex, with 20 to 30 layers of tint and filter coatings. Despite its optimization by Dolby engineers, the double RGB spectrum generates a different color shift in each eye. The brain will rapidly adjust to the color asymmetry.

The real issue comes from the glasses' sensitivity to the light beam orientation. That makes them much less effective in the edges and corners. This may be a problem for the front-row audience who will not perceive floating stereoscopic windows as intended. Some experts consider that its very low ghosting level makes Dolby the best 3D projection system.

FIGURE 10.3
The Dolby/INFITEC system uses a dual RGB spectrum.

Master image

The Korean company Master Image presented a wheel at ShoWest 2008 that is placed in front of the projector lens and circularly polarizes the light. As with any polarized system, this one requires a silver screen. As of November 2008, Master Image claims 50 sales worldwide. The company offers two dual projector systems, one polarized and one in wavelength multiplexing.

XpanD

XpanD is a Slovenian company that merged with MacNaughton-NuVision and sells its LCS glasses to the 3D cinema market. The reusable, sealed electronic

glasses work with any 3D projector that is equipped with an infrared transmitter to synchronize them.

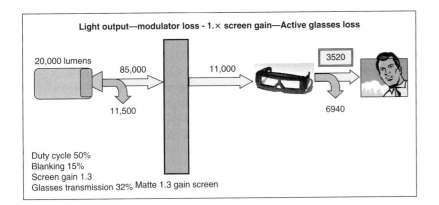

FIGURE 10.4
An active glasses 3D projection.

Dual projection

Many companies sell dual projection systems, including the projector makers themselves. Such systems are not tied to any patent and generate more than twice the amount of light, because both projectors run full throttle, with no dark time during the left-right switch, as we will discuss in the next section.

The dual projector architecture faces a big financing challenge, because for the exhibitor the whole point of 3D is to generate incremental revenue that pays for the digital projector and server. Doubling the digital projection cost makes the breakeven point harder to reach, unless you equip large rooms with large screens that require more light.

On the other end of the wealth scale, if you are on a budget, you can build your own rig with a pair of commodity projectors, paint your screen, buy the filters on the Internet and get your glasses out of the recycling bin of a 3D theater.

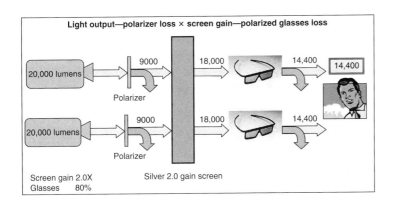

FIGURE 10.5
The dual projection system is the most powerful.

THE ISSUES

Single-projector digital 3D systems basically overcrank the whole imaging gear. Despite the efforts of all the geniuses who have worked on the processes, the physical limits of the DLP and the light path eventually show up, as we will see now.

Light efficiency

All the 3D systems have awfully poor light efficiency. To begin with, an active stereo projection alternately blinds one eye, dropping light efficiency by 50 percent. Additionally, a dark time is inserted to let the encoding system shift sides. Then the filter on the projector and the glasses takes an additional toll on the light beam. Eventually, the overall efficiency of the system is around 20 percent. The use of high-gain screens, up to 2.0 silver screens, makes the light efficiency comparison charts a bit obscure to the nonspecialist. What is important to know is that the residual light is about 5 foot-lamberts, when a 2D projection is expected to deliver 14 foot-lamberts.

Ghosting and ghost-busting

No 3D projection system perfectly isolates the left and right images. There is always some leaking from one eye to the other. The amount of crossover light is usually within a few percentage points of the original source. On most systems this leak is small enough not to be really disturbing.

Over a few percentage points of leaking, you see ghost images, especially with high-contrast images. Because the ghosting is asymmetrical, it generates a lot of retinal rivalry; it's a major cause of impaired depth perception. The RealD system is the most affected by ghosting, to the point that it necessitates a special visual effects pass to counter it. This pass is called ghost-busting. The principle is to evaluate the crossover level and precompensate for it by subtracting from each eye the known pattern of light expected to leak from the other.

A crossover test pattern includes

- a solid white background in the left eye
- a solid black background in the right eye
- a gradient from pure black to pure white inserted in the right eye image

The measurement is done by closing the left eye.

- The black background is actually dark gray, due to white leak.
- That dark gray matches one stripe in the gradient.
- The white level of that stripe is the leak ratio.

The precompensation for a crossover of 10 percent is done like this.

- The left image dynamic is compressed to raise the black levels to 10 percent.
- A copy of the right image is corrected to reduce its dynamic to 10 percent.

- The corrected right image is subtracted from the left image.
- The same operation is repeated to generate the ghost-busted right image.

It should be noted that the dynamic of the image is reduced by a factor equal to the amount of crossover.

> **Ghost-busted Images = (Original × (1-Leak Level) + Leak Level × Pure White) − (Opposite Eye × Leak Level)**

FIGURE 10.6
The ghost-busting process.

Color fidelity

No digital 3D system is perfectly color neutral. The best is the RealD polarization, which has a slight magenta or green shift when you rotate your glasses.

Dolby's wavelength multiplexing system suffers from an asymmetry of the two RGB subspectra: One leans toward green, and the other leans toward magenta, to the degree that if you look at anaglyph images with the Dolby 3D glasses, you would see most of the 3D effect. Because that asymmetry is evenly weighted and our brain processes the color as very relative information, you will forget all about the color shift within seconds of putting the glasses on.

The current generation of LCS glasses can barely run at triple flash speed and suffers from color banding. Color banding is a color depth reduction artifact that generates stripes of flat colors where a continuous gradient should be seen. The culprit is the release cycle, when the glasses go from opaque to transparent. Its duration of 3 milliseconds conflicts with the maximum dark time of the projector, which cannot be longer than 1 millisecond for light efficiency and stability reasons. As a result, there is a 2-millisecond-period when the glasses are not transparent enough and the color dithering process of the DLP projection is impaired.

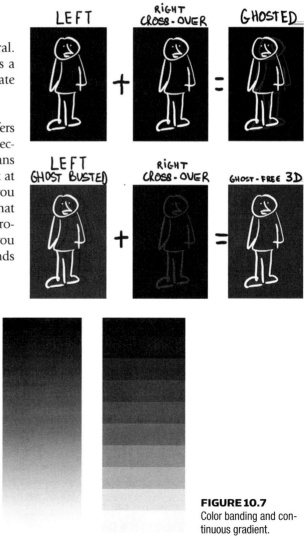

FIGURE 10.7
Color banding and continuous gradient.

GLASSES

Glasses-free display makers argue that audiences do not like to wear glasses. As a matter of fact, people wear prescription glasses, sunglasses, sky masks, and protective goggles for gardening without complaint. Our understanding is that as long as the 3D glasses are light enough and provide a clear visual benefit, the public will enjoy using them.

We would like to bring to your attention the case of telephone handsets. The technology evolution changed what was a rare luxury into a disposable commodity. The handset and the underlying technology have been vastly redesigned every 10 years, but the overall design of a microphone and a speaker on both ends of a handle has never been overcome. And it will likely never be, because we are facing a law of evolution: the function commands the shape. A telephone handset has a tremendous signal-to-noise ratio (SNR) filtering capacity inherited from its mere shape. The mike is near the mouth, the speaker is near the ear, and no electronic treatment or computing power will beat that design.

The situation may well be the same for 3D glasses: as long as we want to provide a good binocular SNR, we may never come up with a better object than a pair of filters as close as possible to our eyes. Hence, 3D glasses.

This still leaves a huge market for glasses-free 3D: all the public places where you can't hand glasses out to the audience or get them back into inventory.

The glasses

The best 3D system is as good as its worst piece, and the glasses handed to the audience are the weak link in almost all systems. A simple fingerprint on polarized glasses makes them unfit for proper use, and you'll experience yourself that it's hard not to smudge them by the end of a movie. Reusable glasses can be cleaned in dishwashers that guarantee their disinfection. Their optical quality can be impaired as the cleaning product builds up over time, as we have personally experienced in commercial venues. Unless a magical product is coming along in the research labs, having a lens-cleaning tissue handy is a good move when going to watch a 3D movie.

The triple-flash resolution

When the projector's DLP runs in triple-flashing mode, it could well project an image that is actually refreshed 144 times per second. At 2 K, on a 1:2,41 widescreen in 10 bits of color depth, that's a huge bandwidth, more than 7 gigabits. The control electronics of the 1.2-inch DLPs can't actually run that speed, so the actual imaging resolution is scaled down to a level that is almost a trade secret. In 2005 *Chicken Little* is said to have used only 1400 pixels per line to impress the audience. Since then, progress in optimization of the microcode that animates them seems to have yielded a few hundred more pixels, with 1600 pixels of effective on-screen resolution in use by 2007. The new generation

of 0.98-inch chips handles triple-flashing at full resolution, hence a fully active surface, providing 30 percent more light for 2009 releases. Considering the light levels on screen, the movie industry rightfully considers this technical peculiarity to be a nonissue.

FUTURE DEVELOPMENTS

Laser light sources

Laser light sources are expected to enter the projection booth soon. They offer

- better overall performance with more lumens per watt
- native red, green or blue tint, within tunable and narrow bandwidth, perfect for wavelength multiplexing systems
- natively polarized light, but polarization preservation along the imaging block, especially during the reflection on the DLP, is not yet solved.

Advanced color encoding

The color encoding process made huge progress with digital post-processing. The next generation does much more than perfectly tweak and mix the colors, and it is our understanding that it will fill the gap between the available catalog of 3D movies and the legacy 2D home cinema market. Because we are waiting for the patents to be published and the first commercial products to come to market, we cannot comment further on them.

New generation of LCS

Texas Instruments is introducing a new synchronization system called the DLP-Link. The infrared receiver on the glasses is replaced by a visible-light sensor that follows the actual left and right image displays. An invisible light burst is sent during the dark time to identify between left and right. This system is already included in the DLP-based 3DTVs and can be deployed in digital cinemas via a software upgrade. It is most likely that home theater front projectors that are based on third-generation DLPs are compatible with the technology.

How to color grade for stereo

Your 3D movie will most likely have at least one 2D and a couple of 3D versions. The 2D movie will be printed on film, DVD, and Blu-ray. The 3D version will be shown on various systems, like IMAX 3D, RealD, Dolby, and XpanD active glasses.

THE REGULAR 2D GRADE

First, you do your regular 2D grade, from which you will generate

1. the mono master for film and digital prints
2. the mono master for IMAX
3. a neutral grade for IMAX 3D

IMAX has its own proprietary treatment for its 3D format and it doesn't need a ghost-busting pass. Due to the large screen, it doesn't need any floating windows, either.

THE 3D GRADE

You need to grade your movie for 3D with your glasses on, because the color and luminance are strongly affected. Furthermore, you should grade on a screen that matches the system's needs. If you're using Real-D, a silver screen is needed, and for Dolby or active glasses, a white screen is needed. Color processing hardware is available for the Dolby system.

3D system specific global trim

For the RealD system, a global trim needs to be added.

- Add a bit of gamma, to compensate for reduced luminance without burning up the whites.
- Add a bit of magenta to compensate for the green tint of the glasses, and keep the skin tones balanced.
- RealD will run the ghost-busting pass at any of its licensed facilities.

The specifics of a 3D grade

You will now set your stereoscopic color grade based on the mono grade with the global trim on top. Among the details you'll want to fine tune, you will notice that warmer hues appear closer and colder hues, like green and blue, appear farther away. In most cases the latter are okay because it's mostly trees and the sky that are actually in the background. Lighter vignettes help choreograph where the viewer looks, and they will complement the DP's work. It is advised to use big soft shapes because they almost never need to be adapted to the second eye.

It's now time to get to the beauty pass. Most maps are on the main character, and that character usually stands close to the screen plane. These will not need to be adapted: only maps on the secondary characters in the background need an offset. You will notice that tracking is difficult in stereoscopy and you may prefer procedural keying and mapping. They will almost never fail you.

DEPTH GRADING

Depth grading extends the concept of color finessing to the depth domain. You should make sure no depth setting remains unfixed, and the depth reading of the movie flows according to the director's will.

Fixing depth

If there is a depth bump in the movie that has not been groomed yet, this is your last chance to fix it.

LAST-CHANCE STEREO TOUCHUP

Any vertical disparities, rotations, or keystones of any sort have to be cured.

Fixing divergences

No shot should leave the grading station with background objects farther away than the maximum allowed parallax. If needed, bring the whole scene forward and adjust its in and out transitions.

Fixing interoculars

If at this point of the production there is a shot with too big a depth bracket, it is time to make a miracle. Send it to your visual effects department or vendor and have them run it in Nuke with the Ocula plug-in. There is a very good correspondence-map computation node. When used in combination with a displacement map node to create a view synthesis group, it allows you to virtualize the lenses. Bring the background to middle ground and do not move the front pixels until you fix the whole shot's convergence. This is a quick fix for 50 percent of shots. If it does not work, you have a problem, and a decision has to be made about releasing the movie with a glitch or sending the shot to undergo a serious FX fix, such as a full 3D conversion.

DEPTH BLENDING

The strongest depth jumps were likely fixed at the edit station. It's your job to finesse them with a final pass of active cuts, as explained in Chapter 9.

Adapt the masters to screen sizes and geometries

THE ZERO PARALLAX SETTING

A movie released for IMAX will not have the same depth settings as the movie released for digital 3D cinema. The IMAX format works in the parallel paradigm, with the infinity parallax set to zero on the film medium and all scenes in negative parallax. At the projection, the two images, issued from two projectors, are reestablished behind the screen by shifting them 2.5 inches apart.

A movie released for digital 3D cinema is formatted in the converged paradigm with the screen plane set at zero parallax. At the projection, no shift is ever performed, and the left and right images are projected exactly aligned as they are on the master.

SCREEN SIZE

As we have seen many times, a stereoscopic movie is designed to fit a specific screen size. Until recently, the light efficiency of digital 3D projection restricted its use to mid-sized screens. Light-doubling systems, laser sources, and other technological or commercial progress may lead to the 3D conversion of larger

screens. A 3D movie played on a super-sized screen without special care will show painfully diverged stereoscopy. The only adaptation possible to perform in the projection booth is to bring the whole action forward with a global HIT. The result is close-up effects being brought even closer.

Will 3D movies eventually enjoy medium-screen, large-screen, and large-format releases?

Floating stereoscopic windows

The floating stereoscopic window (FSW) is the latest strong new cinematographic tool to join the 3D moviemaker's palette. The constraint to respect and preserve the integrity of the screen plane and frame is the heaviest burden on the 3D filmmaker. Scenes, actors, and actions want to fly and occupy the space. Floating the window turns the almighty flat screen into an obedient volume that can be shaped and moved all around the place at the cinematographer's will. A deadly trap is turned into a creativity tool. Let's see how it's done.

WHAT IS A FLOATING WINDOW?

A floating window is created by adding black masks on the sides of the left or right images. If you mask both images on one side of the screen, you reduce its visible size. If you mask only one image, you change the perceived position of the screen. The actual depth position of the displayed scene is not affected by the screen repositioning.

If you mask the right image on the right side, the right edge of screen seems to move toward you. If you mask the left part of the left image at the same time, the whole screen moves toward you. The opposite masking, left on right, right on left, will push the screen behind the wall.

The masks do not have to be aligned along the vertical axis. You can pull the top corners and lean the virtual screen toward the audience.

The masks can be asymmetrical and animated, with many more options still to be experimented in feature movies, like complex shapes, multiple depths, or animated sharpness.

The mask width is equal to the parallax of the protected object, plus one or two pixels. This leaves some space between the FSW and the closest object.

In most cases there is no continuity issue with FSWs, and their positions can be cut without particular caution.

CHARACTERISTICS OF FLOATING WINDOWS

Floating the screen makes it a virtual screen (VS) that can be shaped, placed, and moved in or out of the theater space. This addresses the cinematographic concepts of personal space and story space. We will review here a short typology of the FSW.

Push versus pull

Pulling the window brings the VS inside the room, creating additional stereoscopic real estate where the 3D action can evolve without hitting the frame. The most-used of all VS displacements, it brings the action closer to the audience and permits control of the gigantism effect encountered when objects are projected behind the real screen (RS).

Pushing the window beyond the RS is very rare. It is used to push the whole scene further away, or to exaggerate an out-of-screen effect of an object that cannot be brought further in the room, due to the miniaturization effect.

Static versus dynamic

Static windows stay at the same position through the shot, with no intended effect.

Dynamic windows change over the course of a shot, making the VS move. Such movement is surprisingly unnoticeable. It is used to accommodate frame breaking due to an action or camera movement, like a character entering the frame while being in front of the VS.

If you pay attention to making the frame movement noticeable, you will actually generate a camera movement because the effect is perceived as a relative movement of the frame, i.e., the viewer's position, toward the scenery.

Angled FSWs: side asymmetry

Angled FSWs have asymmetric depth positions of their left and right sides; the VS is angled, with one side closer to the audience that the other. An angled window puts the space in perspective, and makes one side closer than the other; it is typically used in over-the-shoulder two-shots.

> Note that we are talking about the left and right sides of the screen, not the left and right images of the movie. FSWs have, by definition, asymmetric left and right values. This does not impact their left and right symmetries.

Leaning FSWs: vertical asymmetry

Leaning FSWs have the top or the bottom of the VS pulled in toward the audience. The most typical use is to solve a close ground stereoscopic window violation. It is typically used for low-camera positions and wide lenses, with the ground entering deep inside the theater.

In the other direction, a leaning FSW creates a "the-sky-is-falling" effect, with the screen seeming to be suspended above the audience.

Twisted FSWs: corner pitch

Twisted FSWs are any VSs modified with top-bottom and left-right asymmetries, seen as three-dimensional corner pitch. They are used for SWV control with very dynamic camera positions and huge negative parallaxes.

TYPES OF FSWS AND CASE STUDIES

You can modulate the FW dynamism through its shape: flat, angled, leaning, and twisted. You can animate its position and shape. If your floating window animations follow the action or the camera movement, FSWs will remain unnoticed most of the time. Actually, you need to pay attention to see them, and to remove your glasses to accurately assess them. If you shape or animate the floating window in excess of or in opposition to the on-screen movement or action, it will make itself noticeable. And you may want to use FSWs as narrative tools.

In low-intensity scenes, you will keep one characteristic low, like using flat and dynamic or angled and static windows, in the pixel parallax (pp) range of –10 to –20.

In medium-intensity scenes, you will use angled and dynamic windows, up to twisted and leaning, with no stability, in the –20 to –40 pp range.

In high-intensity scenes, like chases, climaxes, and fights, follow no rules. Break and float the window in every direction. Do not respect any stereoscopic rule except the duration rule: No retinal rivalry should stay on screen long enough to be detected and become annoying. If needed, reduce the depth bracket to shallow 3D, get an easy-to-read stereoscopy, and let the camera movements and classic fast cut take care of the scene intensity, without impeding them with imagery that is too complex.

Creating a simple FSW

Let's consider this example: A shot of a crowd, with the first row in medium full shot, in front of a building. The building is behind the screen, at +20 pp. The crowd hits the frame on both sides of the screen. Had the scene been shot for a depth setup behind the screen, you would face the following issues:

1. The depth budget of 20 pp is too small, and the extras look like layers of cardboard standups.
2. The medium full shot set behind the screen makes the people look gigantic.

Thanks to good depth planning, the scene was shot with a total depth bracket of 40 pp. Keeping the building in the +20 pp brings the crowd to –20 pp. The whole screen has to be moved a bit more than 20 pixels toward the audience. Here's how.

1. On the left side of the left eye, mask 20 pixels of the image with a black solid.
2. On the right side of the right eye, mask 20 pixels of the image with a black solid.
3. Watch the effect in stereo and adapt the mask sizes to 21 or 22 pixels, creating an easing gap between the crowd and the virtual frame.

FIGURE 10.8
A simple static FSW case: The crowd and the building.

Objects enter the frame with negative parallax

This case-study establishing shot opens on a subjective view of the scenery at 15 pp. The camera pans slowly to the left, bringing the hero into the frame at –15 pp. While entering, the hero breaks the SW. An animated FSW is set up as follows:

1. Create a key at the last frame before the character enters.
2. Use Bézier keys with flat handles to control the start and stop speeds.
3. Set the FW to zero, on both sides.
4. Create a key at the frame where the character generates the maximum violation.
5. Set the right handle of the right FW to –16 pp.
6. Adapt the keys' velocity to keep the FW in front of the character while he enters.
7. Create a third key just after the character has fully entered.
8. Set the right handle of the right FW to –5 pp, to angle it.
9. Adapt the keys, keeping the FW in front of the character while he leaves the frame edge.

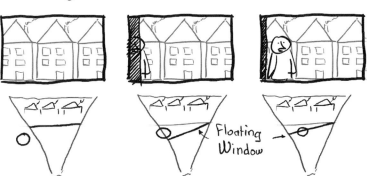

FIGURE 10.9
A simple animated FSW case: The frame entrance.

Walking toward the camera

In this imaginary shot, the villain is walking toward the camera. In 3D, we expect him to move toward the audience. Unless we are in orthostereoscopic conditions, his progression is actually compressed by the same factor as his visual depth. If the roundness factor is 0.3, he seems to moonwalk by a factor of 3. If you change the convergence point, using HIT to slide him inside the theater, you get two effects.

1. The whole scene advances with him, and the progression toward the audience is not perceived.
2. The sizing effect makes him appear smaller as he advances, impairing the frightening impact of the shot.

The solution is to

1. create a symmetrical FW at −25 pp on the first frame.
2. animate it to +15 pp to the last frame, making sure nothing breaks the SW.
3. use plain linear keys, unless the camera motion starts or stops during the shot.

FIGURE 10.10
An animated FSW can simulate camera movement.

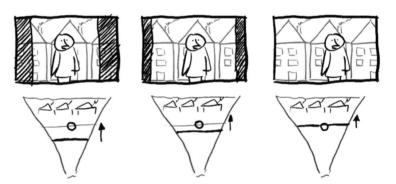

Subtitles in depth

Subtitles are blocks of text positioned in the lower third of the frame, translating the actors' lines. They are embedded in digital cinema packages either as a set of prerendered PNG images or as a text file. Both come with timing cues and are added to the picture at play time by the server. The third option, to burn them onto the image, is usually not employed because it forces you to render a movie per language market. As we will see, this is, unfortunately, the only option for 3D movies until an addendum to the DCI specification includes the depth for the text positioning parameters.

WHY ARE SUBTITLES TROUBLESOME IN 3D?

Most likely, we see subtitles as the actors are talking, in medium or close shots, with negative parallax. If the subtitles were rendered as classic 2D text,

they would appear to be inside the actor's body, in stereoscopic violation. Furthermore, they would not be in the image convergence plane, and we would be unable to read them, unless we stopped fusing the action in 3D.

Many tests were conducted to try to resolve this issue. The first idea was to use the extra space below the image. The DLP chip has a 1.77 aspect ratio, and most movies are formatted in 2.35, so there's ample space to put the text. Unfortunately, showing the text outside the frame in the screen plane proved to be uncomfortable. The audience members do not enjoy having to do the reconvergance every time they shifted attention from action to text. The text had to be at the same depth as the action. Showing the text out of the frame, in the action depth, generated too much ghosting. Remember, it's white text on black. And eventually, it was noticed that some theaters have 2.35 screens, with no space for the text.

WHAT ARE THE SOLUTIONS?

The solution eventually used for *Beowulf* was to put the text in negative parallax, closer than any action, with a much stronger and darker dropped shadow that usual. Under the auspices of the Inter-Society Digital Cinema Forum (ISDCF), a group led by Jean-Philippe Violet from Doremi, is currently working on a specification to include in the XML file the depth information to be used in the text rendering.

CONFORMING YOUR MOVIE FOR 3D

Your movie can be released in 3D theaters, for the home market, and on the Internet.

- Conforming for digital 3D cinema is very technical, and obeys strict rules established by the system vendors or trade organizations like DCI or the SMPTE
- Conforming for 3D projection in special venues like museums or trade shows is a simple task, usually taken care of by the movie player provider.
- Conforming for optical disks like DVD and Blu-ray is a road that's under construction, where you will encounter pioneers paving the way and volunteering to give you directions, as we wait for standards to be announced.
- Conforming for file distribution of your movies is the least defined of all the processes, ranging for dummy-proof anaglyph to tech-savvy dual-stream delivery.

Packaging for projections

DIGITAL CINEMA

Since the first digital 3D movies were released, the packaging process has evolved from vendor solutions to industry standards. On July 11, 2007, the

Digital Cinema Initiative produced a "Stereoscopic Digital Cinema Addendum" to its recommendations. The document specifies that there should be:

1. Only one distribution master (DCDM) per 3D movie, discouraging the production of a vendor-specific ghost-busted or color-corrected master
2. Only one distribution package (DCP) per 3D movie, including both left and right movies.
3. Only one stream per DCP, with left and right frames alternated at 48 fps, and left first
4. Only one audio track of both 2D and 3D versions, as it should be interchangeable
5. Only one 250 Mbits-per-second data stream of the 2D standard that is shared between left and right images

The DCI packaging was originally performed by the vendors of 3D systems or servers. It is now an available service in more and more DI houses. If you want to build your package, are on a budget, and have a Linux genius handy, intoPIX is working on an open-source DCI encoder.

SPECIAL VENUES

Many a 3D movie was produced for museums, art installations, and trade shows. In these projects, the production company is in direct contact with the equipment provider and they work together on the system blueprints. All installations should be based upon a high-end home theater PC or a workstation, and be directly connected via DVI to the projectors.

WEBLINKS
The DCI stereoscopic addendum
**http://www.dcimovies.com/DCI_
Stereoscopic_DC_Addendum.pdf**
intoPIX
www.intopix.com

The movie player can be a high-end professional solution like Lightspeed Design's DepthQ Player, or a consumer product like Peter Wimmer's Stereoscopic Player. They are both able to play the left and right movies at once, in parallel processing on a multicore CPU. If you plan to use low-compression, high-bandwidth video encoding, reaching the limit of the hard drives, have each movie on a dedicated unit.

Stereoscopic movies should be free of any compression artifacts. You may want to use a lossless codec, like JPEG 2000 with the appropriate settings, or a lossy codec set at its highest quality, like Windows Media 9.0 in movie archive 95 percent quality. The soundtrack can be embedded in the left or right movie, or in a separate file.

If you experience bandwidth or processing power issues, as with laptop-powered art installations, encode your movie in the over-under format, because it has the best depth definition, and reduce the frame size rather than increasing the compression ratio. A GPU up-scaling demands less power than CPU pixel decoding and its blur is less damaging for 3D than asymmetric compression artifacts.

In all cases, it's always safer to have a spare fan to cool your equipment. Remember: 3D is twice the pixel count, twice the disk bandwidth, twice the lamp power and

projector heat, and can end up with twice the temperature for your CPU, GPU, and drives, too.

3D formats for DVD or Blu-ray

Distributing 3D on disks is an even hotter subject than distributing in theaters. Many players in the field want to see it happening sooner rather than later.

1. Studios, for which home sales represent 50 percent of the industry's 2D revenue, are looking for an aftermarket for their 3D titles, too.
2. TV makers are looking for a new sales incentive beyond HDTV. After years of industrial overcapacity, the flat panel makers are also looking for better profit margins.
3. A 3D Blu-ray disk would be good news after a format war that revealed Internet delivery was a stronger contender than expected. Downloading 3D is not yet an option, due to its increased bandwidth and image quality requirements.

These are three good reasons to see the 3D-at-home among the hot topics in consumer electronics for a couple of years.

LEGACY OF THE 3D DVD AND THE UPCOMING 3D-BLU-RAY

There have been many attempts to release 3D on DVD, basically anaglyph encodings, interleaved on interlaced and proprietary formats. They make the best use of the DVD image quality, and it is possible to enjoy a 3D movie on a DVD, under very strict conditions. The increased resolution and versatility of the Blu-ray disk make it a much better host for 3D content. Not only is 3D much better in HD, but the Blu-ray 2.0 offers additional features that perfectly fits what 3D needs in a media player.

The issues with DVD as a 3D support

Being digital, the DVD is a much better 3D support than consumer videotapes were, but it still has limitations.

- Composite connection to the TV kills anaglyph color-encoded 3D.
- Interlaced 3D on TVs are played at 30 fps per eye, causing flickering.
- Interlaced 3D and proprietary formats require a set-top box for decoding and a glasses connection.

Eventually, the best equipment on which to watch a 3D DVD is a computer, with the anaglyph properly handled with RGB connections, or the active stereoscopy on 120 Hz displays. Software DVD players include a progressive scan conversion that has to be disabled to preserve the 3D.

If you have to deliver 3D on a DVD, like a demo reel, it is advisable to offer a set encoding formats, like anaglyph, interlaced, and regular 2D. A warning screen inviting the viewer to use a computer is useful, too. For best quality, you may want to put a data track on the DVD with a demo version of a 3D movie player and computer file version of your movie.

3D virtual players in the Blu-ray 2.0 framework

The video decoder of a Blu-ray player is actually software loaded on a piece of computer-like hardware. The Blu-ray 2.0 specifications include a copy-protection system called virtual player, where a disk may contain a program that is loaded and used to decode the content. This architecture was aimed at simplifying the regular upgrades of the anti-copy systems. The specifications even include an Internet connection for interactive content. You already see the benefits of such a system for 3D. A virtual 3D player, run on a Blu-ray disk capable of playing 2D at 1080 p, is able to process 3D at twice 720 p. The all-digital connection to the display, over a high definition multimedia interface (HDMI), allows for checkerboard encoding and direct display on DLP-based 3D RPTVs from Samsung and Mitsubishi.

The capacity, blueprints, and proof of concept are already part of trade show demonstrations. All we need is an agreement on formats and players that ends as an industry-wide standardization, unless a studio comes up with its own virtual 3D player implementation.

Because Blu-ray was designed as a 2D media, the format will have to be somewhat 2D compatible.

2D-COMPATIBLE IMAGE FORMATS

Backward compatibility (BC) describes the ability of a new technology to interact smoothly with the preexisting generations. The color TV formats NTSC and PAL are backward compatible with content and equipment. You can watch a color channel on a black-and-white TV, and you can watch black-and-white movies on a color set.

The objectives of 2D backward compatibility for 3D delivery formats include

1. recorded on legacy support
2. played on legacy players
3. seen in 3D on legacy displays
4. seen in 2D on legacy displays
5. seen in 3D on dedicated displays

All the 2D-compatible image formats are legacy-supporting backward compatible, because we can record them on a Blu-ray disk support.

Anaglyphs and color encoding

The anaglyph DVDs were doomed by the composite video connections and a computer was the best equipment to enjoy them on. The HDMI digitally delivers the images to the display. That makes color encodings serious contenders for 3D content delivery until most homes include a real 3DTV.

The basic encoding formats are the well-known red and blue, red and green, and the less-used yellow and blue and magenta and green. There is an endless debate as to which color should go on which eye.

Anaglyph color scheme selection, color grading, color encoding, and media encoding are more of the "looks-so-easy" 3D traps. You will find thousands

of color shops willing to process your images, and very few able to deliver top quality. The video encoding needs specific care to avoid additional damage from the color subsampling and color space conversion in the MPEG compressor. Special desaturation filters are needed to avoid image ghosting and washing out the colors. The anaglyph encoding is best done by an expert 3D color artist at the grading station.

> Anaglyph encoding backward compatibility
>
> - Anaglyph is legacy-player backward compatible.
> - Anaglyph is 3D-on-2D-display backward compatible.

Row interleaved 3D in a field alternative video

As we have seen, this format is compatible with legacy DVD hardware, if you can cope with the flicker. A 3D movie encoded as interlaced 3D in a 1080 HD stream on a Blu-ray and played on a Micropol 3D LCD panel will be seen in 3D. We would not recommend this makeshift solution, except for installations where you control the whole display chain. You will have to make sure there's no progressive scan, HD scale-up, or image enhancer processing at any step. The second generation of consumer 3DTVs is expected to include 3D chip sets that will handle such formats.

The interleaved encoding is a very simple one-pass process that can be done by any visual effects station. The real challenge is at the encoding and authoring stations. The images shall be encoded using an interlaced video compression preset. This will make the left and right images encoded as two separate streams.

> Interleaved-in-interlaced encoding backward compatibility
>
> - Interleaved-in-interlaced is legacy player backward compatible.
> - Interleaved-in-interlaced is 3D-on-2D-display backward compatible.

Spatial compressions

All the anamorphic formats, including mesh, checkerboard, and quincunx are putting left and right images inside a single frame. Because most HDTV home theater players are computers or computers disguised as Blu-ray players, they have versatile image manipulation capacities. It is too tempting to harness them to 3D display functions.

Simple encodings like side-by-side and over-under offer no real benefit over interleaved encoding.

The new 3D-capable rear-projection TVs use a checkerboard-like left-right multiplexing pattern. For psycho-perceptive reasons, they have a better effectiveness than simple anamorphic compressions. Such images cannot be recorded as-is, because they would be washed out by the discrete cosine transform (DCT). If it's reorganized to put all pixels from each eye into each side of the image, it looks

like a side-by-side picture. A decoder embedded in the player or in the TV set reshuffles the left and right images to the appropriate 3D patterns at play time.

Until such decoding systems are put to mass market, they should only be used in venues and art installations with their appropriate decoding units of software.

ANAMORPHIC FORMATS BACKWARD COMPATIBILITY

- Anamorphic formats are designed for 3D-on-3D display.
- Legacy-player compatibility requires a software or hardware upgrade.
- Anamorphic Blu-ray Disks can self-update the players to 3D-on-3D display.
- Anamorphic Blu-ray Disks can self-update the players to 3D-on-2D display.

Multilayer, multicamera MPEG streams

From its inception in the 1980s the video disk's format was multicamera capable. The DVD extended this feature to the possibility to switch cameras as you were watching a recorded football match. These options never took off except on a couple of interactive TV games that barely sold. Nevertheless, the scheme for hosting a multicamera program in a single digital video stream was consciously included in the subsequent versions of MPEG-2, MPEG-4, and H264. Many an engineer in the field knew about stereoscopy being a form of multicamera content. The beauty of this format is that both images are recorded at full definition, and a legacy player will just ignore the second image. Its drawback is that it requires twice as much bit rate, forcing you to chose between choking the hardware or increasing the compression ratio and reducing the visual quality.

As of today there is no reference implementation of a multilayer stereoscopic format. This format is the leading contender for 3D Blu-ray disk format, along with the reconstructed checkerboard.

MULTIPLE MPEG STREAM BACKWARD COMPATIBILITY

- Multilayer formats are legacy-player backward compatible.
- Multilayer formats are 2D-on-2D display backward compatible.
- Multilayer supports can self-update the players to 3D-on-3D display.
- Multilayer supports can self-update the players to 3D-on-2D display.

WEBLINK
ColorCode 3-D
www.colorcode3d.com

COMMERCIAL PRODUCTS

ColorCode 3-D

ColorCode 3-D is a color encoding process using variants of yellow-blue anaglyph. It is an asymmetric encoding, in luminance, definition, and color density. The eye behind the yellow or light brown gel gets a well-defined, well-colored image, while the eye behind the blue filter gets a dark monochrome image. The visual system processes them and rebuilds the colors.

If you register on the ColorCode 3-D web site, you will receive two pairs of glasses to evaluate the system.

Trioviz

The Trioviz system uses green-magenta glasses, but involves much more than a simple color encoding. It actually involves a full visual effects pass. As a result, the 3D image is surprisingly comfortable to watch on a regular 2D display.

WEBLINK
Trioviz
www.trioviz.com

There's very low retinal rivalry in the luminance, definition, and color domains. The drawback is that the overall depth of the scene may have been reduced to be kept inside the system comfort zone. Regular color encoding processes hurt the audience when their binocular separation power is maxed out by huge parallax and color dynamics. Trioviz encoding offers the option to reduce the 3D effect to the very amount of depth it is possible to squeeze in a color encoding. The process works best with landscapes and behind the screen layouts than with on-your-lap 3D effects. As of late 2008, the process is slated for release in video game engines and Blu-ray disk in Europe first.

TDVision

TDVision is a multitalented 3D company working on 3D helmets and the design of a 3DTV framework. They implemented a stereoscopic multilayer MPEG codec, and demonstrated it. A single Blu-ray disk can be played in 2D in a

WEBLINK
TDVision
www.tdvision.com

Blu-ray player and in 3D using their software player on a computer. They are working on implementing their code as a virtual player in a Blu-ray disk, and claim IP on the system, based on a patent filed in 2003.

SENSIO

SENSIO has developed a proprietary optimization of the checkerboard subsampling. They also acquired some IP in real-time conversion from JVC and repackaged it with their 3D format and other 3D formats conversion into a single chip to be integrated in 3DTV sets. They have recently pre-

WEBLINK
SENSIO
www.sensio.tv

sented a high-definition implementation of their codec in a Blu-ray disk, and a real-time encoder for live 3DTV production. SENSIO is definitely a company to keep on your radar, and to consult for release projects.

CURRENT STANDARDIZATION AND TRADE ORGANIZATION EFFORTS

It seems that the objective not to get into another format war is shared among 3D industrial and trade associations.

SMPTE 3DTF

To complement the work of DC28.40 group on stereoscopic cinema, the SMPTE created a 3D task force in charge of studying the needs for a common practice reference in 3D production. The group meetings surprised their proponents, with more than one hundred attendees, when other SMPTE task forces gather 10 to 20 persons. The task force is currently working on assessing the needs, tools, and evaluation criteria for a production format standardization.

Consumer electronics

On October 22, 2008, the Consumer Electronics Association had its first 3D Video Discovery Group meeting in Las Vegas.

In the summer of 2008, the Blu-ray Disk Association started working on a 3D format, with Panasonic submitting a proposal by the end of the year.

The HDMI 1.4 specifications will include 3D-specific functions to handle 3D format declaration and conversion processes.

The consortia

There are at least two 3D consortia: the original 3D consortium created years ago, gathering mostly Japanese companies, and the recent 3D-at-Home consortium, joined by US and European members.

Key Points

- Digital 3D cinema projections have very low light efficiency.
- The 3D luminosity is one third of 2D luminosity.
- Each projection system has a different impact on colorimetry.

DCI-compliant 3D projection systems

- RealD
 1. Active stereoscopy with single projector
 2. Alternated light polarization, encoded by the Z-screen
 3. Passive glasses with gray filters
 4. Disposable plastic glasses costing less than 30 cents
- Dolby
 1. Active stereoscopy with single projector
 2. Alternated RGB subspectrum, encoded by a color wheel
 3. Passive glasses, with colored filters with a slight magenta-green shift
 4. Reusable glass glasses costing about $30
- XpanD (McNaughton-NuVision)
 1. Active stereoscopy with single projector
 2. Active glasses, with liquid crystal shutters (LCS)
 3. Reusable glass glasses costing about $50
- Other systems
 1. Dual projectors and passive polarization
 2. Dual projectors and dual RGB spectrum
 3. Dual projectors and active glasses

4. Single projector with rotating light polarization wheel
5. Single projector with beam splitter and passive polarization

Color grading

- Color grading for 3D should be done on a real 3D projection system, at the real light level.
 1. It is based on the 2D grading.
 2. It includes one pass to compensate for the 3D projection system effect on the images.
 3. It includes one pass to optimize the artistic look for best depth effects.
- 3D masters are generated for
 1. IMAX 3D, with no specific treatment
 2. RealD systems, with specific color treatment and a ghost-busting pass
 3. other digital 3D cinema systems, with specific color treatment
- 3D projection-specific color treatment is to be phased out.
 1. The Dolby system has a real-time color processor.
 2. RealD is developing real-time ghost-buster processors.
 3. The DCI cyphering requirements make them complex to implement.
- The ghost-busting process consists of
 1. establishing a mathematical model of the cross-eye leaking
 2. raising the black levels
 3. subtracting from the images the light that will leak from the other eye.

Depth grading

- Depth grading is to depth what the final mix or color grade is to sound or 2D images.
- Depth grading is aimed at fixing rogue jump cuts and broken floating windows.
- Depth grading enforces the respect of
 1. the depth comfort zone
 2. the depth continuity
- Depth grading uses
 1. reconvergence by horizontal image translation
 2. floating stereoscopic windows
 3. view synthesis in extreme cases
 4. active depth cuts
- IMAX and digital 3D cinema do not have the same infinity references.
 1. IMAX 3D requires a parallel master, with no positive parallax.
 2. Digital 3D cinema requires a converged master, with infinity in negative parallax.

FLOATING STEREOSCOPIC WINDOWS

- Floating windows are made with asymmetrical black masks on the sides of the plates.
- Floating windows move the perceived screen along the depth axis, behind the wall or toward the audience.

- The resultant virtual screen can be twisted, bent, or leaned for depth placement effect.
- Floating windows can be animated and moved during shots for artistic effect.
- There's no requirement for FW continuity along shots and cuts.

ACTIVE DEPTH CUTS

- Depth cuts are cuts between shots with difference depth positions.
- There can be forward depth cuts and backward depth cuts. They are created
 1. by reconverging the images to bring the shots into common depth
 2. just over a few frames, before and after the cuts
 3. at a constant depth velocity.

Packaging

PACKAGING FOR DIGITAL CINEMA

- Digital 3D cinema packaging is defined in an addendum to the DCI recommendation.
 1. single package, single stream with both eyes embedded
 2. 48 fps frame-alternative 3D with left image first
 3. unique audio track for both 2D and 3D versions
- Inter-Society for Digital Cinema Forum (ISDCF) is working on the subtitles problem.

PACKAGING FOR CONSUMER OPTICAL DISK (DVD AND BLU-RAY)

- There's no official 3D DVD format.
 1. Most releases use anaglyph or field-alternative 3D.
 2. Some releases use proprietary formats like SENSIO.
- There's no official 3D Blu-ray disk format.
 1. One standard is expected by 2010.
 2. In the meantime, anaglyph seems to be the norm.
 3. New 3D formats use a software 3D decoder loaded in the Blu-ray player.
 4. New color-encoding using heavy FX passes comes to market.
- Patent-free formats
 1. classic anaglyphs (red-cyan and magenta-green)
 2. quincunx (likely not patented)
 3. side-by-side
 4. interlaced
- Proprietary formats
 1. color anaglyph (ColorCode 3-D)
 2. VFX anaglyph (Trioviz)
 3. Proprietary checkerboard (SENSIO)
 4. Proprietary dual stream (TDVision)
- Standard candidates
 1. embedded dual stream in single container
 2. optimized quincunx and reconstructed checkerboard

THE 3D PHOTOGRAPHY EQUIPMENT

The bare minimum to shoot 3D is a 3D camera and a 3D monitor. For productivity improvements, you will want to use a 3D-capable disk-based recorder and for depth quality insurance you will set up a makeshift 3D theater close by. 3D cinematography requires images matching on photography and geometry. This is provided on set by specially engineered cameras. Some of them have adjustable interaxial distance, when others have fixed interocular.

3D camera with adjustable interaxial: The rigs

Modern 3D rigs are apparatuses that hold the cameras together and allow for dynamic lateral shift, sometimes with convergence adjustment. Such rigs may include a mirror. Keeping all the parts tightly aligned is no easy task. It takes years of experience and a whole machine shop to create a fully functional one. Rig makers may be by the dozens around the world, but only a handful of companies have mastered the craft to the point that their products can be used on feature productions. Most of their systems are one-of-a-kind, with rare exceptions of rigs intended for rental or resale. For each type of rig presented here, you will be introduced to its pros and cons, as well as the name of company that makes it. Some advice is given on how to build rigs, but in most cases this subject is far beyond the scope of this book.

FIGURE A.1
A parallel rig with cameras mounted side by side.

THE PARALLEL RIG

The parallel rig is the simplest of all 3D rigs, and you can make a rudimentary one in a few minutes as explained here.

Principle

In a parallel rig, the cameras are mounted side by side, on an adjustable ruler. Its mechanical sturdiness is important to avoid rotation issues due to the cameras' weight.

Sweet spot

The parallel rig is well adapted for long shots on distant subjects like landscapes or wide views of sports arenas.

Pros

The qualities of the parallel rig are its relatively small size and low cost. With the cameras being physically placed along the optical axis, the parallel rig is a perfect rig to learn how to apply the rules of 3D photography.

Cons

The main limitation of the parallel rig is that its minimum interaxial distance is equal to the cameras' widths. For many years parallel rigs were unable to get camera separation smaller than a few inches, forcing us to zoom in and therefore causing cardboarding to the image. The latest generation of tapeless HD cameras, both professional and amateur, allows for much smaller interocular distances and give this rig's geometry a new shot.

Do-it-yourself, low budget

The parallel rig is the solution of choice for a first attempt at building 3D rigs. The key point is in the camera choice. You want cameras to be as small as possible, with bolting sockets that prevent rotation. Battery, memory card doors, and cable sockets should be on the front or back. Your mechanical assembly should secure the cabling along with the camera. You'll need a LANC port for proper synchronization. A composite video can be useful for visual control, but digital connectivity like DV, HDV, or even HDMI will be preferable for proper 3D recording and control as explained in Chapter 7.

The biggest issues with low-cost cameras are the high compression ratios and low light gain noise. The compression noise will harm the 3D quality, generating a compression blur that shows up as a curtain of dirt right in the screen plane. It can sometimes be avoided by selecting the highest compression bandwidth or by makeshift direct-to-disk recording. The low light gain noise is a side effect of the lenses miniaturization and cannot really be compensated for. Recording underexposed footage is even more dangerous because the under-lit areas will show as flat patches with no depth cues.

High end

High-end parallel rigs offer full motorized control of interocular, convergence, focus, zoom, and iris. Some even integrate optical zoom compensation and fiber-optic links to disk recorders. To the best of our knowledge, they are not

available for sale, but come as part of a package including 3D production consultancy and camera crew. Companies offering such services include Pace, 3ality, Paradise FX, and NHK. 3Ality announced at NAB 2009 that their 3Flex camera systems are now available for sale.

THE BEAMSPLITTER RIG

If you want to make the best-looking 3D images, you need to get close to your subject and bring the camera interocular down to a few millimeters. If you use large cameras and optics, the parallel layout is inadequate and you'll need a more complex rig, known as a beamsplitter rig.

FIGURE A.2
A beamsplitter rig's interocular can be narrower than the camera itself, down to zero.

Principle

The beamsplitter rigs get their name from the half mirror they use to split the light beam into two even shares between the two cameras. The mirror makes a 45-degree angle with the camera axis, and one camera is 90 degrees above or below the other one. In this configuration, the interaxial distance can be as small as you want, down to zero. Downward-looking rigs, with the vertical camera placed above the mirror, are suitable for low angles. Upward-looking rigs, with the vertical camera placed under the mirror, have the good grace to be much less prone to catch dust on their reflective surfaces.

Pros

The beamsplitter has only one good quality and tons of faults; it makes the best 3D pictures, and some stereographers would say "the only good 3D pictures." Its impressive list of drawbacks is actually a statement for its artistic qualities.

Cons

The biggest issues with the beamsplitter rig are its complexity, inherent size, weight, and fragility. The use of mirrors makes it sensitive to dust and fast accelerations. The mirror needs to be big enough to accommodate wide angles. It requires accurate mirror placement toward the cameras; otherwise keystone artifacts will affect the images. Such rigidity is obtained at the cost of the overall weight and limited access to the cameras. Eventually, the recorded image needs to be flipped back into its original orientation before it can be seen in 3D.

Do it yourself

A simple search on the Internet would lead you to many examples of makeshift rigs. Most do not offer dynamic interocular and only a few have the adjustable mirror attachment. A good mechanical engineer should be able to produce a rig in a few weeks. The Encyclopedia Pictura team who produced the 3D music

video of Bjork's "Wanderlust" impressed the whole 3D community in 2008 with an amazing movie shot with a rig made of aluminum rails. However, don't let their success fool you; the design of a functional and robust 3D rig requires years of stereoscopic experience. Unless your long-term objective is to start a rig-making business, it is wiser to rent or buy one.

Beamsplitter rig for sale

WEBLINK
P+S Technik
www.pstechnik.de

You can find rig makers on the Internet within a few minutes. All custom-make the rig upon request. As of the end of 2008, only P+S Technik has many 3D rigs ready for purchase. It's actually a modular line of elements used to assemble the rig you need.

FIGURE A.3
The P + S Technik 3D rig was designed by Alain Derobe and Florian Maier.

3D camera with static interaxial

There are many shots that can be photographed with a fixed interocular about the size of the human eye width, to the point that many people still believe all 3D should be produced using such a camera setup. For a lot of indoor shots, provided they are staged appropriately, a fixed interocular camera can be extremely handy, thanks to its simplicity, compactness, and robustness.

COUPLED 2D CAMERA

Coupled digital cinema cameras

The company 21st Century 3D designed a series of 3D cameras made of a couple of SD heads, two Mac minis, and solid-state hard drives. The resultant camera recorded raw image captured data and regenerated a 720 p image offline. This camera offers point-and-shoot capability that no rig can match.

FIGURE A.4
3D shoulder camera from 21st Century 3D.

Coupled industrial vision cameras

There are many industrial and scientific applications that require stereoscopic vision, including telepresence and space exploration. Even if these cameras do not offer the colorimetry, resolution, and frame rate of a real digital cinema camera, it may be worth it to look at them for the specific needs you may encounter in your productions.

FIGURE A.5
Andrew Woods presents his 3D camera used in underwater exploration projects.

Coupled film cameras

WEBLINK
Gemini 3D Camera
www.gemini3dcamera.com/Home.html

Sean MacLeod Phillips created the Gemini Film camera for IMAX 3D productions. This compact 8-perf 35 mm camera has a complex and flexible optical system that allows for rapid lens change, and convergence control. It's another solution that you may need in special cases.

3D OPTICAL ATTACHMENTS

Stereoscopic optics mounted on monoscopic cameras was one of the underlying technical reasons for the 3D revival of the 1970s and 1980s. Such an optical attachment is mounted in front of the lens, where it combines the left and right views into a single frame that is recorded as a regular 2D picture. Many 3D formats were tried—anamorphic side-by-side, widescreen above-under, and even rotated side-by-side. The main benefit of 3D optical mounts is that they solve most 3D issues of synchronization and rig bulkiness, and as such, they are as reliable as the

FIGURE A.6
Jason Goodman shoots single-camera 3D with a lens attachment.

camera they are mounted on. Their limitations are the fixed interocular distance and the reduction of the resolution. On film, widescreen formats in above-under layout could make the best use of the medium's resolution. On a digital camera, the loss of resolution is hardly manageable. Other issues include the fact that any four-corner vignetting is turned into asymmetrical two-corner vignetting. And last but not least, there is no HD-level product available yet. The last product released was an attachment produced by Canon for its XL1 in 2001.

Other 3D systems

You can shoot 3D with a single camera using either time shift or motion control to generate parallax.

TIME SHIFT 3D

If you are moving your camera along a controlled axis at the right speed, you can extract 3D from a single point of view with a simple delay for the second eye. This is sometimes referred to as Pulfrich 3D. If your object is rotating along its vertical axis or if your camera is revolving around it, you are actually shooting converged 3D. If the object or the camera is moving linearly, you are shooting parallel 3D. This technique can be used to get 3D views of elements that will be composited into scenes. The main benefit, along with its low cost and simplicity, is the ability to change the interocular distance just by shifting the second eye one frame sooner or later.

MOTION CONTROL

If you are motion-control shooting a static scene, such as a scale model or static objects, you may get a good result by running a dual pass with a single camera. Remember to animate the virtual rig, not just to move the reference point and replicate the movements. This means that you should have a pivot point that is equidistant from the two cameras' positions.

3D camera makers

Pace's Fusion and Reality Camera Systems (RCS) have been developed over the last 10 years for James Cameron's 3D productions. He used them for the production of *Avatar*, his much-anticipated 3D feature slated for release in late 2009. Pace uses modified Sony F900s made to order for Cameron's needs. Pace's latest achievement was to put together a pair of 4K-capable heads for an MBA 3D live cast.

The company 3ality is the historical leader in HD3D beamsplitter rigs. It was the first to show a three-axis controlled F900 on beamsplitter with electronic control of zoom disparities, interocular, and convergence. 3ality is the famous producer of the cinematographic milestone *U2 3D*. It has demonstrated on many occasions an ability to broadcast 3D over satellite links.

Paradise FX, executive producer of many large-format 3D shorts, provided the camera rigs for *Dark Country*, using RED and SI2K heads.

Dimension 3 made the two rigs used on *The Night of the Living Dead 2006*. Dan Symmes created two low-cost rigs using prosumer HDV cameras and demonstrated they could produce adequate images for large screens.

In New York, 21st Century 3D, known for its shoulder 3D camera featured on this book cover, made the 3D rig used on production of *Call of the Wild*.

Besides these happy few, who were actually part of the production of a digital 3D feature movie, there are three companies that deserve to be mentioned.

Lightspeed Design has devised a full production pipeline, from the 3D rig to the projection hardware, including an inhouse-developed 3DHD recorder and player, and a complete set of tools that interface with After Effects.

The German film-gear-maker P+S Technik is offering a 3D rig for sale. It's a modular system that comes in three sizes, depending upon the type of camera and optics you want to use. It is also available for rent at the major rental places like Band Pro in Burbank for the United States and Boggart in Paris for European productions. The BBC selected this rig for its 3D research team too.

The French start-up Binocle, is producing compact camera sockets that integrate the motors and computers needed to animate 3D parameters. They can be arranged in many configurations, including parallel, upward-looking, and downward-looking beamsplitters and Steadicams.

Monitoring 3D

Monitoring 3D is crucial to 3D production to the point that no stereographer agrees to shoot without some sort of monitoring. You need two levels of control: one small control monitor for each crew member who is controlling any aspect of the depth settings, and one large-screen control, close to your set, for artistic evaluation of the depth feeling.

ON-SET 3D VISUAL CONTROL

The DP and camera crew may decide they do not need a 3D display to run the shoot. The director can follow the stereographer in his or her choice to use a 3D monitor. Unless you are producing a TV show or commercial, the actual perception of the 3D is not that important because the image is not at its real size on a 3D field monitor. What is important is to control the image disparities against visual rulers indicating the amount of onscreen parallax allotted by the depth script and the depth budget. Therefore, this monitoring can be done using a real 3D display, or a makeshift control system like a 50 percent mix of the two views.

If you decide on a stereoscopic head-mounted display for portability and ambient light reasons, be aware that you will have hard time evaluating the depth placement and convergence on such a display.

If you are shooting with a beamsplitter, you need to flip one image to get stereo control on a regular 3D display. On the other hand, if you are using a beamsplitter

display composed of two screens and one half mirror you can feed it the raw 3D image, provided the 3D monitor's image orientation matches the rig's.

FIGURE A.7
Onset 3D monitoring tool developed by Lightspeed Design as a part of their DepthQ stereoscopic suite.

A few years ago, your only option was to mix together two analog 3D images. The digitization of the cameras and the graphic computing capacity of the recent laptops lets you control your image at full resolution. Live video mixing software designed for Video Jockey offers the color channel and mixing effects needed for anaglyph monitoring.

For more advanced controls, you may want to use Stereo Multiplexer, from Peter Wimmer, which offers HDV monitoring as a beta feature, along with many output formats, including 3DTV and all sorts of projection systems.

In Chapter 9, you were introduced to LumaChroma, an After Effects plug-in with real-time control functions.

High-end 3D monitoring systems

All the major 3D production companies and camera makers have created software and hardware monitoring systems. For example, 3ality has its Betty Box. Pace uses an Evertz dedicated image-processing blade, the 7732DVP-3D-HD. Other vendors involved in digital cinema deployment have solutions like Cine-tal's eL1000 and Davio. If you are planning to use 3D-capable digital disk recorders (DDRs), select one that is based on a Linux computer, with a powerful graphic card, because they usually offer 3D monitoring and replay as a basic feature or upgrade.

Quantel offers 3ality's Digital Betty Box under the reference SIP2100.

FIGURE A.8
The 3ality/Quantel real-time 3D processor SIP2100.

Image courtesy of Quantel.

The 3flex SIP2100 allows front panel or GUI operation

AUTOMATIC DISPARITY CORRECTION TOOLS

What to do when the perfect 3D camera rig does not exist, but the audience expects perfect images? Real-time post correction is the answer, and a few teams are working on it. Some corrections are easy to process, like colorimetry and luminance. The geometrical errors can be corrected manually or automatically. Human-controlled corrections need skilled and coordinated crew members. Automated corrections require powerful computation and fast processing. If you did the Chapter 4 workshops, you know how complex theses operations are, and have an idea of what a challenge it is to perform them in real time.

Currently, only 3ality Digital, with the SIP2100, and Binocle have shown some sort of development of such equipment. Binocle announced the availability of a fully functional studio system by the end of 2008 and a portable unit in early

FIGURE A.9
Screen shot of real-time disparity monitoring and correction.

Courtesy Binocle SA, France.

2009. The systems search for homologous points, detect and correct vertical disparities, and display horizontal disparities that are color-coded according to the depth budget parameters.

FIGURE A.10
Screen shot of real-time disparity monitoring and correction.
Courtesy of Quantel.

FULL-SIZE MONITORING OF 3D

It looks like we have not repeated our mantra for quite a number of pages. Maybe, this time we should sing it together: "Always visually check your 3D, and check it on a full-size screen." This is where your request may be a hard sell to the production accountants, but you really want your 3D theater on set. On the studio lot, you may have access to a projection room. On location, you will have to be creative. Rent a warehouse next door, project on the production truck while shooting night scenes, do whatever it takes, but never break down a set until you have seen your pictures on a large screen.

Recording 3D

Pairing systems in slave-master mode makes one of them receive orders from the other, but this does not guarantee they are always obeyed at once. You could get perfectly synchronized footage, with a perfectly synchronized one-frame delay that will kill your audience. Furthermore, when such a glitch occurs, it may not ring an alarm. It will likely not show up on the real-time monitor, or even on the TC-controlled instant replay. It will eventually show up on the edit computer, when imported assets have a one-frame discrepancy, despite sometimes showing the same frame count. This would be the case if the glitch repeated at the stop of the recording, or replicated at the later phase, due to a program script that imported the slave assets according to the master's duration.

GENLOCKING THE CAMERAS

If you don't already know the in and outs of video equipment time synchronization known as genlocking, it's time for you to rush to a bookstore or an online encyclopedia. In stereo cinematography, we need extremely accurate genlock, up to the pixel clock for fast action shots. Depending on your budget you will face three situations, ranging from hope-for-the-best to perfect.

Low-cost solutions using LANC protocol

The poor man's options presented in Chapter 4 for digital still cameras apply to video. With basic systems, like the LANC Shepherd and the SteFraLANC, you switch on both cameras at once and check that they stay in "good enough" synch. You'll soon know what drift to expect, when you'll get the best synch, and how long you can shoot before you need to reboot the camera. This timeframe is counted in minutes, depending upon the level of synchronization needed by the shoot's action pace. The LANC 3D Synch offers the option to actually control the internal clocks of the cameras and to keep them in synch for a long period of time. Unfortunately, this device is not manufactured and you will have to make yours based on the open-source blueprints provided on the web site (www.boehmel.de/lanc).

Note that the LANC protocol offers much more than simple synchronization control and Zoom In/Out and Record Start/Stop controls are among the functions already implemented.

Professional genlock and timecode

If you have experience in multicamera production procedures and hardware setup, you will put them to good use. On a 3D cinema set, every camera is a multicamera set by itself. The more accurate your synchronization, the better. SD cameras have to be genlocked and in phase. HD cameras use a tri-level synch signal, and digital cinema camera heads sometimes offer pixel-accurate coordination. This way, you can make sure that any pixel on a given frame was scanned at the very same moment on both cameras. Obviously you will want to distribute the timecode among cameras.

3D FIELD RECORDERS

Once upon a time, 3D movies were recorded on analog tapes and edited as two independent movies. Thanks to the digitization of the production pipeline, we dug ourselves out of that nightmarish situation. The constant drop in hard drive cost per bit makes the tapes close to pointless in image acquisition.

Makeshift solutions

If you cannot afford a real DDR and you can't settle for the low quality of the tape recorded video, you may want to investigate your own makeshift DDR. Blackmagic Design offers a low-cost card with HDMI inputs that can get full 4:4:4 signal in HD from some selected HDV camcorders. You will need to get

some fast hard drives and have to conduct all the research to make sure you actually record all the frames on disk. Another potentially useful tool for make-shift DDR is Stereoscopic Multiplexer. Its author, Peter Wimmer, warns that it is capable of handling DV, but it may drop frames with HDV signal.

Professional DDR

Most modern 3D filmmaking should be directly recorded on hard drives, unless specific location or budget constraints state otherwise. Some DDRs are actually computers with digital video in and out and a graphics card in the middle. This means they offer instant replays in 3D, and that's priceless. Such tools are offered by Wafian, Codex Digital, and Digital Ordnance.

Tape–based recorders

If the amount of footage you'll get makes the DDR solution impractical, you will have to synch pairs of digital tape recorders to record a full 4:4:4 signal. The Sony SXW Sony HDCAM-SR recorders have an interesting option: to record two 4:2:2 HD streams at once. They were used by Fred Meyers on location to record *Journey to the Center of the Earth 3D*.

RECORDING METADATA

Onset metadata generation and archiving is a brand-new class of job, with a study group of the American Society of Cinematographers (ASC) technical committee addressing the issue.

Files Included on the DVD

MOVIES

This section of the DVD contains examples of 3D movies. You will find them in various formats, including anaglyph, anamorphic, side-by-side, and dual stream with sound. You can watch the anaglyph movies directly in your computer, including Apple and Linux systems, but you will need a 3D player to enjoy the other formats. I do recommend Peter Wimmer's "Stereoscopic Player" and you'll find a demo version in the software section of the DVD.

Santiago Caicedo, AMAK, and ENSAD: "Moving still"

"Moving Still" is a very good example of mixing live action 3D and CGI. Furthermore, it shows how very good 3D can be produced with a single camera, using the Pulfrich effect. It won the "best first presentation" movie award at the 2008 NSA convention. "Moving Still" is ©2007 by Santiago Caicedo, Amak, and Ensad.

Eric Deren: Demo reel and experiments

The Eric Deren demo reel and experiments shows the use of 3D in extreme situations like skydiving or super slow motion. The demo reel shows the effectiveness of CGI 3D and transparency.

Phil McNally: " Pump-Action"

"Pump-Action" is the movie that brought Captain 3D to Hollywood, where he is now Studio Global Stereoscopic Supervisor with DreamWorks. This CGI short won many awards around the world in various 3D competitions.

Ray Zone and Ron Labbe: "A Better Mousetrap"

This short movie, produced by Ray Zone and directed by Ron Labbe, was originally rendered and presented in IMAX3D format. The massive size of the screen allowed Zone and Labbe to put the scene in front of the screen, and this has to be adapted for Digital Cinema. In the same folder you will find an After Effects project that resets the action behind the stereoscopic window. If you are using the movie in a workshop, you can make the same adjustment using floating windows exclusively.

Celine Tricart: "Reminiscence"

The French cinematographic studies school Louis Lumiere started a 3D teaching and research program in 2005. Three years later, the class of 2008 was producing its first 3D movies as part of their graduation requirement. "Reminiscence" tells an unconventional story of intergenerational connection through imaging technologies.

AFTER EFFECTS PROJECT FILES

In this section of the DVD you will find full project folders of real 3D movies to explore, modify, and play with.

Slow glass – shot of hell

This is an example of why you should always avoid rotoscoping in 3D. The blue screen is impossible to set up due to overlapping white and blue props and HDV compression artifacts.

The original project file used stereoscopic movies as inserts, making the total project more than 17GB. The movies have been replaced by still pictures in this distribution version in order to fit on this DVD.

Slow glass – title sequence

This is an example of a pair of cameras being used in a simulated 3-dimensional composition world in After Effects. The left and right plates are used as backdrops for, respectively, the left and right cameras. The interocular distance is set to have the correct "depth progression" of the synthetic 3D elements when they move toward the cameras. Once the camera interocular is set up to a roughly correct value, a simple 3D animation of the title places it in depth.

THE NOGLASS FOLDER

This is the composition with no glass effect, created to set up the 3D space and masks. It has eventually been duplicated into the Stereo_Glass folder to inject the glass effect into the 3D setup. Title Left and Title Right are duplicates; only the camera Y position is different.

THE STEREO_GLASS FOLDER

This is the master composition with *Left* and *Right* for final rendering, and *Stereo* used for real-time 3D viewing and rendering dailies sent to the director.

THE STEREOGLASS_L AND _R

StereoGlass_L is the original flat project in which the effects were set up and fine-tuned in 2D. It has then been duplicated in two compositions with only two differences:

[1] The camera Y position
[2] The source footage in backdrop

SOFTWARE AND TUTORIALS

Louis Marcoux tutorial on stereoscopy in 3Ds Max

Learn how to use 3D Studio Max, a 3D movie-making tool with anaglyph preview and a 3D camera. These movies are provided courtesy of Louis Marcoux.

http://louismarcoux.com/MaxTips.htm

You will find more tutorials on his Autodesk space :

http://area.autodesk.com/index.php/tutorials/tutorial_index/stereoscopy_tutorial/

Bas-Relief demo

Bas-Relief is a depth-map creation tool used to create 3D conversions of 2D pictures. It is included on the DVD courtesy of Evgenia Wassenmiller.

Inition Stereo Brain demo

Stereo Brain is a computing tool used to set the optimal interocular for your 3D scenes. If you want to continue using it after 15 days, you'll have to buy a license from www.inition.co.uk.

Peter Wimmer stereoscopic player and other tools

Peter Wimmer's tools are at the top of must-have 3D tools lists. The most useful are the 3D player and 3D multiplexer.

The player can ingest any 3D recording format and re-encode it on the fly into any 3D display format. You will need the player for most of the full-color and full-resolution 3D movies available on this disk.

The multiplexer can ingest two video sources, like two digital cameras or two webcams, and mix them on the fly into a single side-by-side video stream.

The multiplexer and player can be used together to build a low-cost live 3D monitoring system. You can even feed an Internet video stream with the multiplexer and play it in 3D with the player.

The demo version of the player is limited to 5 minutes.

STILL PICTURES

2D pictures and 3D software screenshots

This folder hosts 2D pictures of 3D equipment or the making of 3D movies. Images appear courtesy of Binocle, 21st Century 3D, Florian Maier, Ray 3D Zone, and Gemini.

The screenshots present the various 3D tools available as of early 2009. You will find images from Autodesk, EON, The Foundry, Quantel, IRIDAS, and more.

3D pictures

This folder hosts images from many 3D artists who agreed to contribute to this DVD. You will find autostereoscopic images, color-encoded images in various formats, 3D conversion examples, and various 3D formats.

3Dimka images are examples of "autostereograms" that you can see without special glasses. 3dimka.deviantart.com.

Celine Tricart, the director of "Reminiscence," shares some plates from the movie and making-of pictures. www.celine-tricart.com.

ChromaDepth is an encoding format where the warmer colors are closer to the viewer and colder colors are pushed behind the printed image. You need special glasses to see them, which you can get at www.3dglassesonline.com.

ColorCode 3D is another color-encoding system. This patented variant of the anaglyph uses blue and light amber gels. It was massively used in February 2009 for 3D commercials during the Super Bowl, and in subsequent 3D shows. www.colorcode3d.com.

Enrique Criado is a famous 3D stereographer known for the quality of his talks. These images are extracts from a presentation he gave to the 2008 Stereoscopic Displays & Applications Conference, where he shared the "best use of 3D" award with Rob Engle. www.enxebre.es.

Evgenia Wassenmiller is a Russian 3D artist who does 3D conversions. She shares with us a few examples of recreated depth maps and the resultant 3D images she created with her tool "Bas-Relief". www.3dmix.com.

The images from **Philips** are examples of 2D + Depth and 2D + Depth + Occlusions that are used in autostereoscopic imaging systems. The 3D player embedded in Philips WOWvx displays recreates up to 46 views from this special 3D format. www.wowvx.com.

Vic Love is a 3D photographic artist whose online gallery can be found at www.MY3DCAM.com.

WHITE PAPERS

This section regroups papers published by various companies and personalities working in the 3D field. They will give you an insight into their respective approaches to 3D. The contributors to this section are Autodesk, Florian Maier,

In-Three, Michael Starks, Peter Wimmer, Quantel, Ray Zone, Brian Gardner, Sensio, and The Foundry.

ONLINE

The world of 3D imaging is an ever-changing one and the Internet is the only place where the information is up-to-date. I invite you to get to this book's homepage at www.digitalstereographer.com.

The Links section will lead you to the most useful 3D web sites, including StereoPhoto Maker, Make3D, Stereoscopic Computer, and LumaChroma.

You will find many 3D pictures and movies at the following addresses:

http://www.stereomaker.net/sample/index.html

http://www.stereomaker.net/sample/stph02.htm

http://www.stereomaker.net/sample/index.html

http://3dtv.at/Movies/Index_en.aspx

For more information, for detailed help, or to engage in discussions about 3D movie-making art and technology, you'll find dedicated fans of 3D movie making on the Yahoo group "3dtv" http://movies.groups.yahoo.com/group/3dtv/ and on the Stereo3D forum http://www.stereo3d.com/discus.